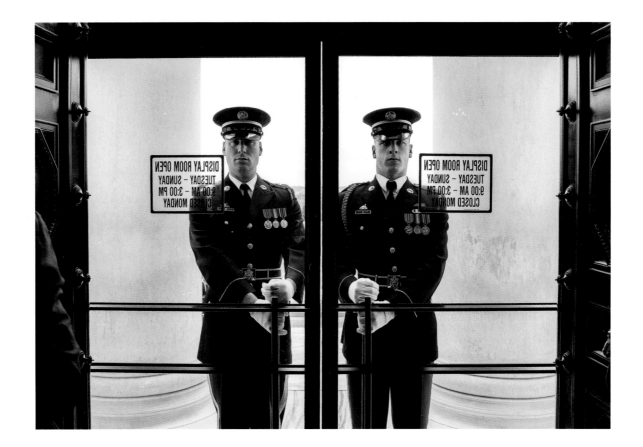

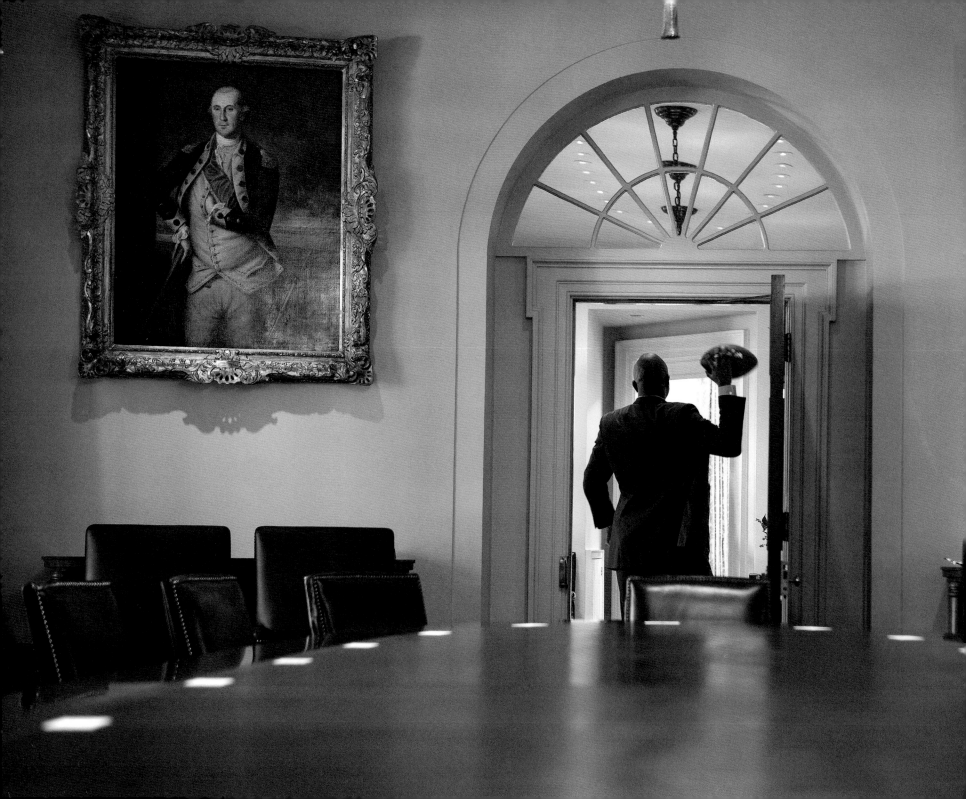

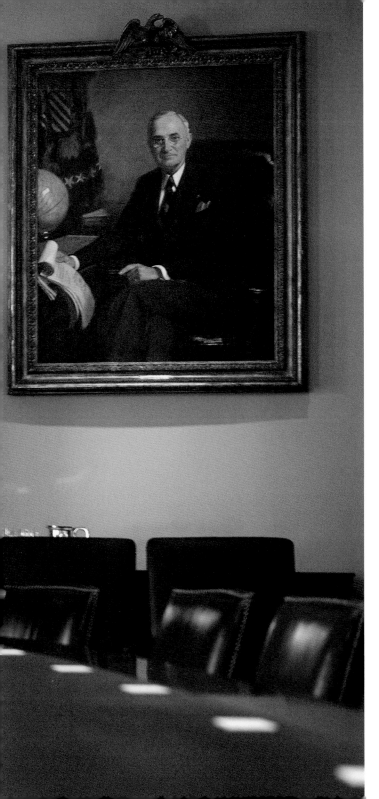

THE WEST WING AND BEYOND

★ WHAT I SAW INSIDE THE PRESIDENCY ★

PETE SOUZA

VORACIOUS

LITTLE, BROWN AND COMPANY

NEW YORK BOSTON LONDON

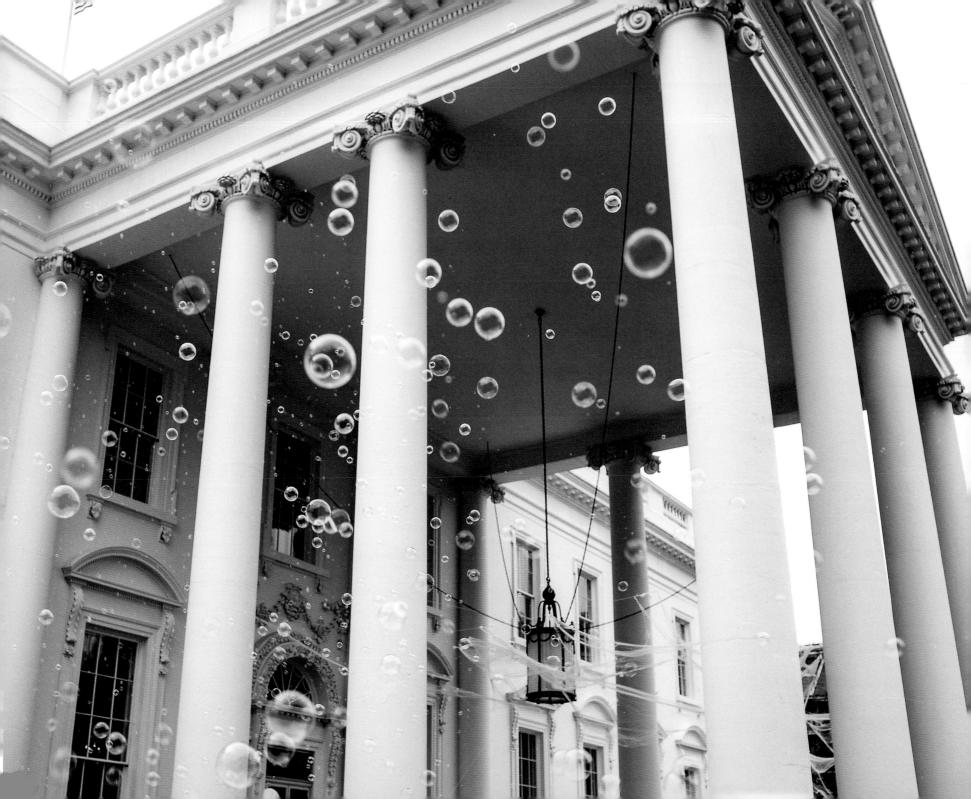

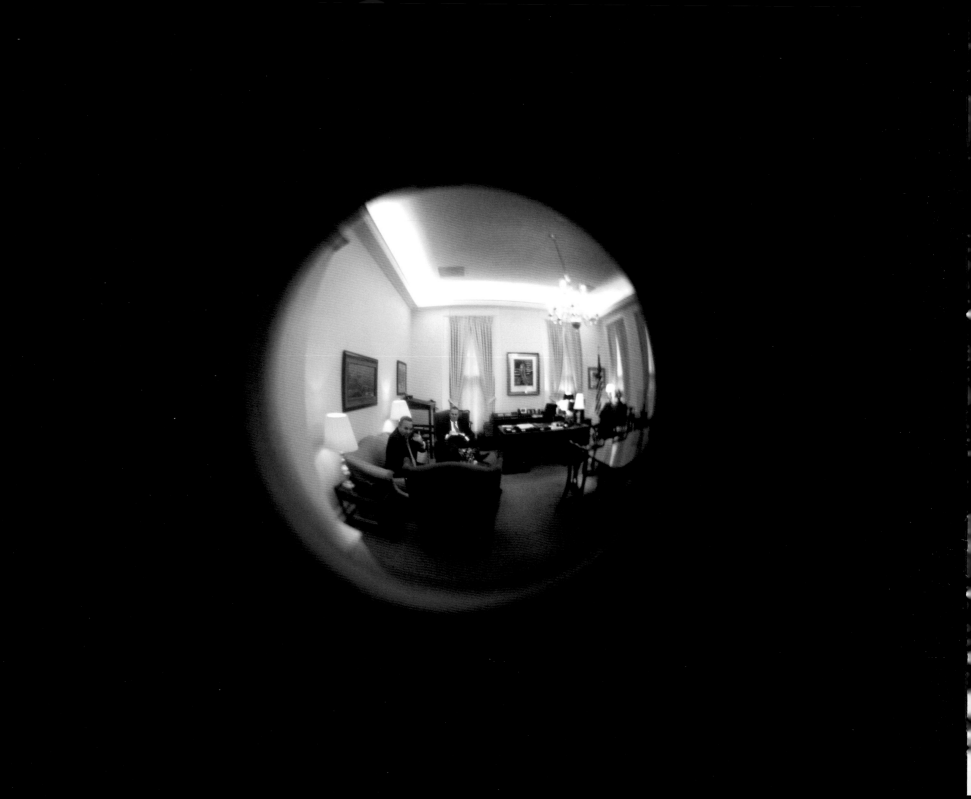

1986: In my West Wing office, with Reagan's photo editor Carol McKay (photo by David LaBelle).

2009: In my West Wing office, the old barbershop, during the Obama administration.

Introduction 11

THE WEST WING

———

THE PEOPLE'S HOUSE

———

ON THE ROAD

INTRODUCTION

Working in the White House is a big job, but it still begins with a daily commute.

It takes the President about a minute to walk from the residence along the West Colonnade to the Oval Office. For everyone else, especially those who live on the other side of the Potomac River, the commute is much longer.

Every morning as Chief Official White House Photographer, I'd join thousands of people driving from the Virginia suburbs to Washington, D.C. I'd take I-395 to Route 110, where the slow crawl toward the Arlington Memorial Bridge began. I'd pass by the Pentagon, on my right, and Arlington National Cemetery, in the distance to my left. Crossing the bridge, I'd see the back of the majestic Lincoln Memorial looming ahead. It reminded me daily of the importance of where I was headed.

Eventually I'd drive along E Street and zoom past an "Authorized Personnel Only" sign at the southwest outer perimeter of the White House complex. There, a uniformed Secret Service agent would check my Secret

Service–issued ID, check the Secret Service–issued parking pass on my dashboard, and then signal a thumbs-up for the Secret Service canine unit to inspect my vehicle.

After the "bomb dog" sniffing inspection, I'd enter and turn left to park on State Place. I'd then walk up to the Secret Service guard station at the southwest gate, show my ID again, and send my belongings through an X-ray machine before walking through a magnetometer onto West Executive Avenue ("West Exec" to everyone who worked at the White House).

Hundreds of other White House employees went through a similar process every day. Many of those walking to work would instead enter the White House complex through the northwest gate on Pennsylvania Avenue or the Eisenhower Executive Office Building gate on 17th Street.

After exiting the Secret Service guard station, I'd walk past the outside of the Situation Room complex to the basement entrance of the West Wing. Although I've seen references to it as the "awning entrance" (presumably

1988: The Outer Oval during the Reagan administration.

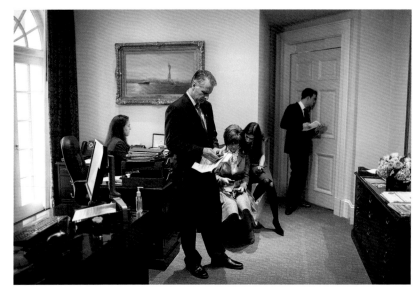
2009: The Outer Oval during the Obama administration.

because of its outside awning), I don't remember anyone referring to it as anything other than the "basement entrance."

After passing through two sets of doors, I'd show my badge to Charlie, another uniformed Secret Service agent seated by the locked front entrance of the Situation Room. My badge was blue, which indicated that I had blanket permission to be inside the West Wing. I became such a familiar face that I did not have to show Charlie my badge after the first few weeks.

Only then was I inside the presidential bubble—free to move about in close proximity to the President. *National Geographic* has described the bubble as "the rarefied, isolated, and protected world in which the presidential entourage moves."

My cubbyhole of an office was less than 50 steps from where I entered the West Wing. On the way, I'd often pass other members of the staff heading down a small hallway to the right to the White House mess to pick up breakfast or coffee. Here, on the hallway walls of the ground floor, is where we hung most of our "jumbos," blown-up photos in the same black frames that we had

inherited from the Bush administration. (I personally was appalled that the next administration switched to gold frames for the jumbos.)

The wooden door of my office had a small brass plaque that simply said, "Photographic." Once upon a time, the plaque said "Barber Shop," which it was until White House barber Milton Pitts retired in 1991 and his job was eliminated. Though the barber's chair was no longer in my office, one wall still had mirrors from top to bottom. (During the Reagan administration, the photo office was just across the hall.)

My office was sandwiched between the homeland security advisor's office and a men's room. You could sometimes hear rats scurrying in the low ceiling above. Inside the men's room was a mysterious locked door; it took me a while to learn that inside was a shower, and that my Secret Service agent friend Charlie had the key and allowed me to use it. That opened new possibilities for my commute, and I began to ride my bicycle to work as often as I could. I called it "my" shower room because I never saw anyone else use it, but for five

1964: A Secret Service agent holds LBJ's hand as a security measure (photo by Cecil Stoughton).

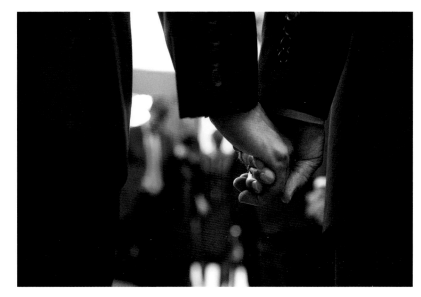

2013: Vice President Joe Biden holds President Obama's hand during a prayer.

years, someone had forgotten his Navy dress uniform hanging on a hook inside. I was always tempted to put it on and wear it as a joke up to the Oval Office but thought it might be a federal offense.

After showering, I'd change into my work clothes. I usually wore a blue or blue-striped dress shirt, and rotated through six gray or black suits from Joseph A. Bank ("buy one, get two free"). At my desk, I'd catch up on overnight emails and then hustle up a set of stairs, pass the White House press secretary's office, and enter the inner sanctum of the presidency—what we called the Outer Oval Office, the foyer-type office area outside the Oval Office.

It was about 88 steps from my office to the Outer Oval, where my job documenting the presidency usually began.

Each day, I spent between 10 and 18 hours inside the presidential bubble. In the Oval Office. In the Situation Room. In the other West Wing meeting rooms. Hanging out in the Outer Oval. On the State Floor. Or outside in the Rose Garden or on the South Lawn. Wherever the President went, I went, too,

with my camera. The only times I returned to my own office were to eat a quick lunch at my desk and then at the end of the day after the President had returned to the residence for the night.

Beyond the West Wing and the "People's House," I was also inside the presidential bubble when we traveled together outside the White House complex. That happened a lot. I spent 1,442,242 miles flying with President Obama on *Air Force One*. That's the equivalent of circling the globe more than 58 times.

By my calculation, I was inside the presidential bubble—whether it was in the West Wing or on the road—for more than 25,000 hours during the eight years of the Obama administration. It's a view that no one else in history has had for that many hours, at least not with a camera in their hands. But I wasn't photographing only Barack Obama the man, the President of the United States. Often, I turned my camera to see what else was going on; things maybe even the President didn't see.

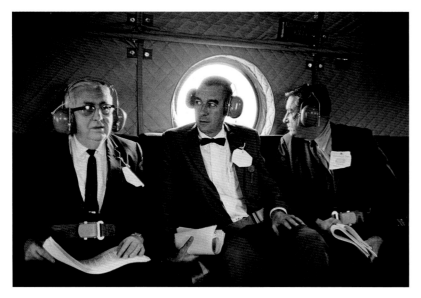

1967: Aboard a helicopter during the LBJ administration (photo by Yoichi Okamoto).

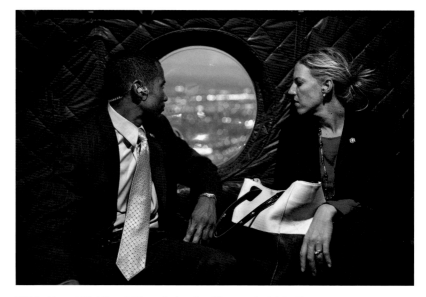

2012: Aboard *Nighthawk Three* during the Obama administration.

This book is my visual documentation of what I saw inside an American presidency. With my photographs, I will take you inside the rooms and the places where I spent every day and where democracy happens. You will see the moments or scenes that caught my eye: Sometimes illuminating. Sometimes quirky. Sometimes just plain bizarre. Yes, my main job was to photograph the President of the United States. But just as important, I felt, was to photograph the presidency itself—the people, the places, the activities that make the nation's highest office run.

Step inside the Oval Office and see where I focused my camera. Jump aboard the helicopter and take in the view as we flew over cities and open landscapes. Ride along inside the armored limousine with me to see the people I saw during our travels around the country, and around the world.

Along the way, I will introduce you to some of the people I worked alongside. People whose jobs you may not have known existed but are crucial to making the presidency function.

In many ways, my photographs will look familiar to anyone who has worked in a modern-day presidency, regardless of the administration. Yet there are stark differences, too.

In this introduction, I've paired some historical photographs from earlier White House photographers with more recent photographs to illustrate this.

Look at the two photographs above. The black-and-white shot by photographer Yoichi Okamoto shows three members of President Lyndon Baines Johnson's traveling party aboard a support helicopter. Three white men, wearing 1960s-era suits, with massive headphones to muffle the engine noise. Contrast that with my full-color photo, which shows two members of the Obama traveling party more than 40 years later aboard a similar support helicopter: a Black man with the White House communications agency, and a female member of the medical unit—each wearing disposable 50-cent sets of ear plugs.

Similar pictures, showing how much the times have changed.

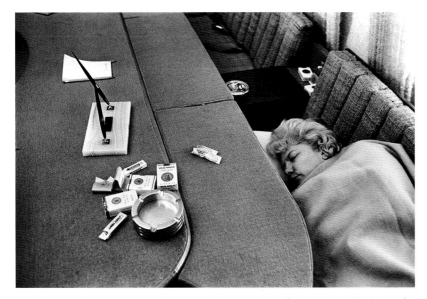

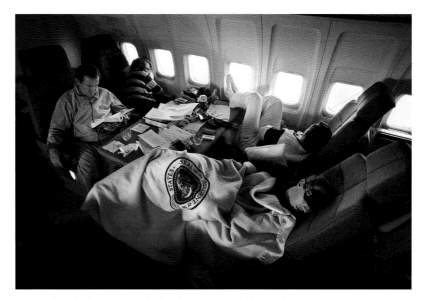

1966: Aboard *Air Force One* during the LBJ administration (photo by Yoichi Okamoto).

1986: Aboard *Air Force One* during the Reagan administration.

And above on this page are two photos of White House staff on *Air Force One*. The black-and-white photo, again by LBJ's photographer Yoichi Okamoto, shows staffer Liz Carpenter in 1967 curled up with a nondescript blanket on the plane next to several packs of cigarettes—this was back when people smoked on planes. Contrast that with my color photo showing sleeping Reagan staffers Larry Speakes, Bill Henkel, and Dennis Thomas (under a blanket emblazoned with the presidential seal). Pat Buchanan, meanwhile, is awake and reading a book. The packs of cigarettes had become packs of M&Ms.

It was during the Reagan administration that I first started to document the presidency beyond what the President himself was doing. I served as an official White House photographer during the last five years of that administration.

Back then, I was still starting my career. At first, I was overwhelmed at being inside the room where it happened. And because my access wasn't as good as it would be during the Obama administration, I was so intent on making use of my limited chances to capture meaningful photographs that I almost always focused squarely on the President.

Later, after my access improved and I got more comfortable in my surroundings, I began to focus on some of the scenes happening around President Reagan as well. But I didn't do it enough; it wasn't until years later that I realized this oversight. When I returned to the White House in 2009, with that regret still on my mind, I vowed to do a better job to photograph the *presidency* and not just the President.

I hope the photographs in this book show you what happens inside the presidential bubble in the same way *Obama: An Intimate Portrait* gave a more personal perspective on one of the most photographed people in history. I hope it shows you what it's like to work in this institution on behalf of the American people, inside the West Wing and beyond. I hope it takes you to places both humble and full of grandeur, and introduces you to some of the people behind the scenes. Beyond that, I hope this book is a valuable documentation of the inner workings of the presidency during this period in history.

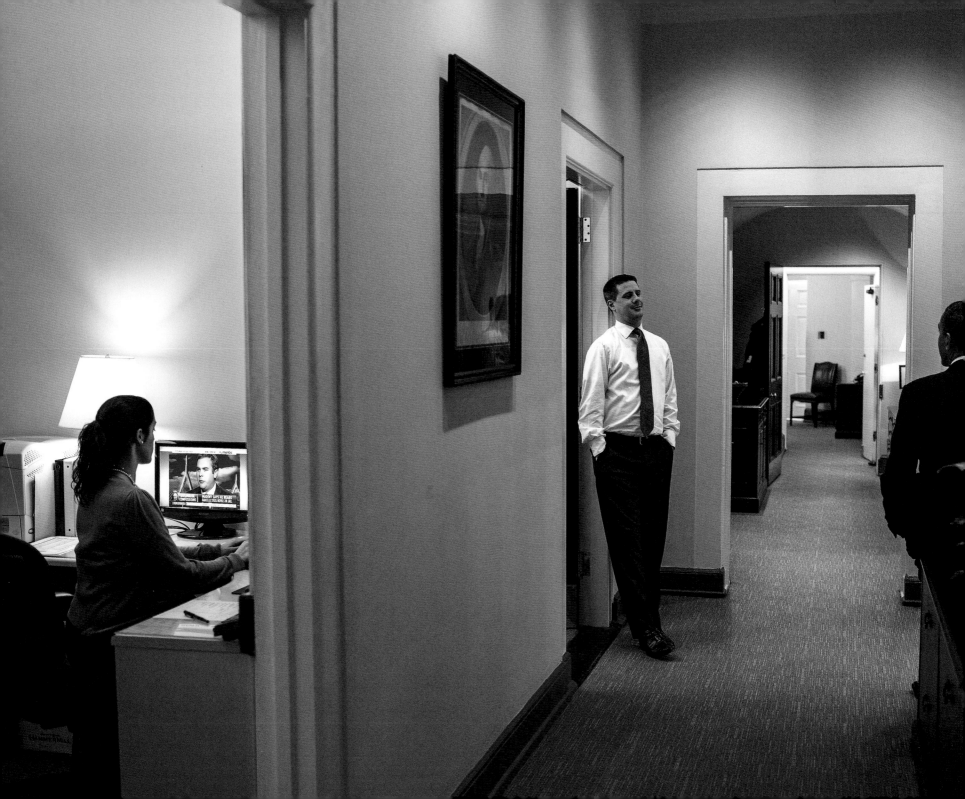

THE WEST WING

It's not as majestic as one would think. Don't get me wrong, the West Wing does have historic rooms like the Oval Office, Cabinet Room, and Situation Room. There are a few grand, expansive staff offices—those of the White House press secretary, the national security advisor, and the Vice President, for instance. The chief of staff's office even has a patio (paid for by President Reagan's chief of staff Don Regan) that is several times larger than the President's patio.

But by and large, the offices used by most staff members in the West Wing are small and ordinary, many with low ceilings and without windows. Some hallways are so narrow that they should be one-way. In a couple of places, there are double swinging doors that can be a hazard. One set of the swinging doors was around the corner from my office, which I'd have to pass through every time I walked upstairs to the Oval. You had to pay attention to not whack someone coming up behind you and to not get whacked yourself going the other way, which once led to a staff member's concussion.

I've spent much of my life in the real West Wing, but the portrayal of the West Wing on the 1990s TV show *The West Wing* describes a place I don't know. The real office space in the White House is not where you'd want to film a TV show. And yet, having an office in the West Wing is the ultimate status symbol, even if you don't know what time it is because you never see the sun streaming through windows that you don't have. But—and it's a big *but*—if you have an office in the West Wing, you *do* have proximity to power: Just down the hall, or up or down a flight of stairs, is the President of the United States. And despite the odd and sometimes cramped workspaces, this is where so much important work is done on behalf of the American people.

In the photo at left, Director of Communications Dan Pfeiffer stands outside a colleague's office in one of the wider hallways, while Sarah Fenn, special assistant to the deputy chief of staff, works in her windowless office. At the far end of the hall, just to the left of the chair, is the formal front door of the Oval Office.

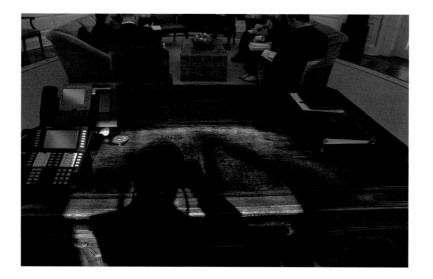

THE OVAL OFFICE

I'll boldly say that I've spent more time in the Oval Office than any person in history, other than maybe some of the two-term presidents.

I have witnessed history in this room. I know the most famous office in the world in extraordinary detail, having looked at it through a camera lens for hundreds of thousands of photographs.

Because of its many windows, the light in the Oval Office is constantly changing. Depending on the time of day. Depending on the time of year. My senses were always heightened in the early morning and late afternoon of the winter months when sunlight streamed through the bulletproof windows behind the Resolute Desk. The desk, constructed from the timbers of the HMS *Resolute,* was a gift from Queen Victoria to President Rutherford B. Hayes. (Above, you'll see my shadow on the desk during the President's daily intelligence briefing.)

It wasn't unusual for people to become overwhelmed the first time they stepped into this office. I felt my knees shake the first time I walked into the Oval in June of 1983 to meet President Reagan. Along with many others who entered the Oval with regularity, I eventually got over that feeling. Yet I still felt the sense of history tugging at me every time I was in that office.

I'm sure Dan Shapiro, pictured at right, felt this way when he met with the President before a head of state call in 2009. "When briefing the President in the Oval Office, you want to make every word count," recalls Dan, who was a senior director of the National Security Council at the time. "Before calling a foreign leader, President Obama would have read and absorbed your memo, so there was no need to repeat what you wrote. You had to bring something new, an update that would help him achieve his goals in the call. If you did, he was all ears."

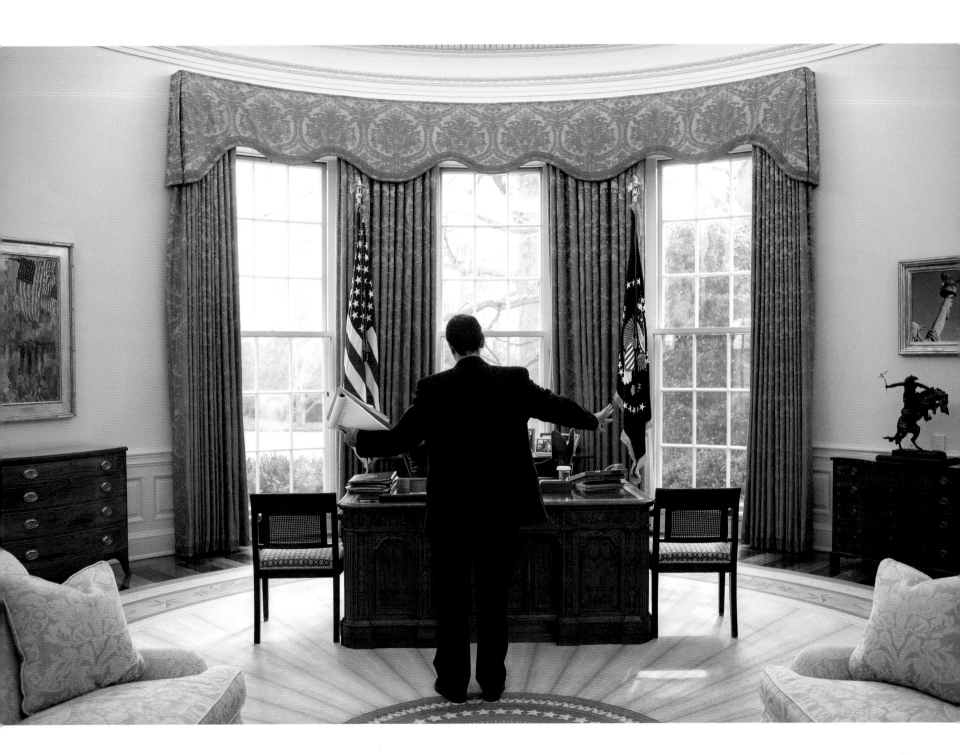

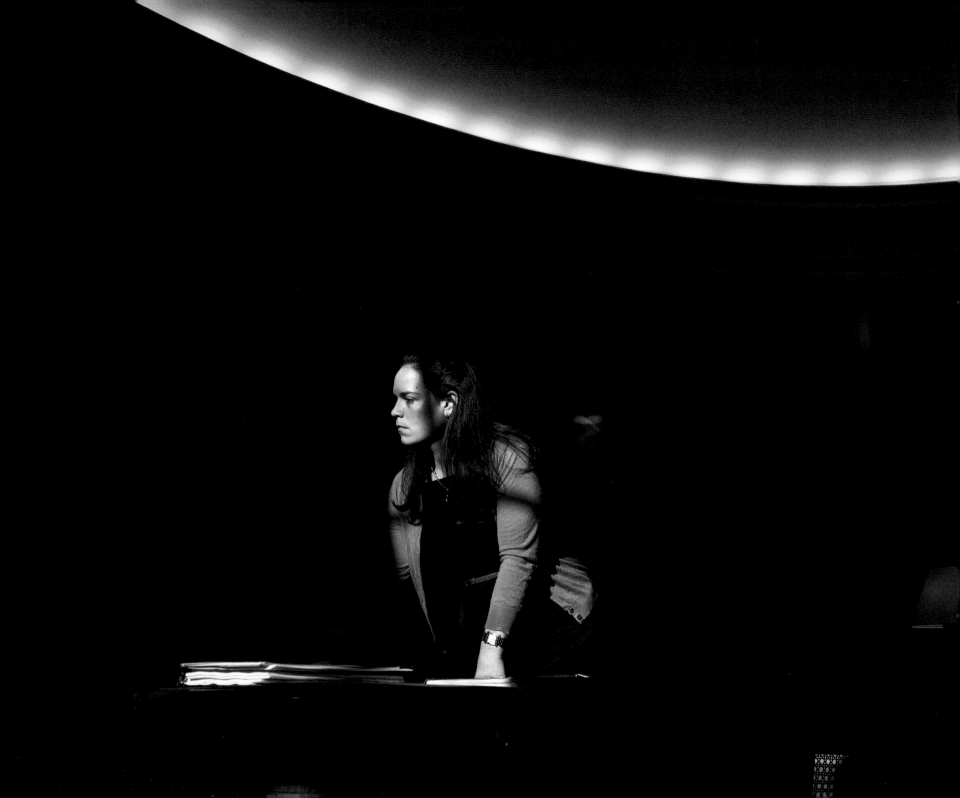

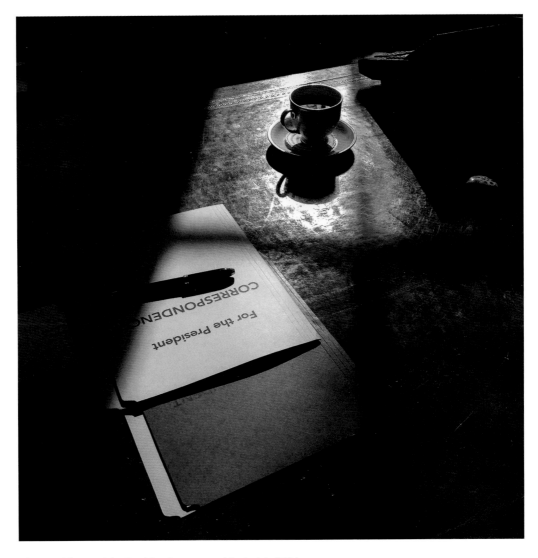

Above: Folders and the President's teacup on his desk in 2014.

Left: Personal Secretary Katie Johnson leans on the Resolute Desk while listening to the President in 2010.

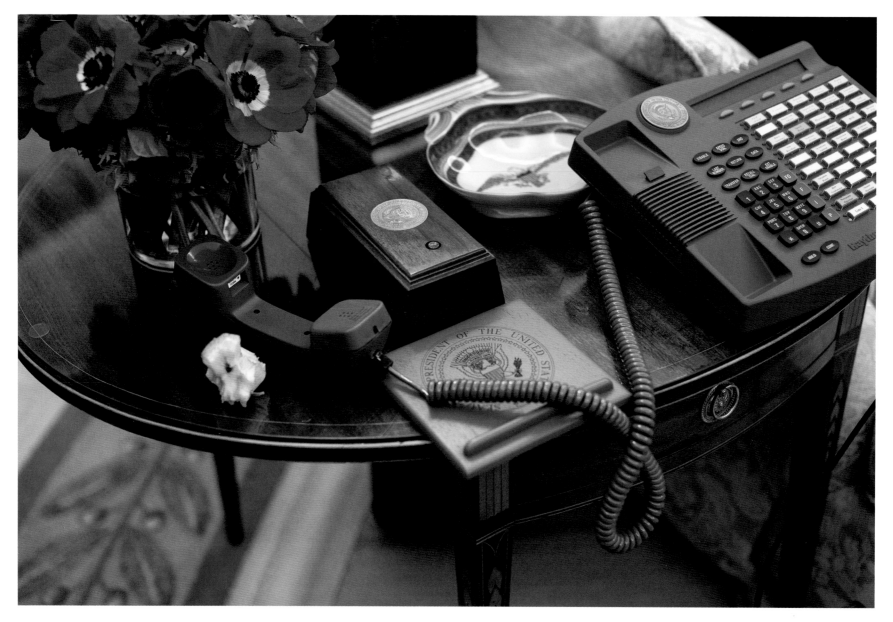

During phone calls with foreign heads of state, the secondary phone in the Oval was used as a speakerphone. A Situation Room staffer would be present to monitor the volume control: lowering the volume to avoid echoes when the President spoke, and raising the volume when the head of state was talking, as happened here during a call with Prime Minister Kevin Rudd of Australia in 2009.

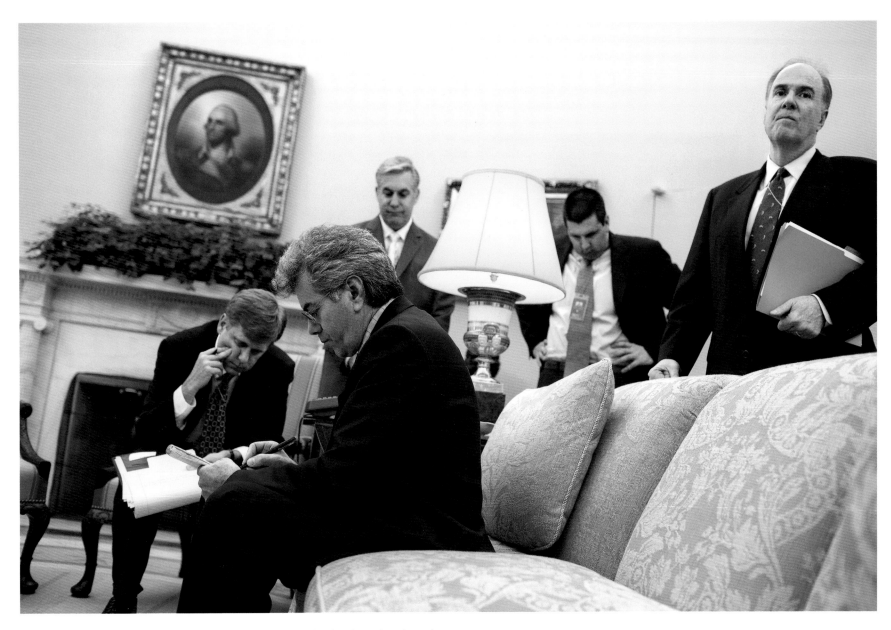

Aides gather around the phone listening to President Dmitry Medvedev of Russia as he spoke
with the President in 2009. At the time, Vladimir Putin was the prime minister, before he
ran for the office again and returned as President of Russia in 2012. Putin's phone calls with
President Obama, and there were many, were not quite as cordial as this one.

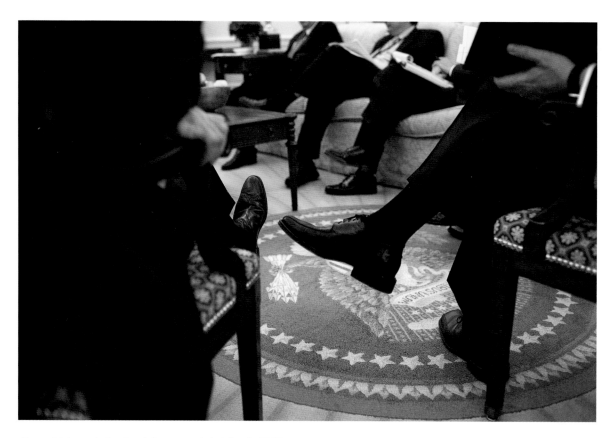

Above: Advisors during the daily economic briefing in 2009.

Right: A reporter takes notes in shorthand during a Q&A with the President and British Prime Minister Gordon Brown in 2009.

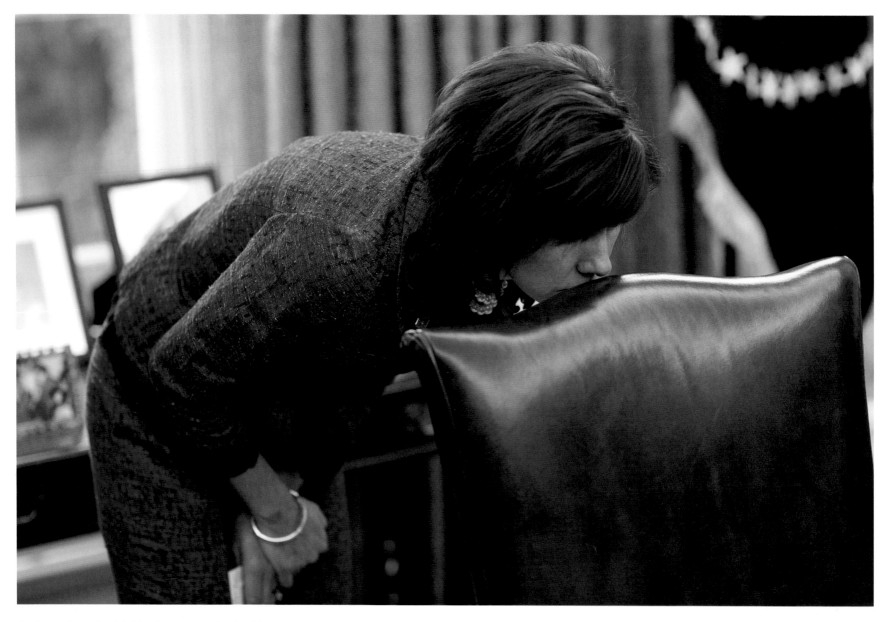

Chief of Protocol Capricia Marshall leans on the President's
desk chair during a delegation meeting with President
Michel Suleiman of Lebanon in 2009.

Lipstick on National Security Advisor Susan E. Rice's coffee cup during a prep session before a meeting with Prime Minister Mariano Rajoy Brey of Spain in 2014.

OVAL OFFICE VALETS Presidential valets have been a presence since our first president. According to the White House Historical Association, George Washington's valet William Lee was enslaved. He was also a confidante of the President, and the only enslaved person specifically freed in Washington's will.

During the Reagan administration, most of the valets were Filipino, partially a result of a 1947 Military Bases Agreement between the United States and the Philippines in which Filipino citizens could be recruited into the U.S. military. One of the Reagan valets, Eddie Serrano, had enlisted in the U.S. Navy in 1946. He was well liked by the staff as well as by Nancy Reagan. Amazingly, he worked for six presidents and retired in 1993.

Today, presidential valets are specially selected members of the military. There is a valet in the White House residence who cares for the presidential clothing as well as all personal matters related to the President's "home." This valet also travels on every trip.

The Oval Office valets deal with the President's needs while at work in the West Wing. During the Obama administration, the two Oval valets were Quincy "Q" Jackson (shown above and at right) and Ray Rogers (see page 111). They would station themselves in the dining room adjacent to the Oval, ready to serve the President and his guests water or juice before each meeting. (They were once caught unprepared when Speaker of the House John Boehner asked for a glass of merlot wine during an early evening meeting with the President.) They would also prepare and cook lunch for the President every day in a closet-size kitchenette. The President often said to me he was amazed by the meals they were able to create in that tiny space.

Ray and Q were also ready for tasks like preparing cupcakes for a staff member's birthday during a meeting, at right, or when a member of the press knocked a glass of water over onto the Resolute Desk in the crush of a photo op (above).

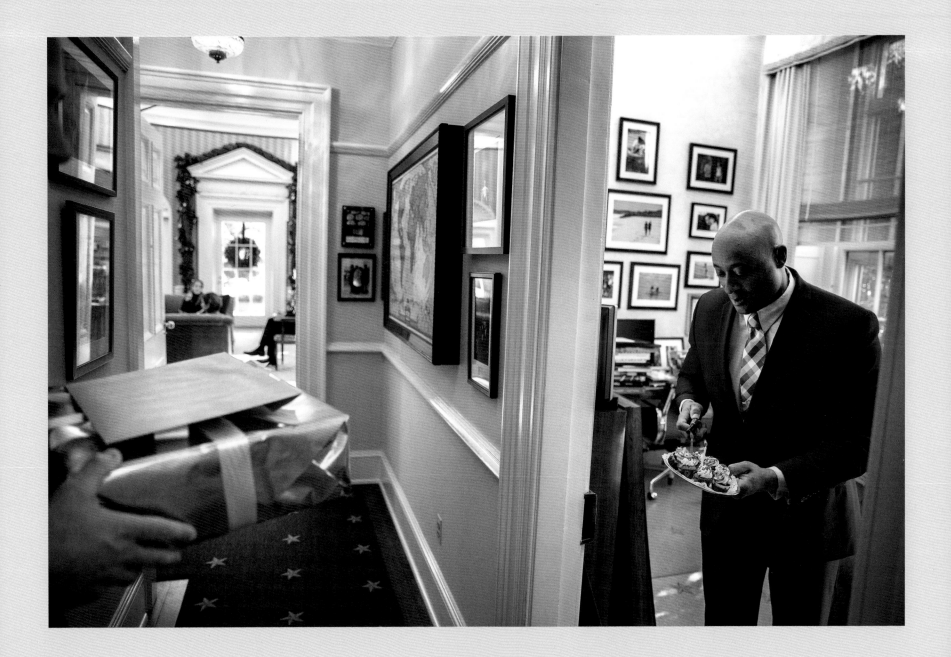

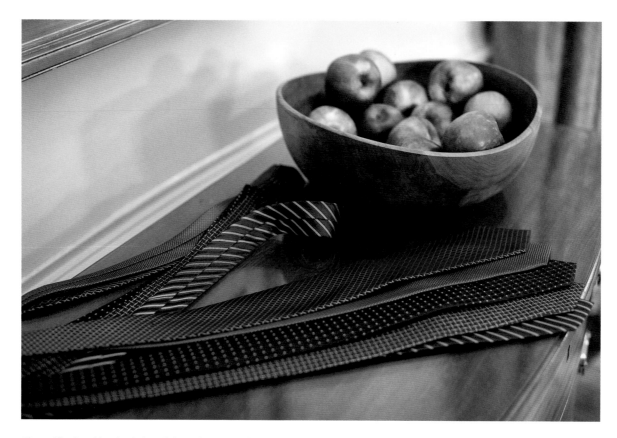

Above: The President's choice of ties prior to an address to the nation from the Oval Office in 2010. The bowl of Gala apples was replenished daily by the White House florist's shop. I ate at least one a day unless there was a mealy batch, a rare occurrence.

Right: Positioning lights before a presidential videotaping in 2009. In addition to sporadic video recordings, President Obama addressed the nation live only three times from the Oval Office. By contrast, President Reagan delivered a live address to the nation 29 times from the Oval.

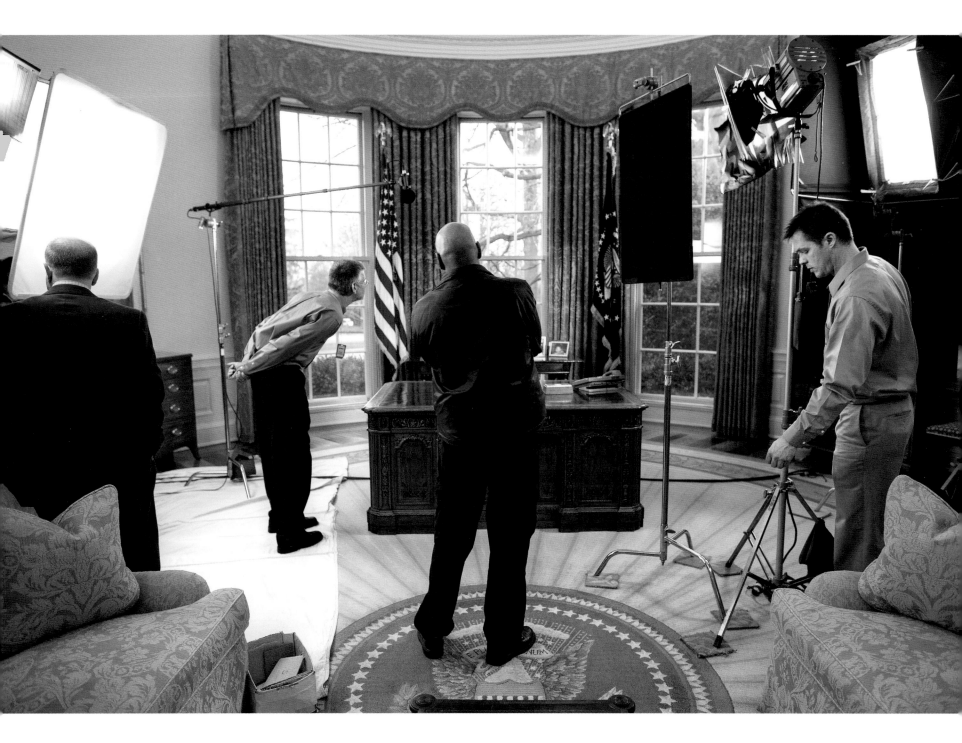

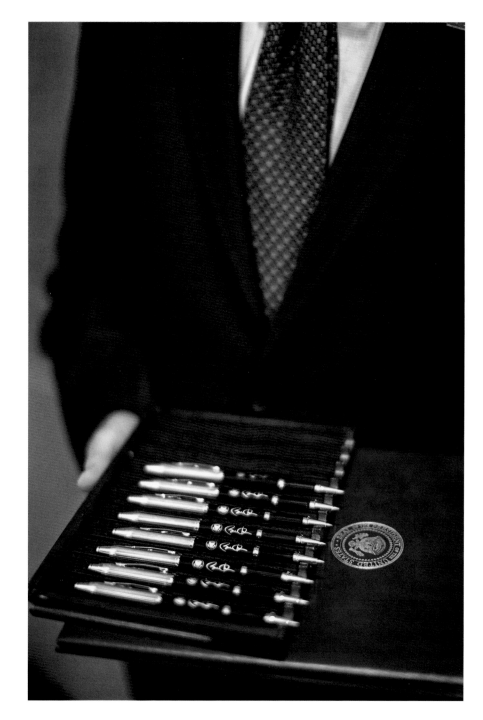

Near right: Signing pens ready for a presidential memorandum in 2009. It was customary for the President to use multiple pens—using one pen for each letter or half-letter of his name—when signing a bill, executive order, or memorandum, so the pens could be given to those who sponsored the bill or helped push it forward. This tradition dates to at least the FDR administration. President Obama used 22 pens to sign the Affordable Care Act. During the commotion onstage afterward, one of the pens became unaccounted for, and it was never determined who had taken it.

Far right: Chief speechwriter Jon Favreau holds the latest draft of the 2012 State of the Union speech. The President edited speeches with a black Uni-Ball Vision Elite rollerball pen.

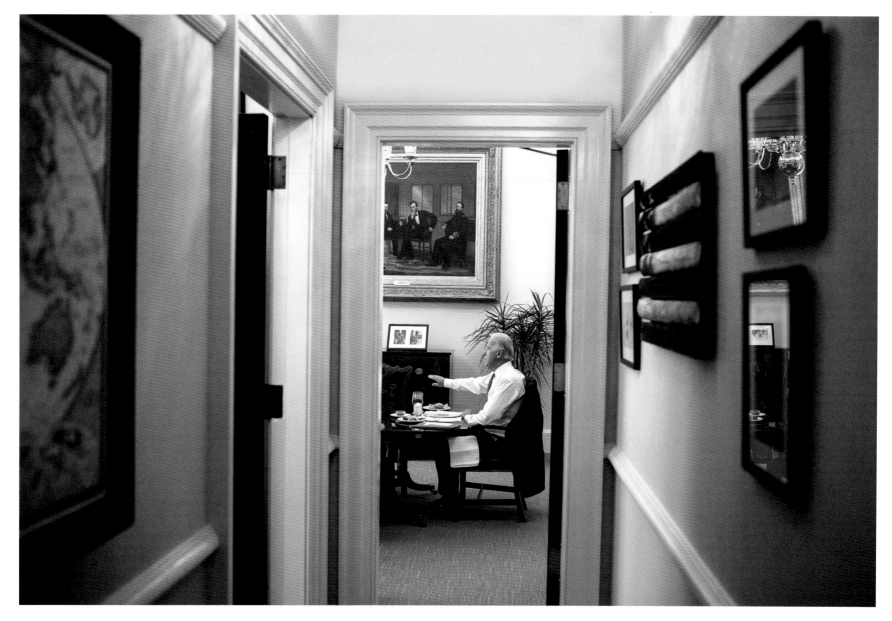

Weekly luncheon with the Vice President in the President's
dining room adjacent to the Oval Office in 2010.

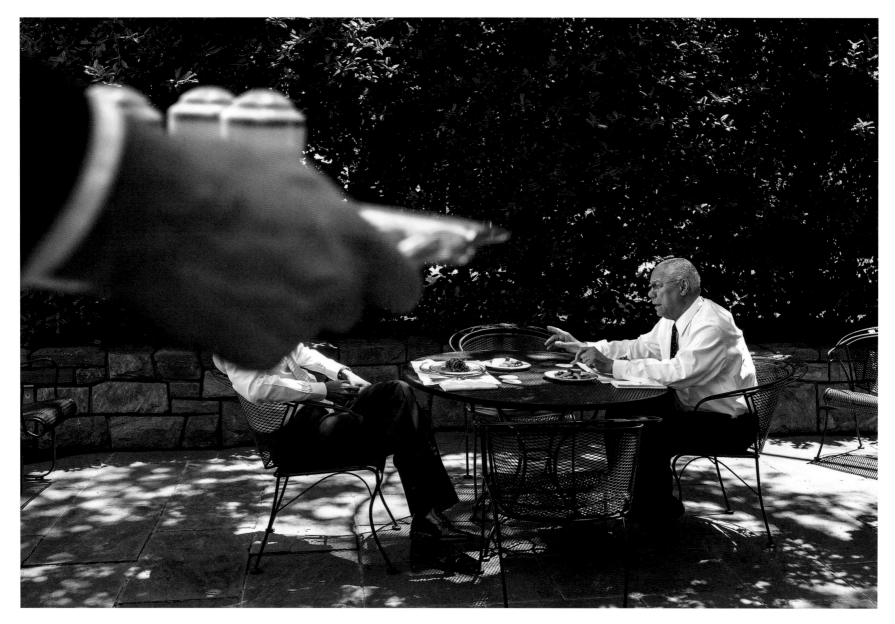

Lunch with Colin Powell on the Oval Office patio, just outside the dining room, in 2011. I had known General Powell during the Reagan administration, and the first time he came to see President Obama, a film producer working on a documentary had asked him if he remembered me. Powell replied, "Of course, I still have one of his jumbos hanging over my hot tub," referring to the large photographs we displayed on the walls of the White House.

Personal Aide Ferial Govashiri and Brian Mosteller, Director of Oval Office Operations, look inside compartments and drawers just before President Obama stopped by the Oval Office for the last time on the morning of January 20, 2017. Standing in the doorway is a Secret Service agent waiting for the President's arrival.

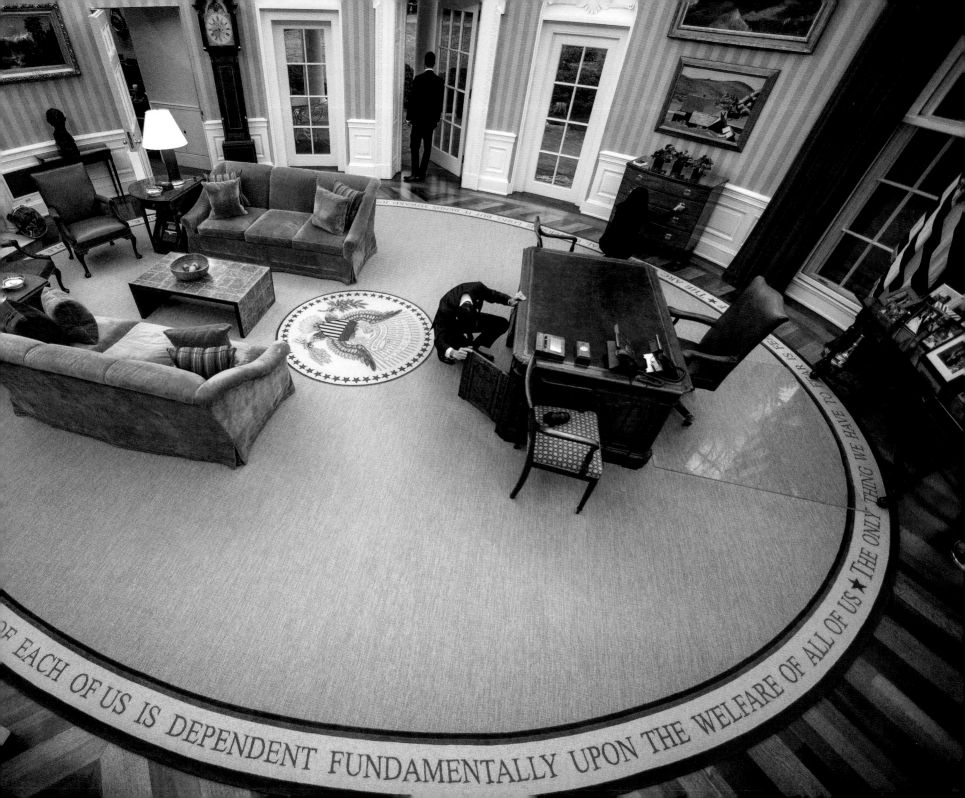

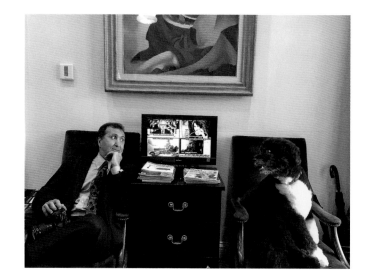

THE OUTER OVAL

"Renegade in secretary's office." A Secret Service agent called that phrase over the radio every time President Obama stepped into the reception area outside the Oval Office, using his code name.

In most diagrams of the West Wing, this area is labeled "President's Secretary." During the Reagan administration, we called it the "Oval Office reception area." During the Obama administration, we called it the "Outer Oval," though the Secret Service continued to refer to it as the "secretary's office." Whatever the official name, the Outer Oval is the main entry and exit point into the Oval Office for any staff meeting with the President (as seen in the picture at right). In addition, it is the entry/exit point for the President's special guests (U.S. Senators or Congressional leaders coming for a sit-down meeting), close friends, or family. Foreign heads of state have come back and forth through that space. President Obama even escorted Pope Francis into the Outer Oval to meet his personal staff.

It was also a working office for three people. There were two desks and a tiny sub-office. Closest to the Oval was a desk for the President's personal secretary (later known as his "personal aide"). The other desk was for Brian Mosteller, the Director of Oval Office Operations. In the cramped office was the President's "body man."

I was the unofficial fourth person who frequently sat in the Outer Oval, though I didn't have a desk. But I did claim a place to sit, which Brian called "Pete's chair." From that position, I was ready to head into the Oval Office at any time, and I could also keep an eye out the door for anything interesting in the Rose Garden or on the South Lawn. On some mornings, I'd walk in to find that "my" chair had been hijacked by Bo, the family dog (above), and I'd be relegated to the chair next to it.

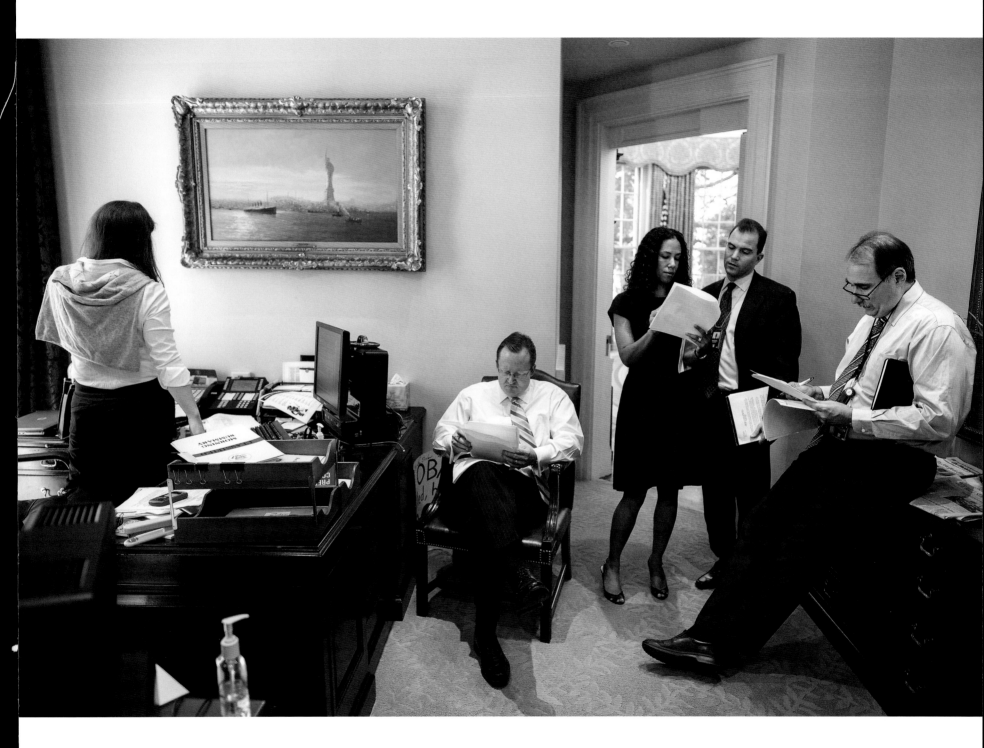

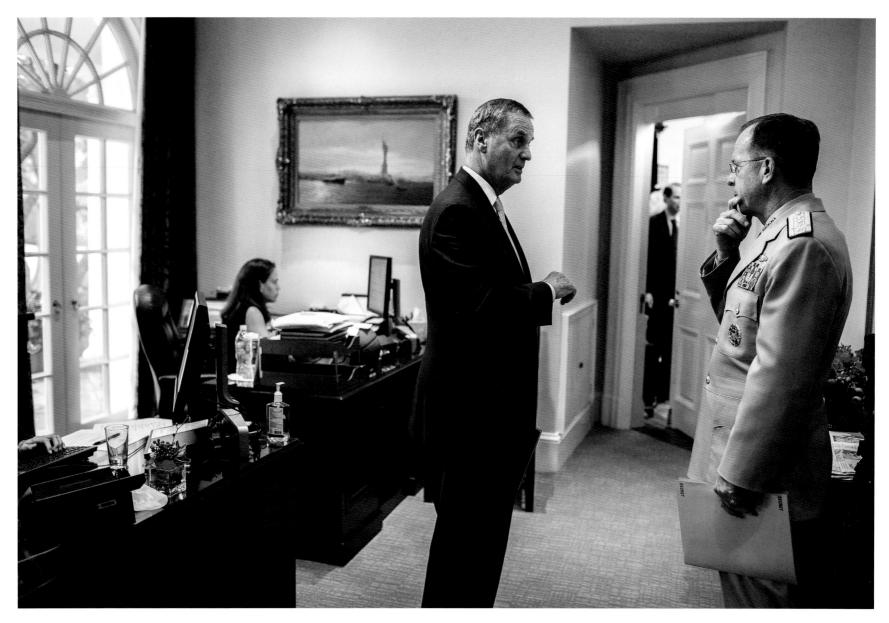

General James Jones, national security advisor, confers with
Mike Mullen, chairman of the Joint Chiefs of Staff, before entering
the Oval Office in 2009. Admiral Mullen is holding a folder
marked "top secret." Seen through the doorway is Senator
Ron Wyden of Oregon. Katie Johnson, left, works at her desk.

Aides wait for a meeting to begin in the Oval in 2009. Folders were color-coded, with green signifying the document inside was a decision memo for the President.

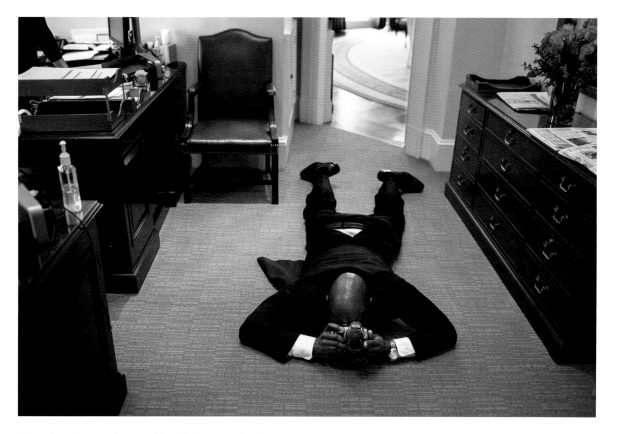

Above: Reggie Love photographing who-knows-what from a low angle in 2010.

Right: The biggest crowd that I ever observed in the Outer Oval, before the daily economic meeting in 2009. Normally, a meeting with this many people would move across the hall to the Roosevelt Room, but it remained in the Oval partially because NBC was filming "a day in the life of the President."

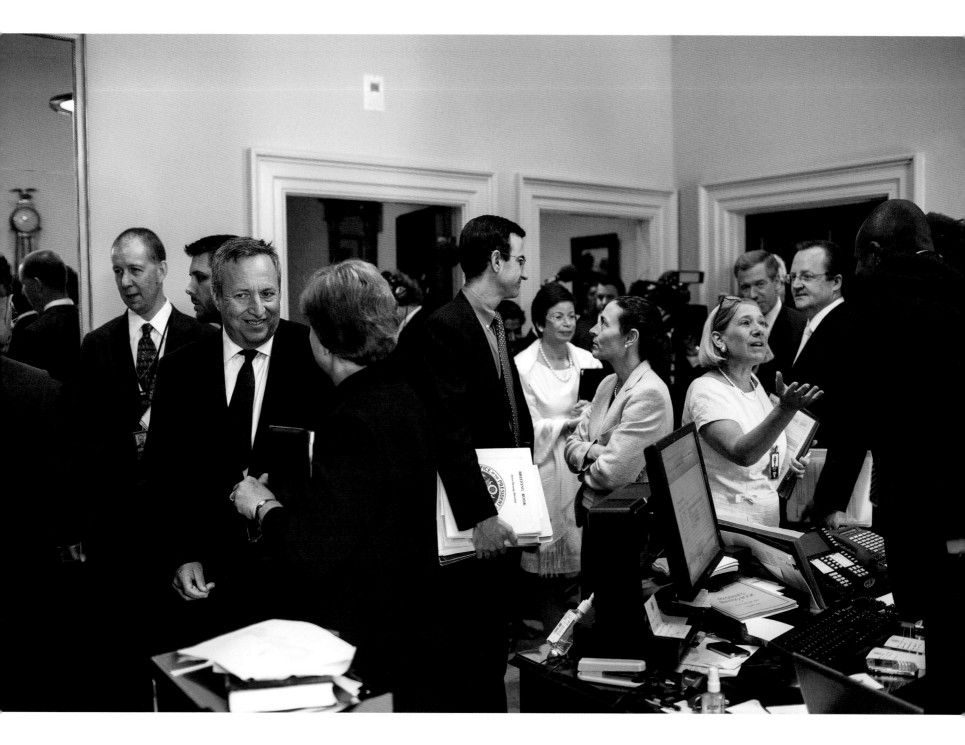

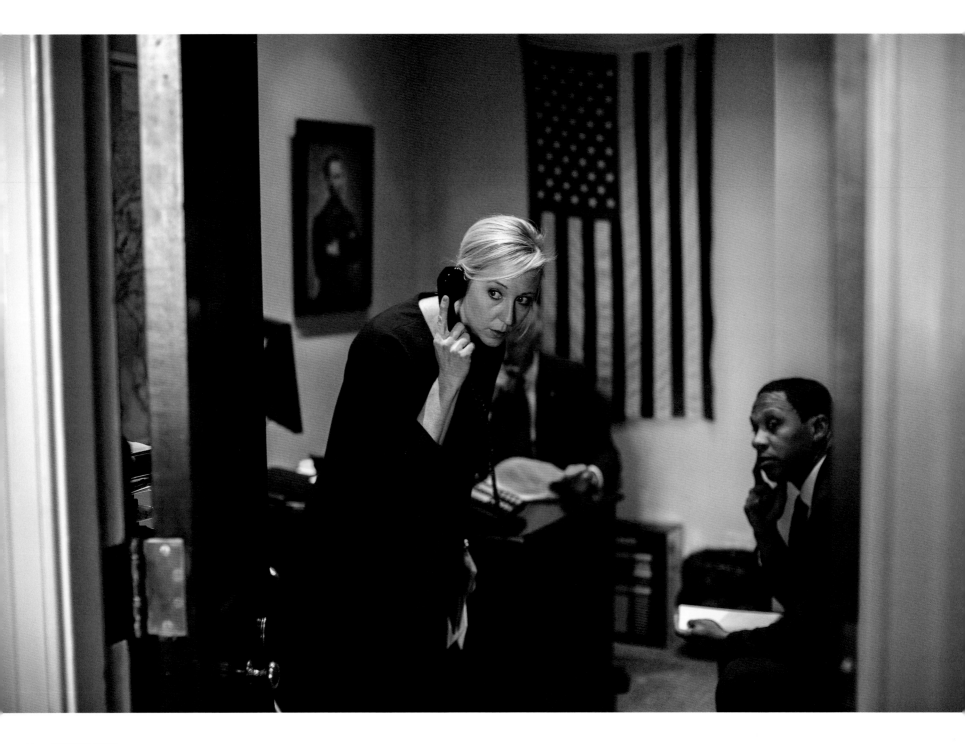

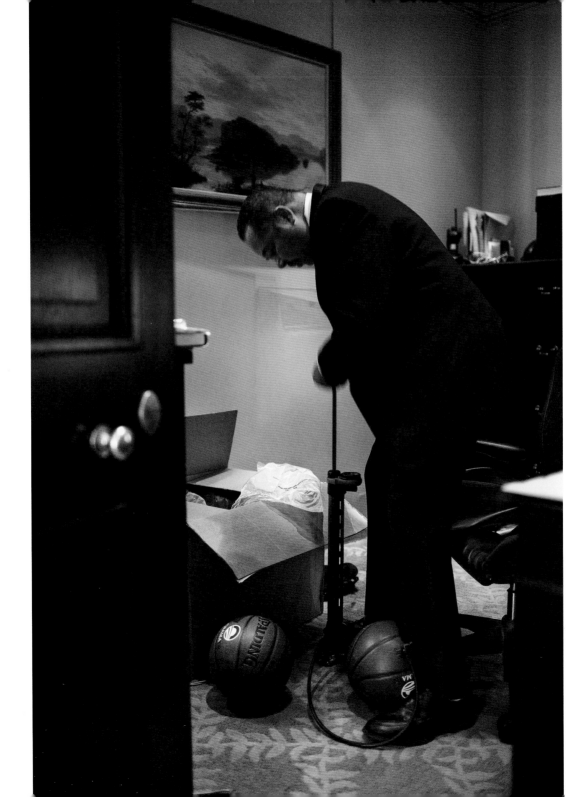

Near left: Inside the body man's tiny office, White House butler Von Everett pumps up souvenir basketballs left over from the Obama campaign in 2009.

Far left: Anita Decker Breckenridge places a phone call for Vice President Biden from that same office in 2012. Legislative affairs director Rob Nabors is at right.

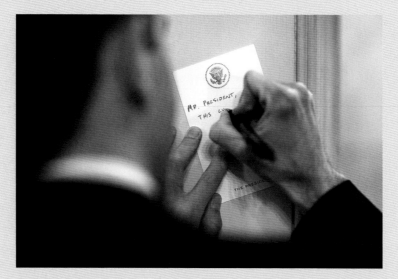

DIRECTOR OF OVAL OFFICE OPERATIONS The only person in the Outer Oval who has a direct line of sight to the President seated at his desk is the Director of Oval Office Operations. Throughout the Obama administration that person was Brian Mosteller.

The Washington Post called him the "anticipator in chief." Brian meticulously orchestrated the President's movements for every meeting and event at the White House. No one got into the Oval Office without going past him or the President's secretary. He would try as best he could to keep the President running on time (above, writing a note to let the President know he's running late). Brian often worked in tandem with the President's personal secretary and body man.

Though this position first originated during the Clinton administration, the functions of the job have been around for a long time. During the Reagan administration, the President's body man, Jim Kuhn, essentially also did the job that became the Director of Oval Office Operations.

At right, Brian checks something on his computer as Vice President Biden and Secretary of State John Kerry wait for their meeting with the President to begin.

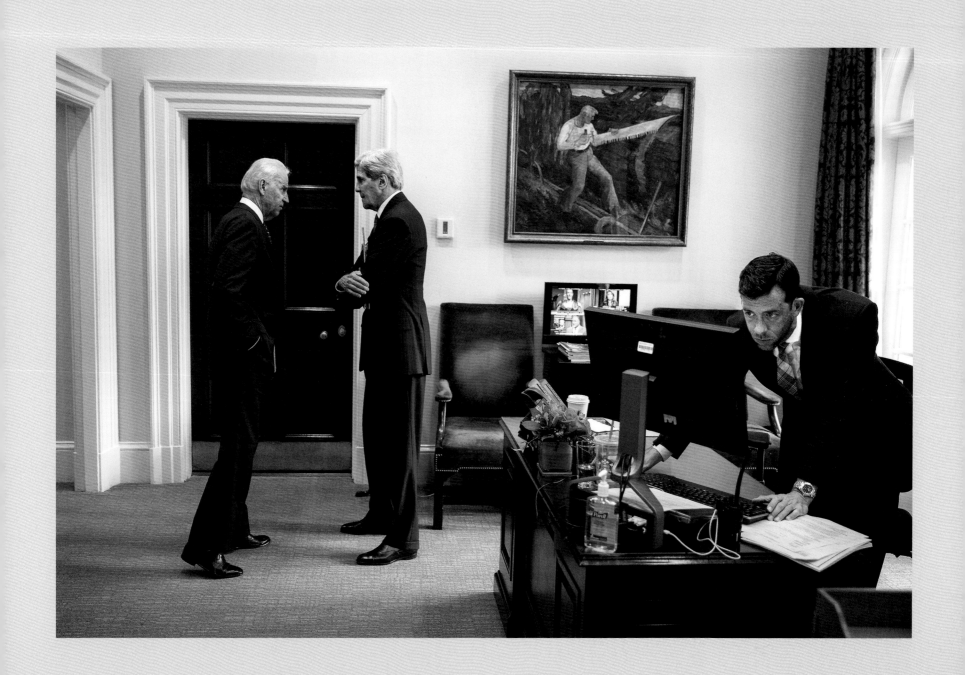

Near right: Chief speechwriter Jon Favreau has a few parting words with the President after they met about an upcoming speech in 2012.

Far right: Personal aide Ferial Govashiri with Bo, peering into the Oval. Ferial thought it was ironic that she had the closest proximity to the President from the Outer Oval yet did not have a direct line of sight to him.

Then-Deputy National Security Advisor Denis McDonough
(who became chief of staff in President Obama's second term)
holds a stash of apples taken from the Oval Office following the
daily intelligence briefing in 2011. Denis often gathered
apples to give to his support staff.

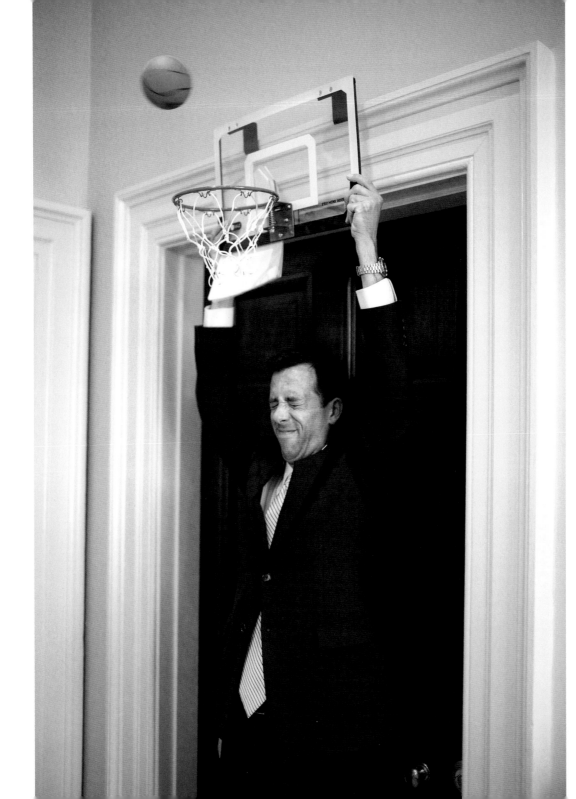

Brian Mosteller holds up a
mini basketball hoop at the
doorway to the Cabinet Room
while the President takes
a shot in 2010.

Nicholas Tamarin, son of longtime aide Nate Tamarin, heads
into the Oval in 2010. A couple of years later, Nicholas
would become the subject of one of my more iconic pictures
when he dressed up as Spider-Man on Halloween and "zapped"
the President into his web in this very same location.

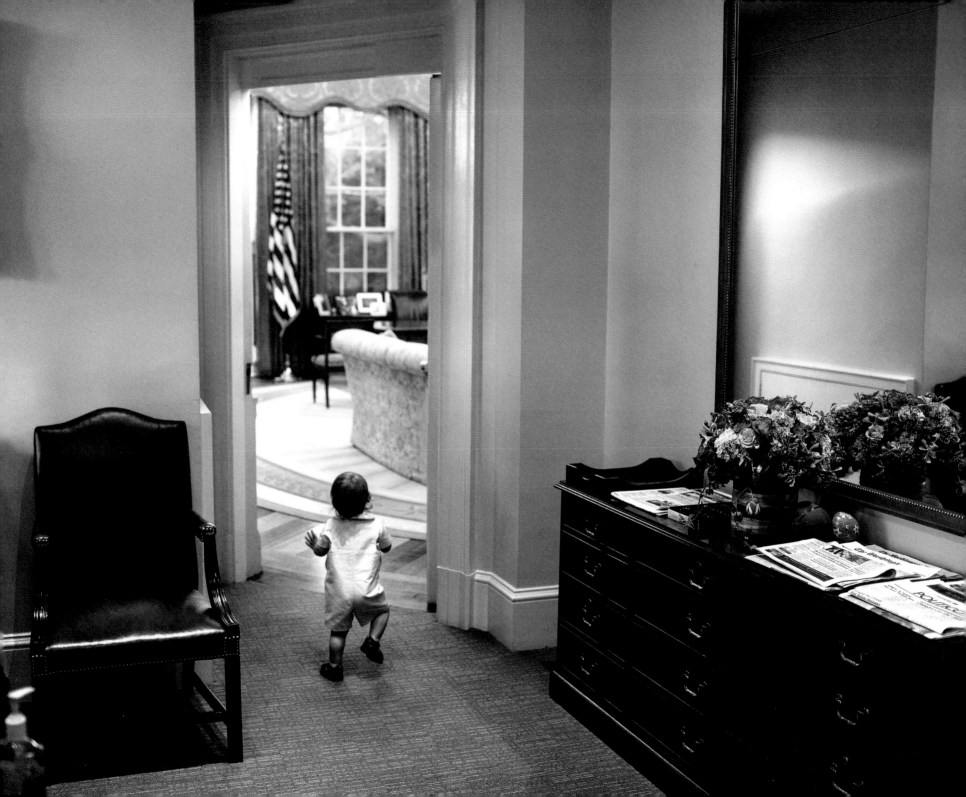

THE CABINET ROOM

Adjoining the Outer Oval is the Cabinet Room. Most presidents use it to meet with their Cabinet secretaries or members of Congress. Pictured at right is Representative Steny Hoyer, conferring with an aide during discussions on the Affordable Care Act in 2010.

In the Obama administration, the Cabinet Room was also used for luncheons with heads of state. Occasionally, the table and chairs were removed, and the Cabinet Room became a backdrop for a presidential signing ceremony or television interview. BlackBerrys and smart phones were not allowed in any meeting rooms in the West Wing, so it was common to see devices piled up outside the room with sticky notes identifying whose was whose.

Each president selects the portraits that hang in the Cabinet Room; for the first few months in the Obama administration, a portrait of Dwight D. Eisenhower was adjacent to the portrait of George Washington. President Obama replaced it with a portrait of Harry S. Truman.

The room was refurbished in 2006 and looked different from how I remembered it from the Reagan years. Still there was the long mahogany table first "loaned" to the White House by President Richard Nixon in 1970. He then depreciated the table on his tax returns as a business expense in an apparent attempt to receive a tax deduction. Nixon later donated the table to "leave his mark" on White House decor.

A famous photograph of First Lady Betty Ford "dancing" atop the table was staged by White House photographer David Hume Kennerly in the latter days of the Ford administration. Less well known is a picture of me standing on the table with a tripod to make Reagan's last official photograph with his Cabinet. To loosen everyone up, I said, "Mr. President, I've always wanted to stand on this table." Reagan responded by reaching over to the four-sided wooden scroll he had on the table. He turned past "Yes," "No," and "Maybe," and settled on "Scram." Everyone burst out laughing. I never had a good excuse to stand on the table after that.

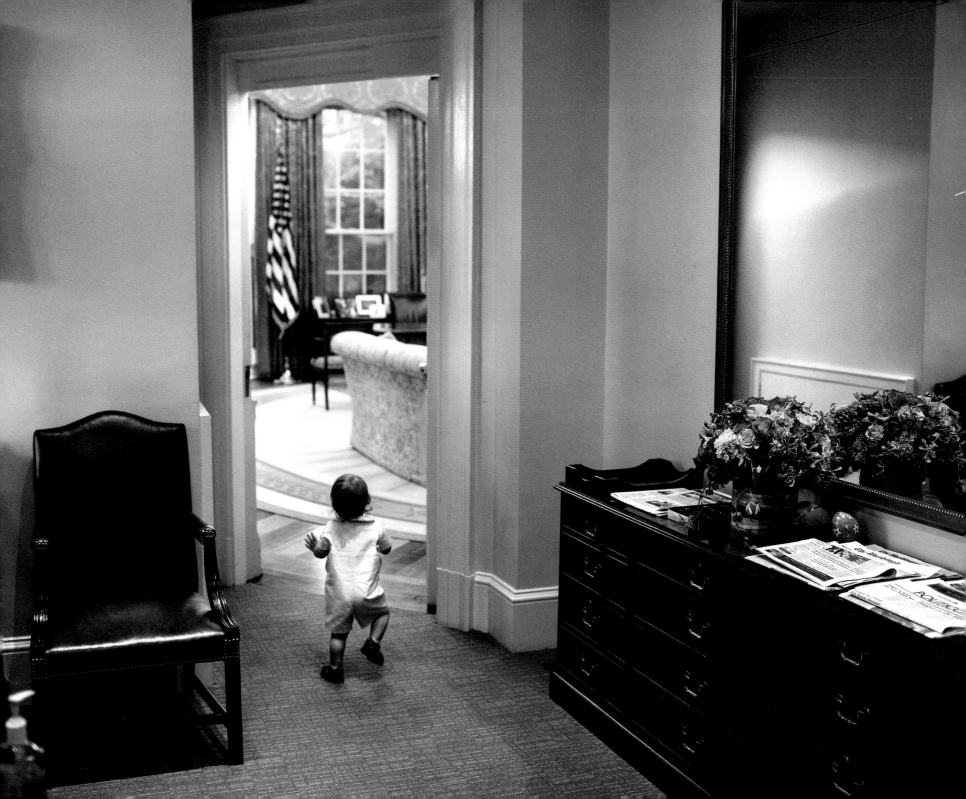

THE CABINET ROOM

Adjoining the Outer Oval is the Cabinet Room. Most presidents use it to meet with their Cabinet secretaries or members of Congress. Pictured at right is Representative Steny Hoyer, conferring with an aide during discussions on the Affordable Care Act in 2010.

In the Obama administration, the Cabinet Room was also used for luncheons with heads of state. Occasionally, the table and chairs were removed, and the Cabinet Room became a backdrop for a presidential signing ceremony or television interview. BlackBerrys and smart phones were not allowed in any meeting rooms in the West Wing, so it was common to see devices piled up outside the room with sticky notes identifying whose was whose.

Each president selects the portraits that hang in the Cabinet Room; for the first few months in the Obama administration, a portrait of Dwight D. Eisenhower was adjacent to the portrait of George Washington. President Obama replaced it with a portrait of Harry S. Truman.

The room was refurbished in 2006 and looked different from how I remembered it from the Reagan years. Still there was the long mahogany table first "loaned" to the White House by President Richard Nixon in 1970. He then depreciated the table on his tax returns as a business expense in an apparent attempt to receive a tax deduction. Nixon later donated the table to "leave his mark" on White House decor.

A famous photograph of First Lady Betty Ford "dancing" atop the table was staged by White House photographer David Hume Kennerly in the latter days of the Ford administration. Less well known is a picture of me standing on the table with a tripod to make Reagan's last official photograph with his Cabinet. To loosen everyone up, I said, "Mr. President, I've always wanted to stand on this table." Reagan responded by reaching over to the four-sided wooden scroll he had on the table. He turned past "Yes," "No," and "Maybe," and settled on "Scram." Everyone burst out laughing. I never had a good excuse to stand on the table after that.

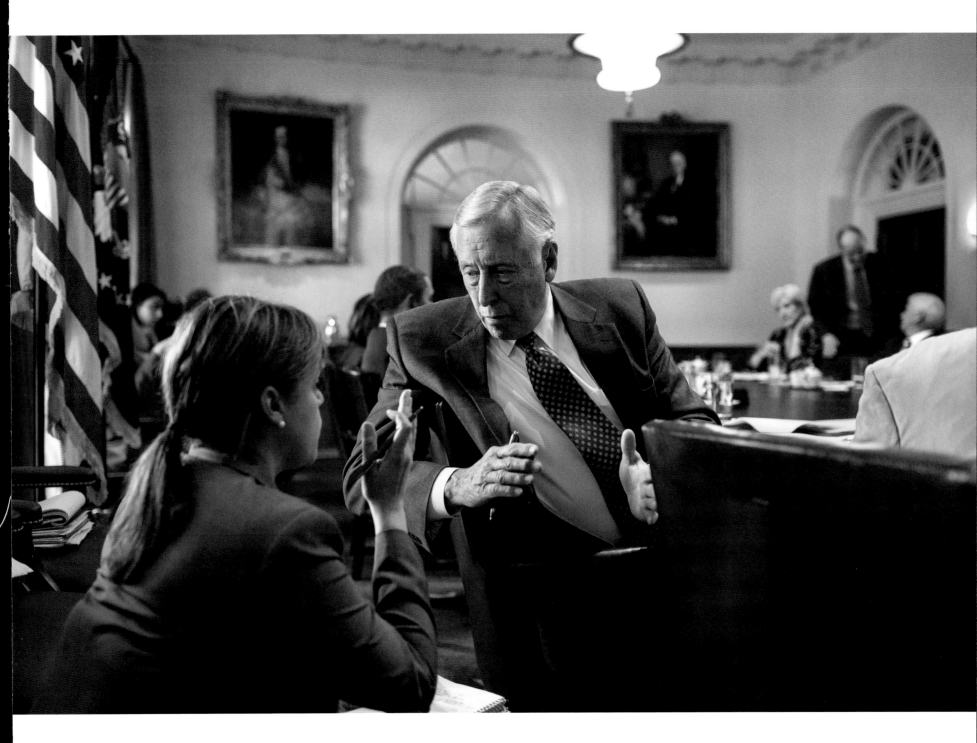

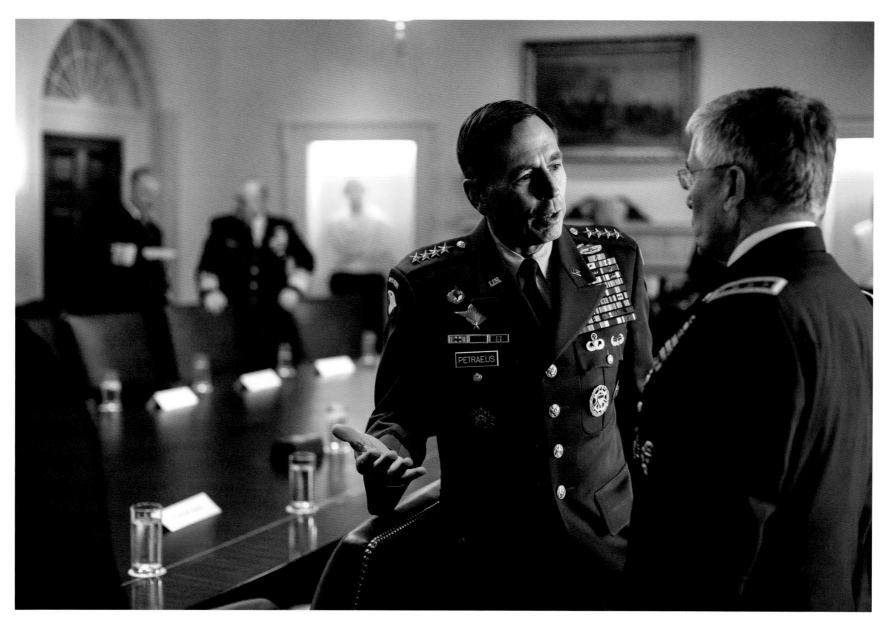

General David Petraeus, commander of U.S. Central Command,
talks with General George Casey, U.S. Army chief of staff,
before the yearly combatant commanders' meeting with the
President in 2009.

Members of the President's Cabinet and staff wait for his arrival before a meeting to discuss energy and the environment in 2009.

Above: Place setting for a working lunch with Prime Minister Recep Tayyip Erdoğan of Turkey and his delegation in 2009.

Right: Preparing the room for the President's working lunch with President Hamid Karzai of Afghanistan in 2010.

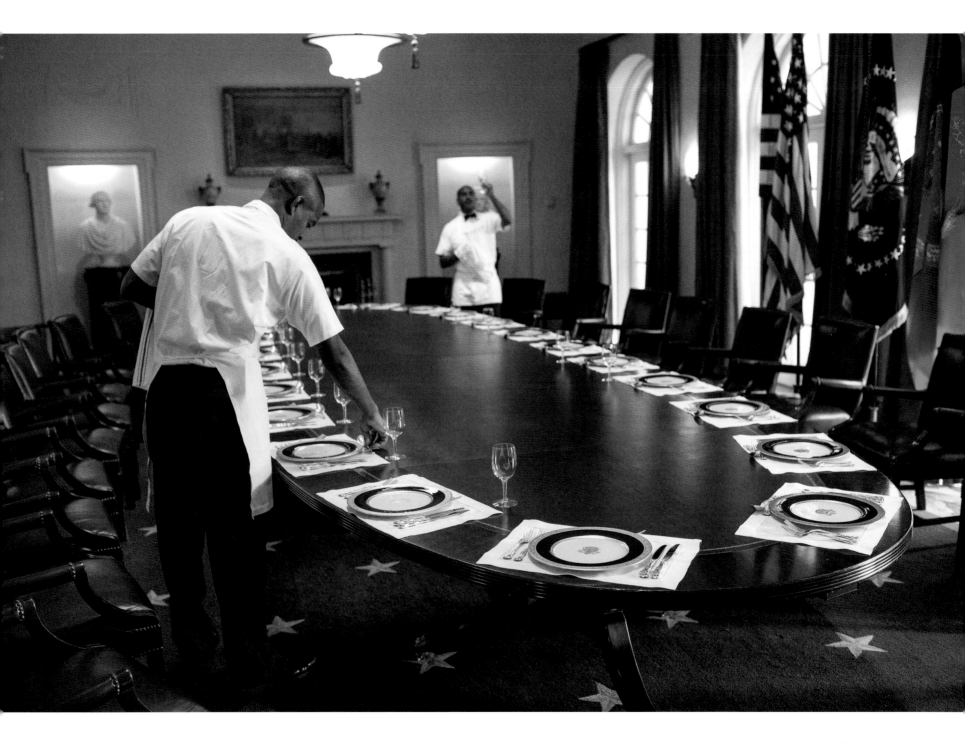

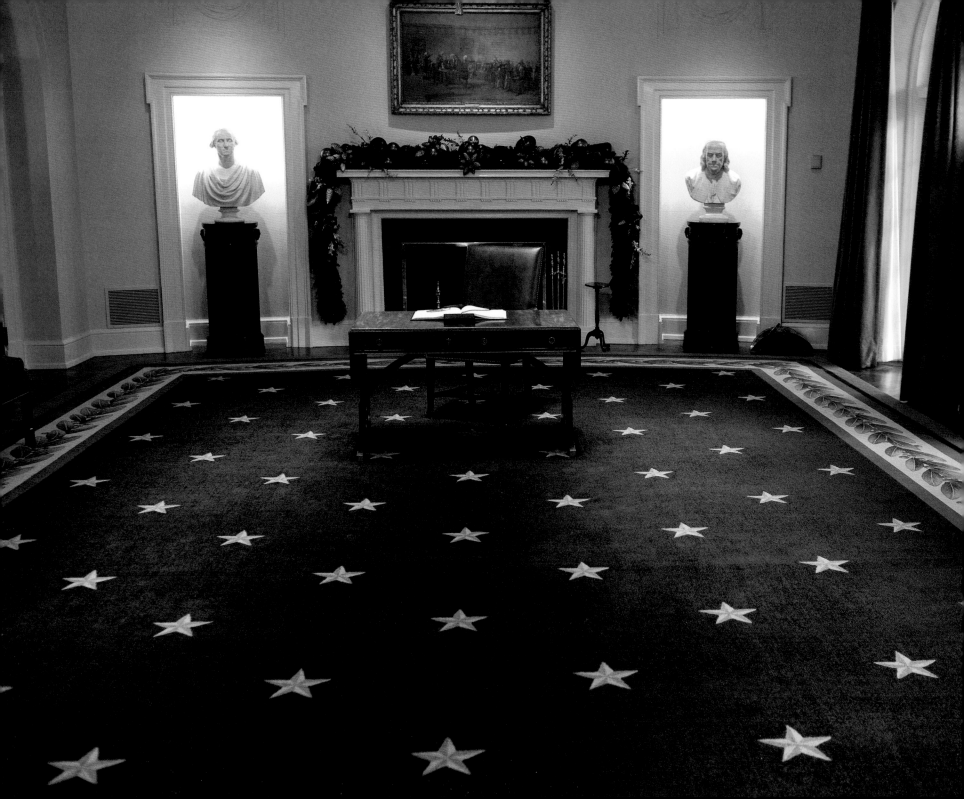

The setup for the President to sign a proclamation for National Pearl Harbor Remembrance Day in 2014. The long mahogany table and Cabinet chairs would be cleared from the room when it was used as a backdrop for a presidential event such as this one.

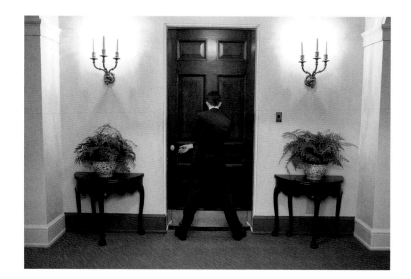

THE ROOSEVELT ROOM

Originally named the "Fish Room," the Roosevelt Room was the location of the President's office when the West Wing was built in 1902. Nixon renamed the room in 1969 to honor President Theodore Roosevelt for building the West Wing and President Franklin D. Roosevelt for expanding it. Portraits of both Roosevelts hang in the room. A bust of First Lady Eleanor Roosevelt was added toward the end of the Obama administration.

Most modern presidents use the room for larger working meetings with staff who are not Cabinet-level, and for meetings with outside groups. President Obama seemingly was in the Roosevelt Room every day early in his administration, having crucial economic discussions with his advisors after the Great Recession. There was an informality in the room, compared to the Oval Office and Cabinet Room. At right, National Economic Council Director Gene Sperling relocates a chair during a fiscal meeting in 2011.

I played a part in improving the Roosevelt Room lighting, which was so directly overhead that it created unpleasant shadows on everyone's faces. There are no windows in the room, so the light was always poor. When the General Services Administration planned to replace the lights with energy-efficient bulbs, I suggested they tilt some of the lights and add a couple more positioned at an angle to reduce the shadows under the President's eyes.

Above, Brian Mosteller looks through a peephole as the President was about to exit a press event in 2012 announcing John Kerry as his new secretary of state.

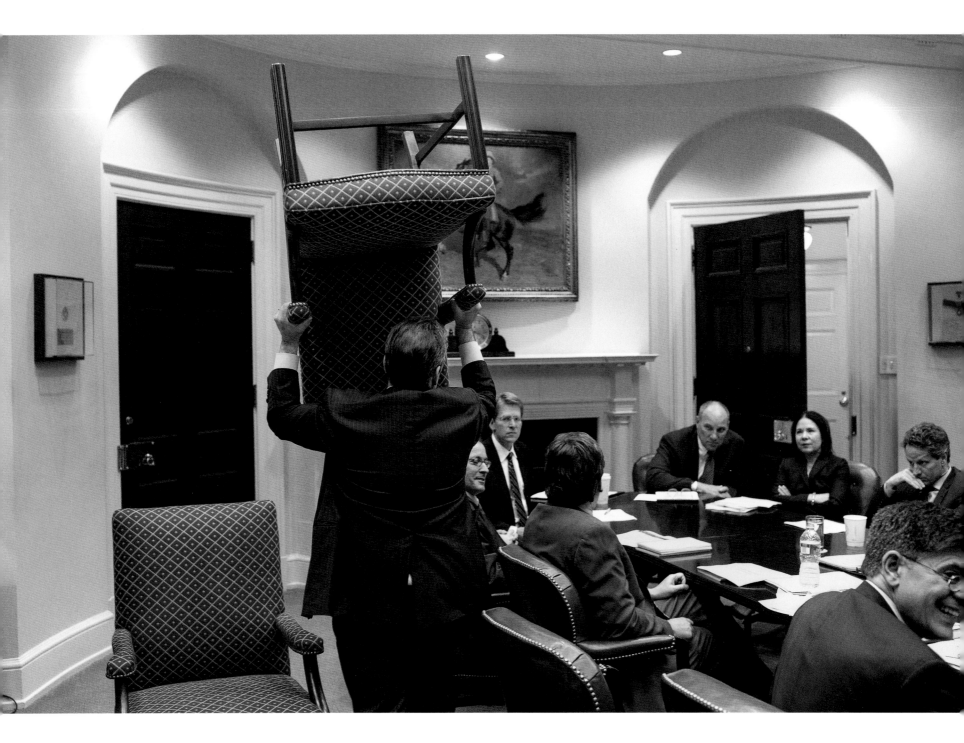

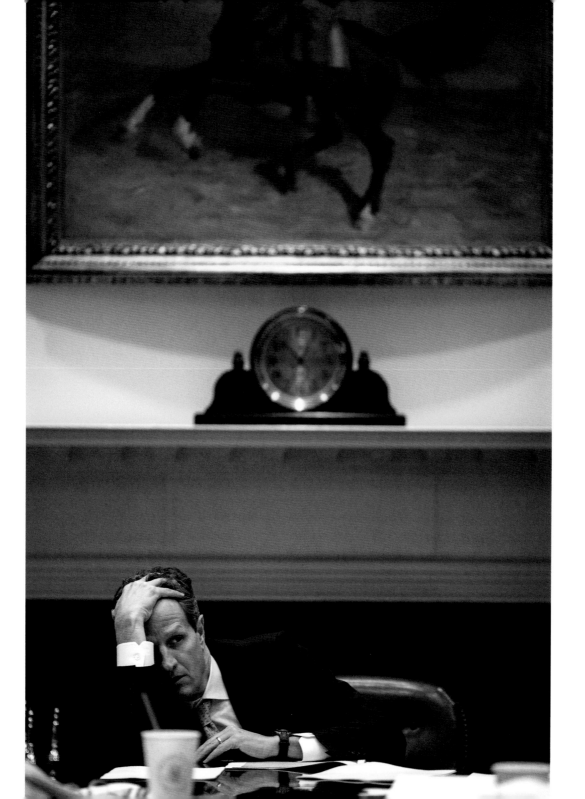

Above: A view underneath the table during the President's meeting with bank executives in 2009.

Left: Treasury Secretary Tim Geithner during a budget meeting in 2011.

Chief of staff Denis McDonough receives a note from Tara McGuinness during a meeting with insurance executives about the Affordable Care Act in 2014. Tara was part of the team charged with implementing the ACA.

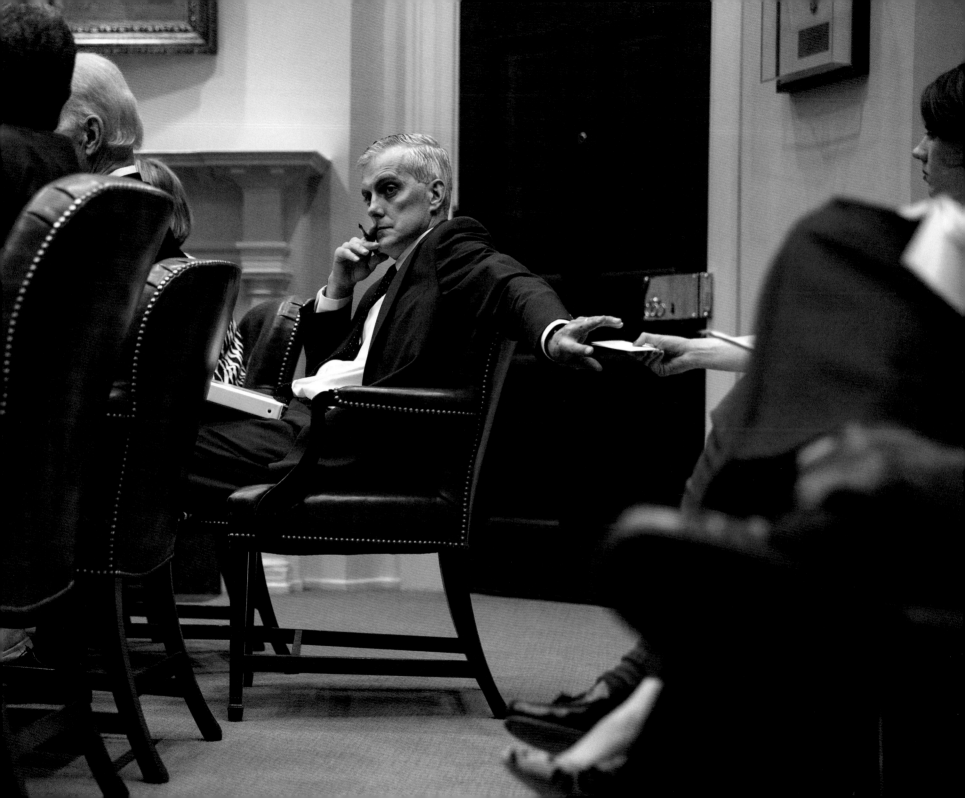

THE SITUATION ROOM

Of all the rooms in the West Wing, the one that changed the most between my two stints in the White House was the Situation Room. It was nearly unrecognizable to me when I accompanied President Obama there for the first time on January 21, 2009. Gone was the cramped, dated conference room I remembered from the 1980s.

The "Sit Room" was established by President John F. Kennedy following the Bay of Pigs invasion in 1961 and was renovated during the George W. Bush administration. The main conference room became much larger than in the Reagan years, and it contained advancements in technology to pipe in secure video from virtually anywhere in the world. I spent many hours photographing in the John F. Kennedy Conference Room as President Obama dealt with a host of complex, stressful national security issues.

"Meetings in the Sit Room are of a different breed," remembers Attorney General Eric Holder. "The stakes are always high—along with the level of tension. You're forced to confront serious threats and to authorize the most consequential responses."

In addition to containing the JFK conference room, the Sit Room is a 5,000-square-foot complex with two additional conference rooms, an office for the director of the Situation Room, and a large open area that is staffed 24 hours a day, seven days a week, to monitor national and world intelligence information.

Above, Denis McDonough whispers to Vice President Joe Biden in 2013. At right, General John Allen (retired), special envoy for Iraq and Syria, briefs the President in 2014.

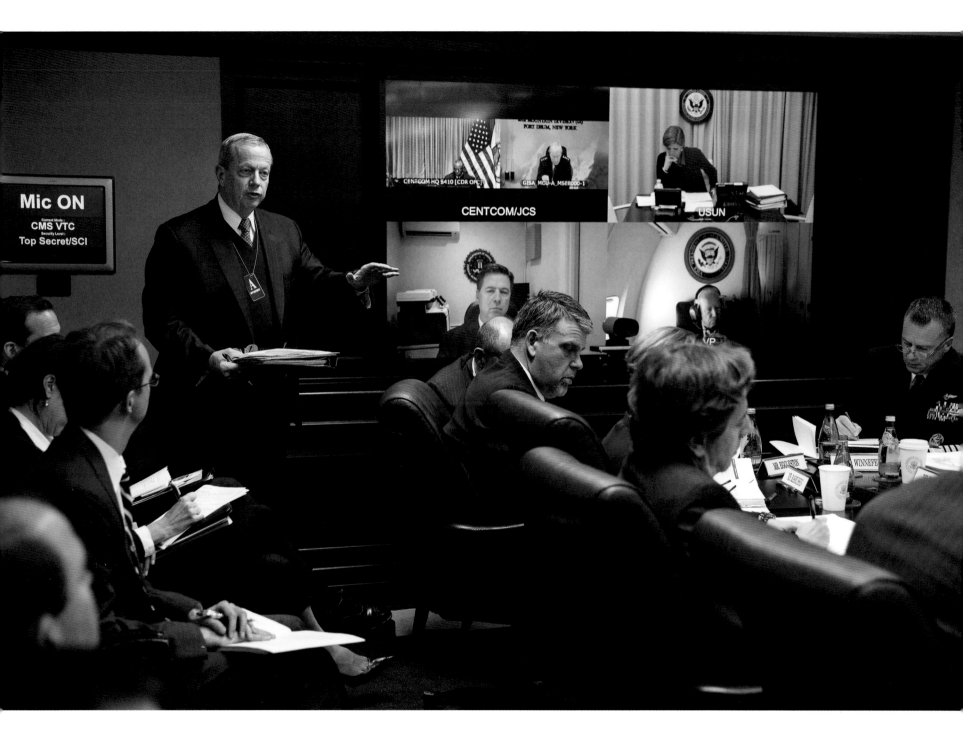

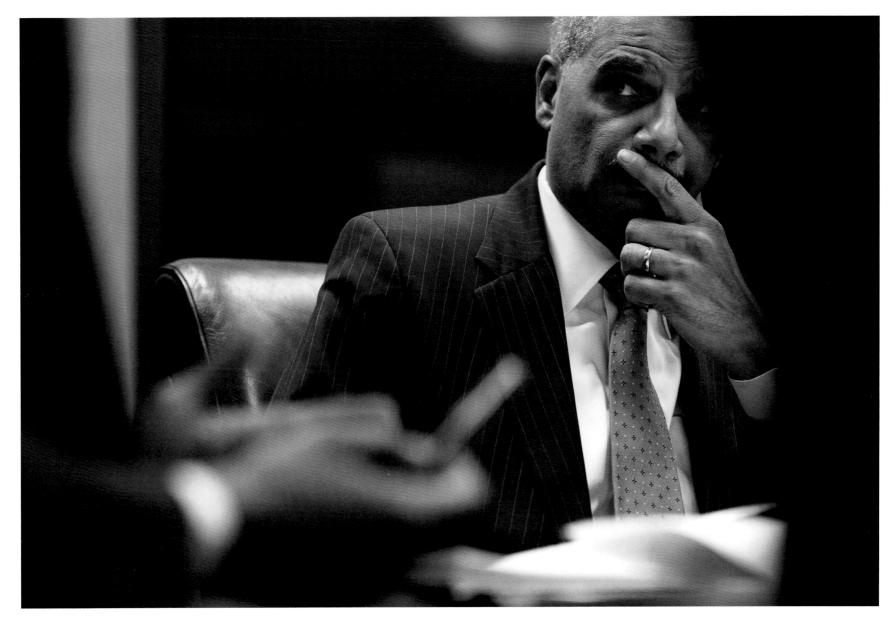

Above: Attorney General Eric Holder listens to
the President during an intelligence meeting in 2014.

Left: United Nations Ambassador Samantha Power
during a meeting about Iraq in 2014.

THE BRADY PRESS BRIEFING ROOM

Normally my view of the press briefing room was from the little TV in the Outer Oval (pictured above). From there I would catch glimpses of White House Press Secretary Robert Gibbs (or subsequently Jay Carney, then Josh Earnest) holding the daily press briefing with the White House press corps.

A swimming pool was originally in the briefing room location, installed for FDR (who suffered from polio) in 1933. President Nixon decided 36 years later to have the briefing room constructed over the pool to accommodate the growing number of members of the press corps. The room was renamed the James S. Brady Press Briefing Room in 2000 in honor of the White House press secretary who was severely injured during the assassination attempt on President Reagan in 1981. The room was renovated in 2006 and 2007. The swimming pool underneath remains structurally intact and is now used to house electronics for the press corps operations.

President Obama would often make statements or hold press conferences here. He would enter and exit through the Upper Press Office, shown at right, as a Secret Service agent manned the doorway. The press office assistants taped amusing pictures of their bosses on the wall under one of the latest jumbo prints.

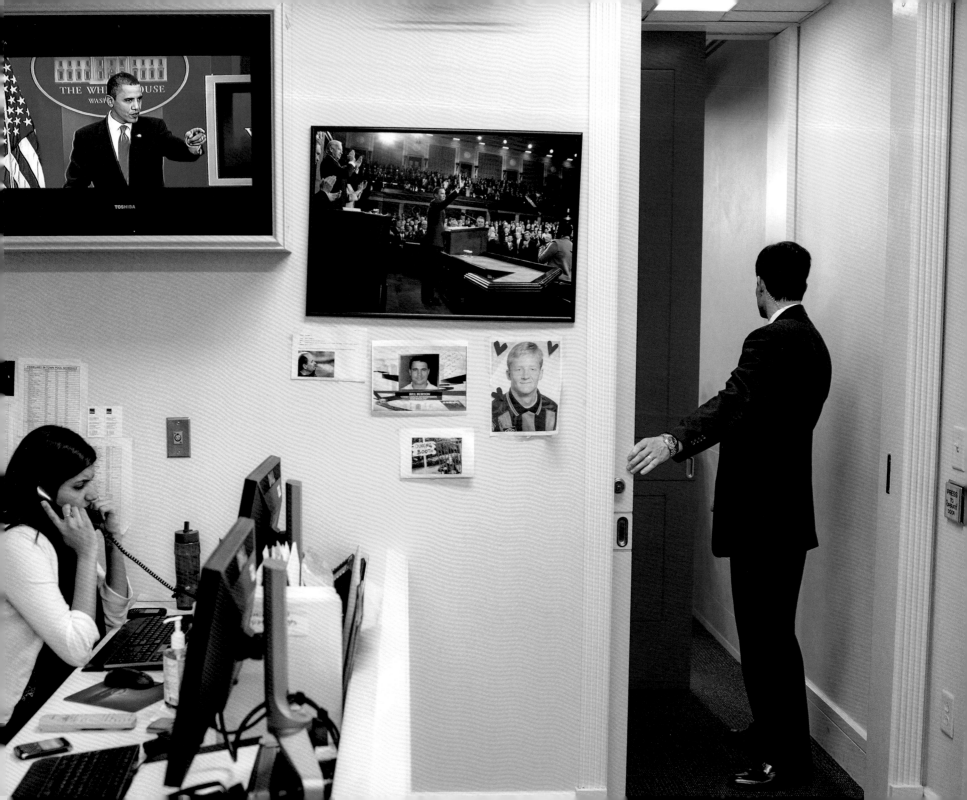

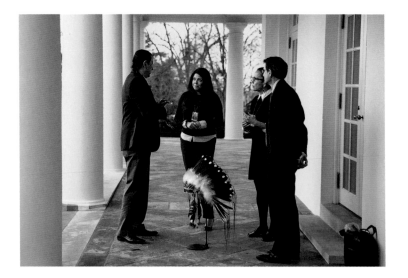

THE COLONNADE

The West Colonnade was originally built during the Thomas Jefferson administration as a connection between the White House and the horse stables. It would be almost another 100 years before the West Wing was constructed, during the Theodore Roosevelt administration. The colonnade thus became the direct route between the White House residence and the West Wing.

"For eight years that walkway would frame my day, a one-minute-long, open-air commute from home to office and back again," President Obama recounted in his memoir, *A Promised Land*. "It was where each morning I felt the first slap of winter wind or pulse of summer heat; the place where I'd gather my thoughts, ticking through the meetings that lay ahead, preparing arguments for skeptical members of Congress or anxious constituents, girding myself for this decision or that slow-rolling crisis."

At right, Brian Mosteller holds the Outer Oval office door open for the President as we were about to walk the reverse route from the West Wing to the State Floor for an official event. The colonnade, to me, represented a majestic symbol of the presidency.

It often became an area for staff to observe what was taking place at events in the Rose Garden (see next spread). Rarely, the colonnade became the setting for an event of its own, as in the above photo. Dave Archambault, left, chairman of the Standing Rock Sioux Tribe, came to the White House to smudge, or cleanse, a headdress that had previously been given to the President. Also pictured are personal aide Ferial Govashiri, center; Jodi Archambault, Dave's sister and the White House special assistant on Native American affairs; and William Perry, legal counsel for the Standing Rock Sioux Tribe.

Near right: Half of the mahogany Cabinet Room table (the one donated by President Nixon, see page 54) is temporarily situated on the colonnade after being removed for an event in 2014.

Far right: White House staff members line the colonnade to listen to the President's controversial—but, for many, emotional—announcement in 2012 that he had signed an executive order to stop deporting some young people who came to America as children of illegal immigrants.

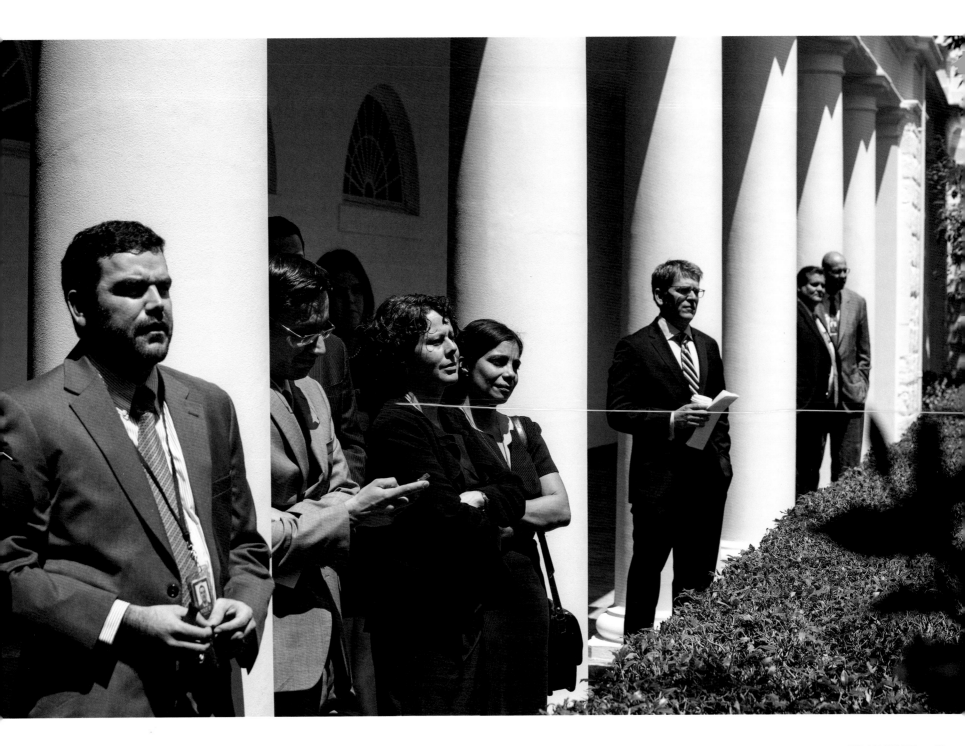

A staff member walks from the executive residence to the West Wing in 2014. Thomas Jefferson first proposed plans for "service wings" on each side of the White House; his early drawings showed a Tuscan order colonnade that provided a covered walkway.

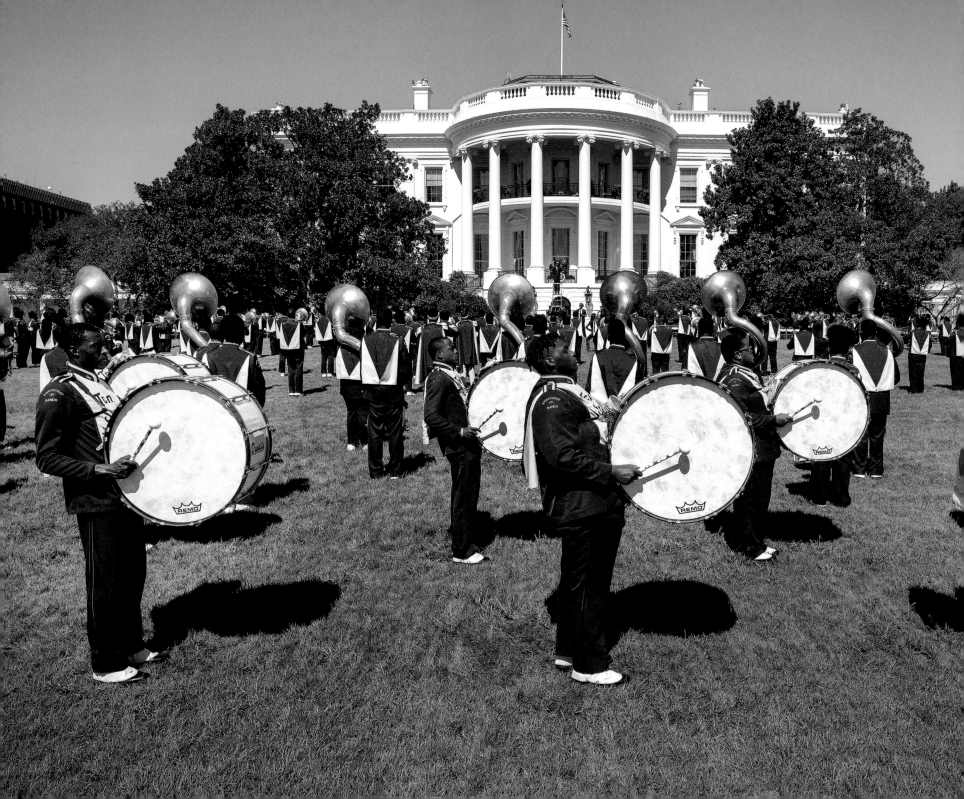

THE PEOPLE'S HOUSE

When I was nine years old, I visited Washington, D.C., with my parents and sister. We toured the White House, yet we have no family pictures of it because photographs were not allowed during the tour. (The Obama administration permanently changed these restrictions; photographs by tourists are now permitted on the public tours.) But my parents had purchased a copy of the aptly named book *The White House,* produced by the White House Historical Association. The softcover version was heavily illustrated with color photographs. There was a section on the creation of a permanent home for the president. A section on life in the White House. Another on the "great paintings." The final—and largest—section was "A Guide to the Rooms."

I wore that book out. Especially that last section, where I endlessly looked at the photographs of the rooms on the State Floor, like the East Room, Red Room, and Blue Room, and the outdoor photographs of the Rose Garden and South Lawn. First Lady Jackie Kennedy had written in the introduction that the book was planned for "children."

"It was hoped that they would go over the book at home and read more about the Presidents who interested them most," Mrs. Kennedy wrote. "Its purpose was to stimulate their sense of history and their pride in their country."

I was one of those children. I imagined what it must be like to see those rooms every day. But there were only a few candid photographs of the people who lived there in the "Life in the White House" section of the book. Almost every photograph of the famous rooms was a still life, without any presence of the people who *worked* and *visited* there. Missing were photographs of those who helped make the White House—and the presidency—function.

I didn't imagine that someday I would spend more than 13 years of my life *being in* those rooms every day, essentially unencumbered to make any photograph I wanted to make. Let me take you into those rooms and introduce you to some of the people around the President and, I hope, further stimulate the "sense of history" that Jackie Kennedy wrote about.

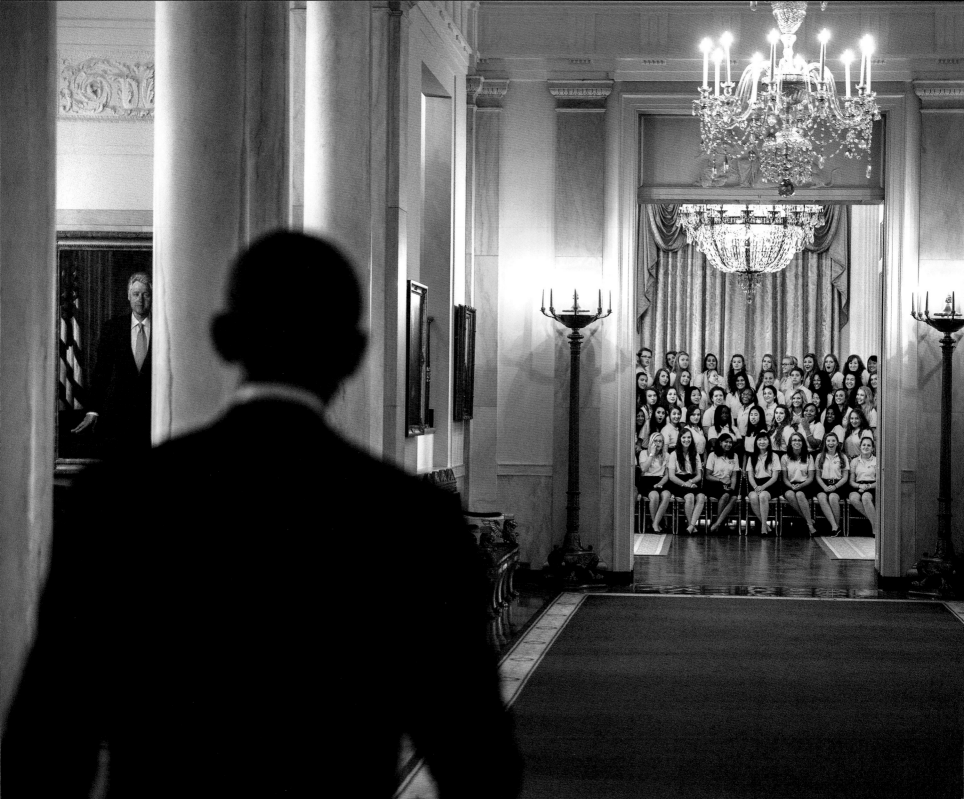

THE STATE FLOOR

The basic layout of the State Floor hasn't changed much since the White House was first built in 1792. Each room on the floor has its own character. The East Room and State Dining Room are used the most for meetings and events. But smaller rooms like the Red Room and Green Room also have their own character. The Social Office, led by the social secretary, is the main point of logistical management of all events on the State Floor.

I've photographed many formal happenings on the State Floor, from official state dinners with heads of state to musical performances by legends like Bob Dylan and Bruce Springsteen. During the Reagan administration, I photographed Princess Diana dancing with John Travolta just to the left of where the adjacent picture was made (which shows members of Girls Nation in the East Room awaiting the arrival of President Obama for a group photo).

The East Room especially has been the site of more serious events in our nation's history. President Kennedy lay in repose here, his casket draped in black cloth, following his assassination in 1963. Richard Nixon gave his farewell speech here following his resignation in 1974.

I photographed President Obama in the doorway of the East Room on May 1, 2011, when he announced that a special operations mission had captured and killed Osama bin Laden, the mastermind behind the September 11, 2001, terrorist attacks.

The floor above the State Floor is called the private, or executive, residence—where each president lives with his family—and the floor below is known simply as the ground floor. The Diplomatic Reception Room on the ground floor leads outside to the south grounds.

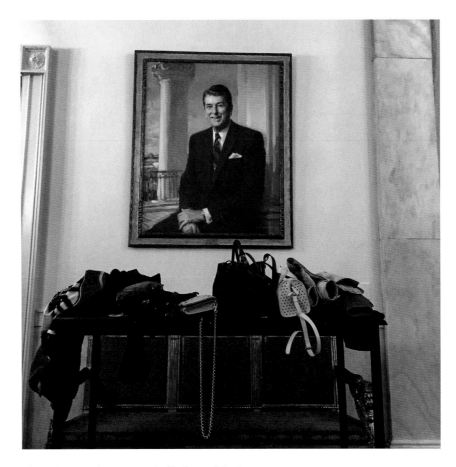

Above: Coats and purses stacked in front of the Reagan portrait by Everett Raymond Kinstler in the Cross Hall before an event in 2015. This portrait of a president for whom I had worked was a daily reminder that my White House photographs were an important visual documentation of history.

Right: A White House social aide waits outside the State Dining Room during a meeting with the nation's governors. The social aides, all members of the military, help ensure that events are conducted with dignity befitting the President of the United States.

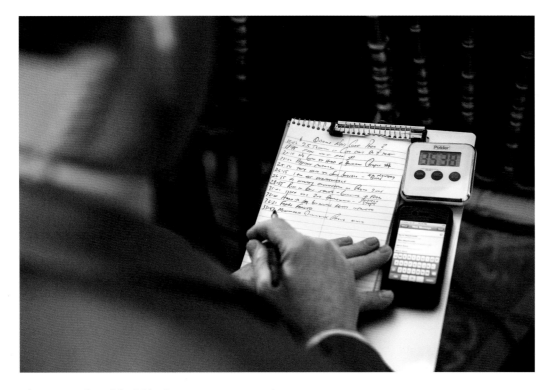

Above: A member of the White House press corps monitors the President's press conference in the East Room in 2013. Modern-day reporters are often taking notes, keeping tabs on social media, and tweeting at the same time.

Right: Assistant Press Secretary Dag Vega, standing at left, watches over a TV production crew in the East Room during the President's 2011 interview with George Stephanopoulos of ABC in the Blue Room.

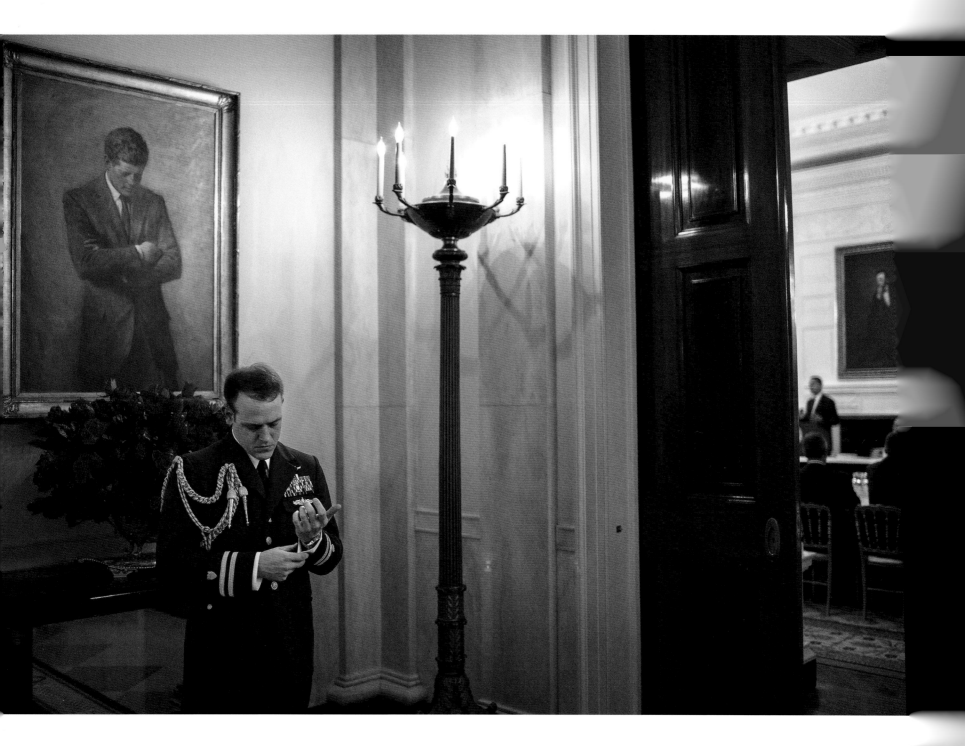

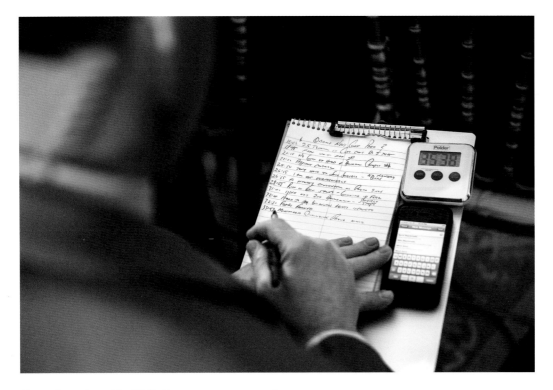

Above: A member of the White House press corps monitors the President's press conference in the East Room in 2013. Modern-day reporters are often taking notes, keeping tabs on social media, and tweeting at the same time.

Right: Assistant Press Secretary Dag Vega, standing at left, watches over a TV production crew in the East Room during the President's 2011 interview with George Stephanopoulos of ABC in the Blue Room.

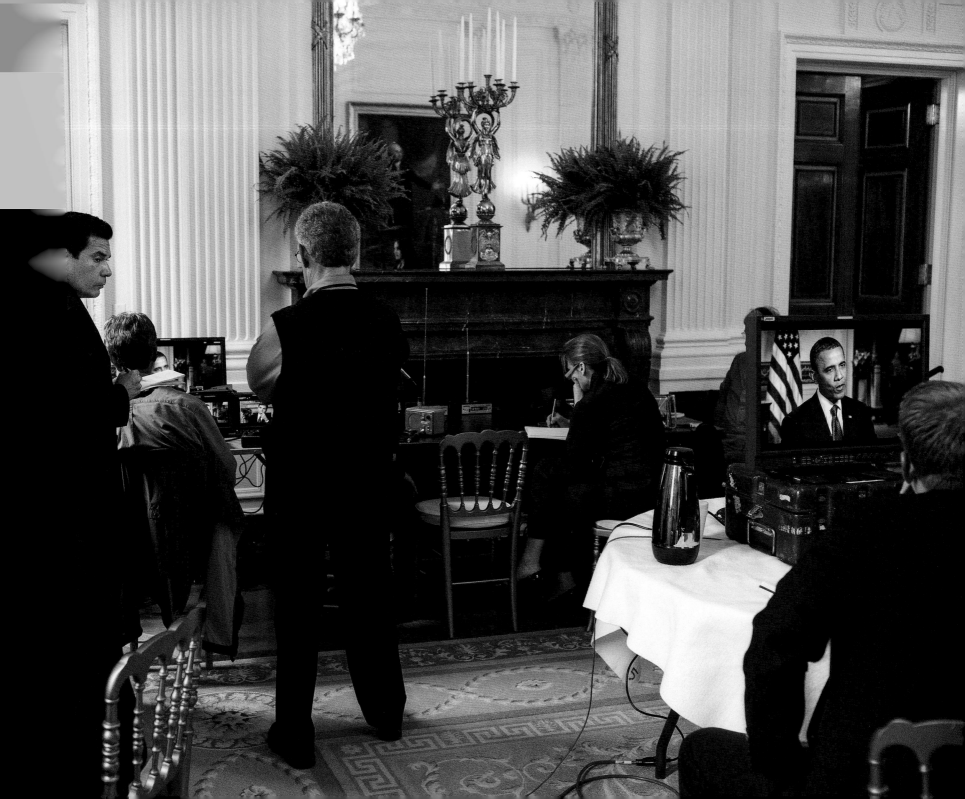

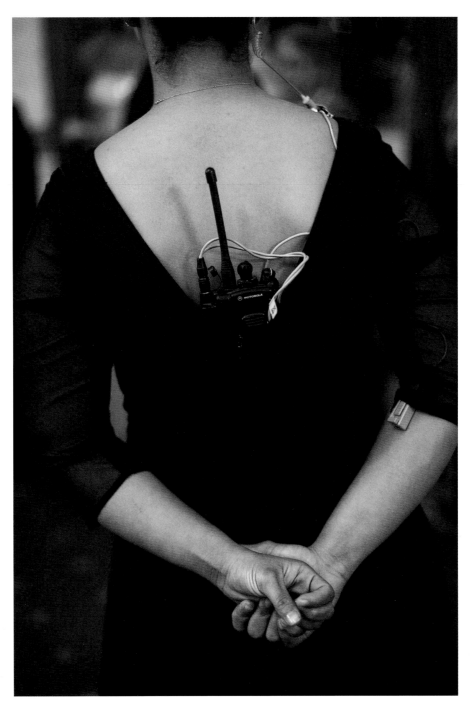

Near right: The First Lady's personal aide, Kristen Jarvis, wears a walkie-talkie to communicate with other staff during a state dinner in 2009.

Far right: Chief Usher Stephen Rochon and the First Lady's personal aide, Kristin Jones, help repair the President's tuxedo jacket upstairs in the private residence before a state dinner in 2010. Rochon was a former Coast Guard rear admiral and the first African American to serve as chief usher. The chief usher is responsible for the maintenance of the White House, as well as the administrative, fiscal, and personnel functions of the entire residence staff.

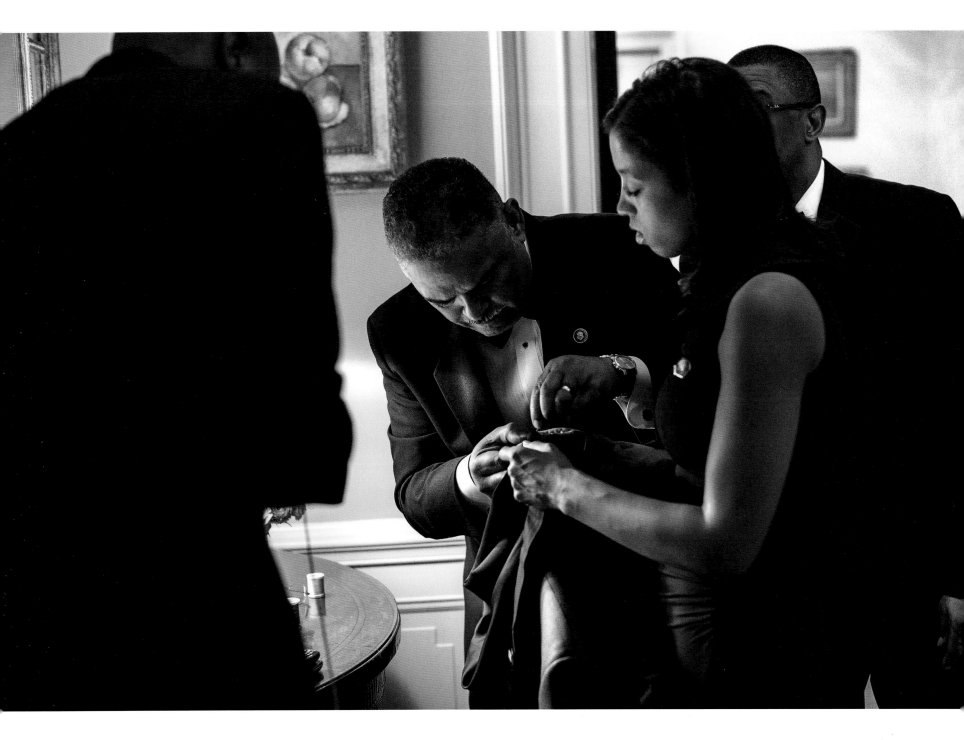

WHITE HOUSE BUTLERS There are dozens of permanent White House staff members who are responsible for the First Family's needs in the executive residence. Almost all of them have worked for several presidents. The butlers, given their direct interaction with the President and First Lady in their home, usually become quite close to the First Family.

I would often see the butlers at official functions like state dinners and formal luncheons even though they spent most of their time in the First Family's private living quarters. Von Everett— pictured above at far right at a state dinner and at left holding the President's suit coat during a luncheon with TV anchors—was one of the butlers I became close to. He and fellow butler Buddy Carter would often sneak me an extra meal during a state dinner or official luncheon.

When my book *Obama: An Intimate Portrait* was published, I received a text from an unknown number in Texas. "Can you send me a book," said the text. "Who is this?" I replied. "Von," was the one-word response. He had just retired after serving six presidents. Yes, I sent him a book.

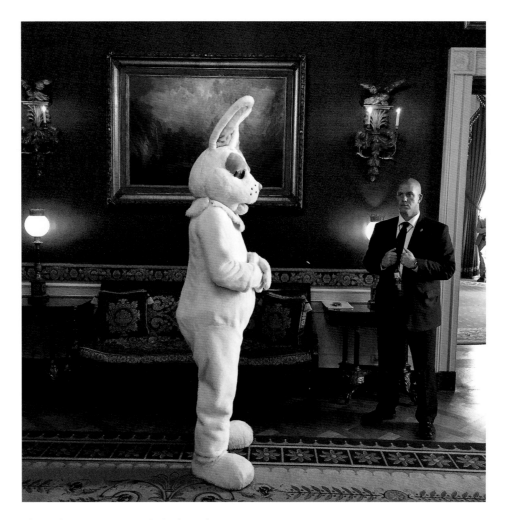

Above: The Easter Bunny waits in the Red Room to enter the adjacent Blue Room to meet the President as a Secret Service agent stands guard before the annual Easter Egg Roll in 2015.

Right: Staff members hold open the swinging doors in the butler's pantry as the President is about to enter the State Dining Room to give a statement to the press in 2014.

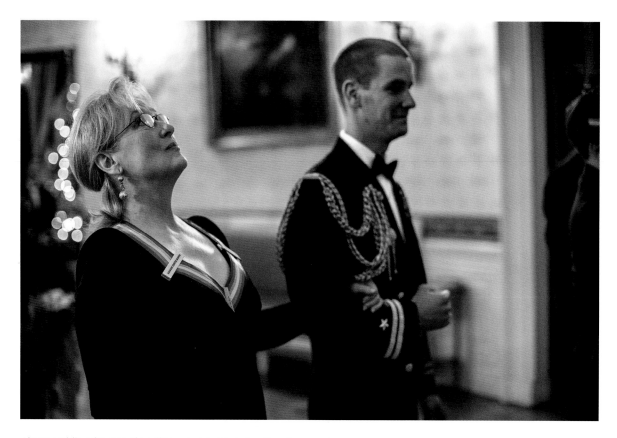

Above: Holding the arm of a military social aide in the Blue Room, actress Meryl Streep looks up as she is about to be introduced as one of the Kennedy Center Honorees in 2011. Streep recalls she was "hoping that [her] parents were watching from far beyond this world."

Right: In the Blue Room for a state dinner in 2011, Manuel Quiroz announces each guest to the President and First Lady. An interpreter at the State Department, Manuel would receive a guest list a couple of days in advance. He would work out the pronunciation of most of the names on his own; the United Nations General Assembly reception guest list was the biggest challenge. Manuel recalls, "It might seem odd, but one of the most rewarding aspects of the job was when I would announce confidently, and without any hesitation, as some guest was timidly expecting me to mangle their name. You could see their face light up at feeling that they had been recognized in a room with the most powerful people in the world."

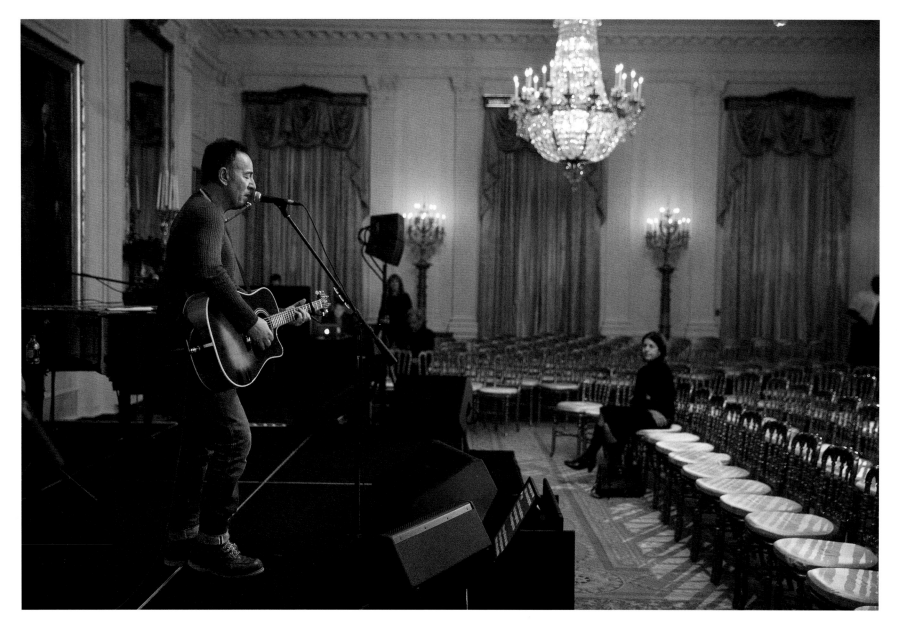

Bruce Springsteen rehearses in the East Room before his performance in 2017 for members of the White House staff who had served all eight years.

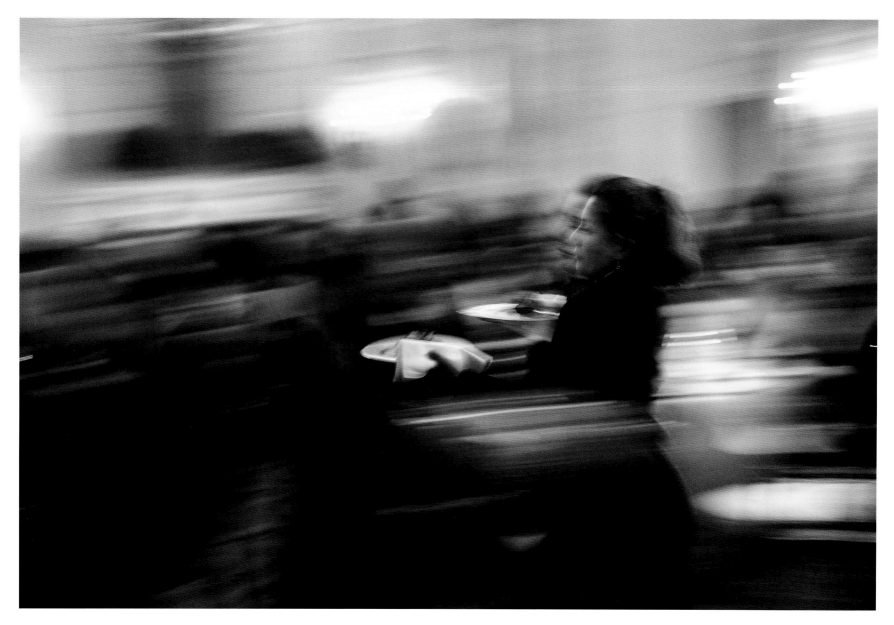

A server rushes dinner plates into the State Dining Room
during the Governors Dinner in 2009.

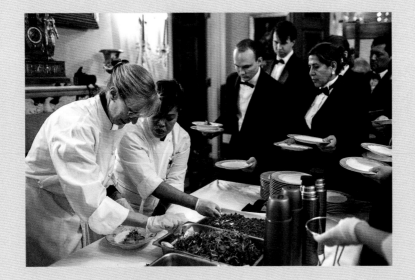

WHITE HOUSE CHEFS Like many others who work in the executive residence, the White House chefs are nonpolitical employees and often serve multiple administrations. During the Reagan administration, Henry Haller was the executive chef until he retired in 1987. He had been hired by LBJ in 1966.

During the Obama administration, the executive chef was Cristeta Comerford, second from left in the above photo. A Filipino American, Cris was hired by the George W. Bush administration in 2005, becoming the first woman and person of color to be White House chef. She remained in the job during the Trump and Biden administrations.

There are other White House chefs, including a pastry chef. During the Obama administration, Bill Yosses was the executive pastry chef until 2014, and was succeeded by Susie Morrison, pictured at right, who had been his deputy. For President Obama's first birthday in the White House, Bill and Susie made several pies (the President preferred pie to cake). Several hours before the celebration, the two pastry chefs brought the pies over to the West Wing and "hid" them in the Cabinet Room. I remarked to Susie, in jest, "I can't believe you didn't make a coconut cream pie." Which was *my* favorite. A couple of hours later, as the pies were being moved to the Roosevelt Room for the event, I noticed that there was now a coconut cream pie.

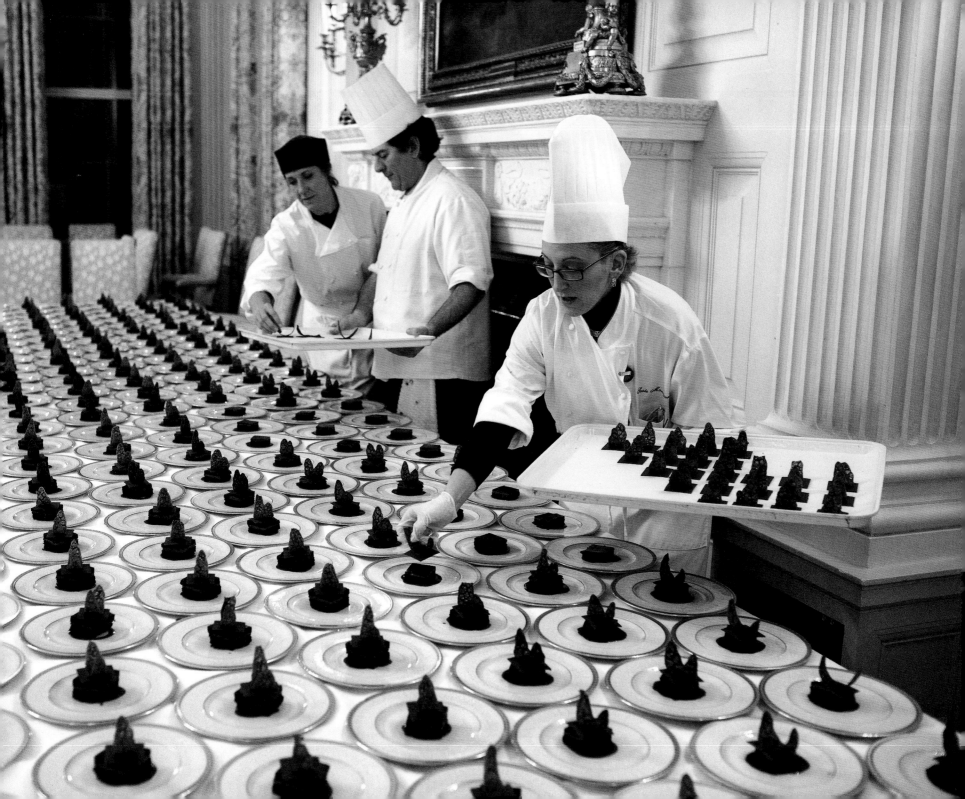

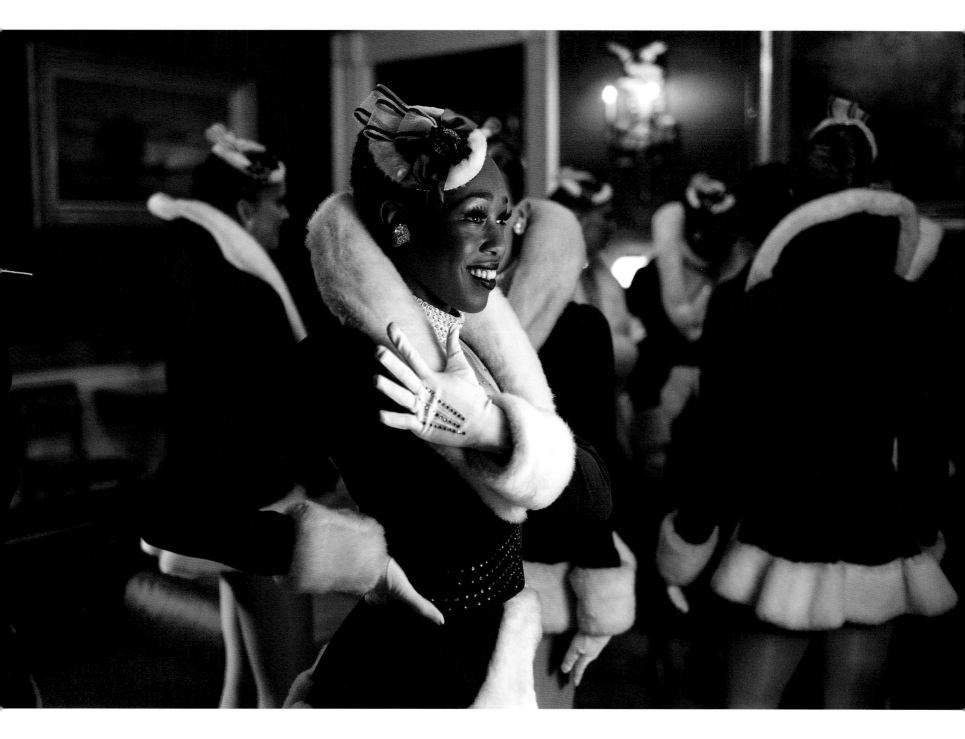

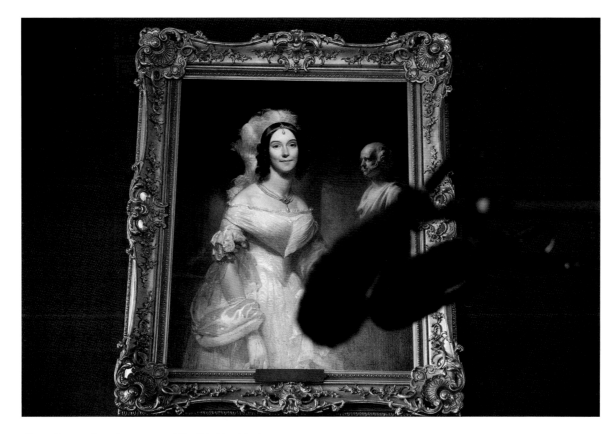

Above: Boom microphones record the President during an interview in the Red Room in 2015. The oil painting by Henry Inman is of Angelica Singleton Van Buren, who was the daughter-in-law of President Martin Van Buren. She assumed the role of First Lady because Van Buren had been a widower for 18 years when he became president and never remarried.

Left: The Radio City Rockettes warm up in the Red Room before performing at a Christmas dinner in 2009.

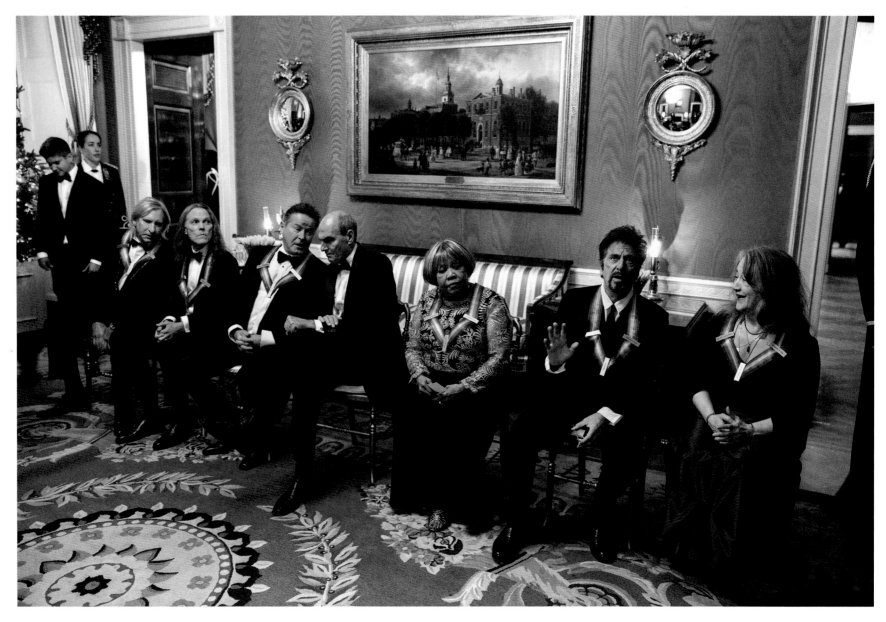

Kennedy Center Honorees wait in the Green Room before being introduced
into the East Room in 2016. From left: the rock band the Eagles (Joe Walsh,
Timothy B. Schmit, and Don Henley; Glenn Frey was honored posthumously),
musician James Taylor, gospel and blues singer Mavis Staples, screen
and stage actor Al Pacino, and Argentine pianist Martha Argerich.

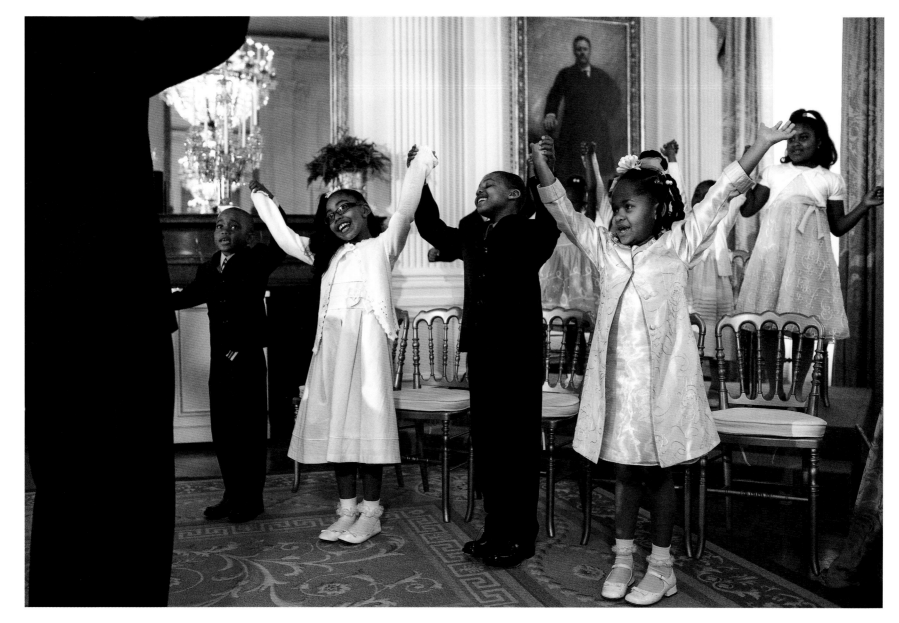

The Mt. Ennon Baptist Church Children's Choir from Clinton,
Maryland, performs at the Easter Prayer Breakfast with
Christian leaders in the East Room in 2010.

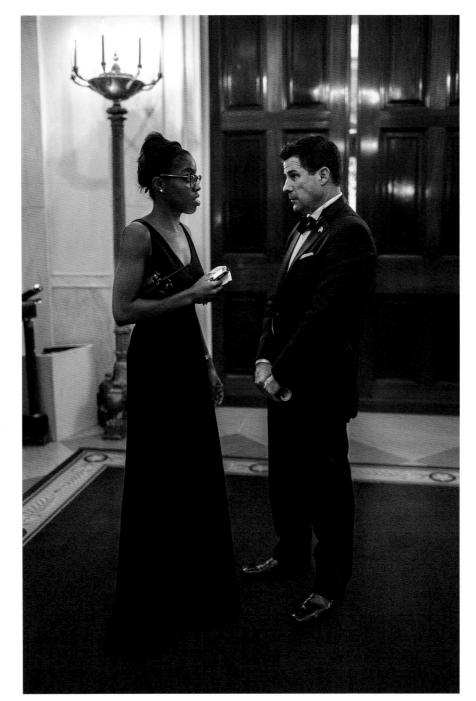

Near right: Deputy Social Secretary Samantha Tubman and Social Secretary Jeremy Bernard discuss last-minute details before a state dinner in 2011. I first met Sam when she was a press wrangler in 2007 during the campaign. She became one of my closest friends at the White House.

Far right: Guests use their phones to capture the moment the President and First Lady descend the Grand Staircase to make an appearance at a Christmas party on the State Floor in 2016. Throughout the holiday season, twice-daily parties with 500 or more guests are the norm for almost three weeks. The White House pastry chef once told me that she and her staff usually made more than 20,000 Christmas cookies for these parties.

THE ROSE GARDEN

I enjoyed photographing the different seasons in the Rose Garden, highlighted by the rose bushes (above) and the annual blooming of the magnolia and crab-apple trees. The White House groundskeepers were working in the garden almost every day, planting ever-changing seasonal flowers. Tulip season was my favorite (left). So was the beauty of the Rose Garden when it snowed.

The White House garden was planned for President John Adams in 1825; subsequent presidents and first ladies contributed to its beauty. The first roses were planted by First Lady Ellen Axson Wilson in 1913, after which it became known as the Rose Garden. It was famously redesigned in the 1960s by First Lady Jacqueline Kennedy, who envisioned it being used for presidential events.

Presidents since have used it for press conferences, signing ceremonies, major policy announcements, and the annual Turkey Pardon. Three weddings have taken place here (including mine). President Obama held a "beer summit" in 2009 with Harvard professor Henry Louis Gates Jr. and Cambridge Police Sergeant James Crowley to ease tensions after what was perceived as a racial incident between the two. One year when the President hosted a Cinco de Mayo reception with invited guests, staff were told not to "crash" the party. After the President had departed and returned to the residence for the night, I did crash the party. I confessed my sin afterward to the deputy social secretary by adding that I also drank two margaritas.

In 1984, I photographed a ceremony to honor the U.S. Olympic hockey team after their historic gold medal. A makeshift hockey rink had been set up, and President Reagan "scored" on a few slap shots. I don't think the goalie made much of an effort to stop the puck from going in the net.

First Lady Melania Trump was criticized for removing the crab-apple trees planted during the Kennedy administration, and for replacing some of the grass with concrete.

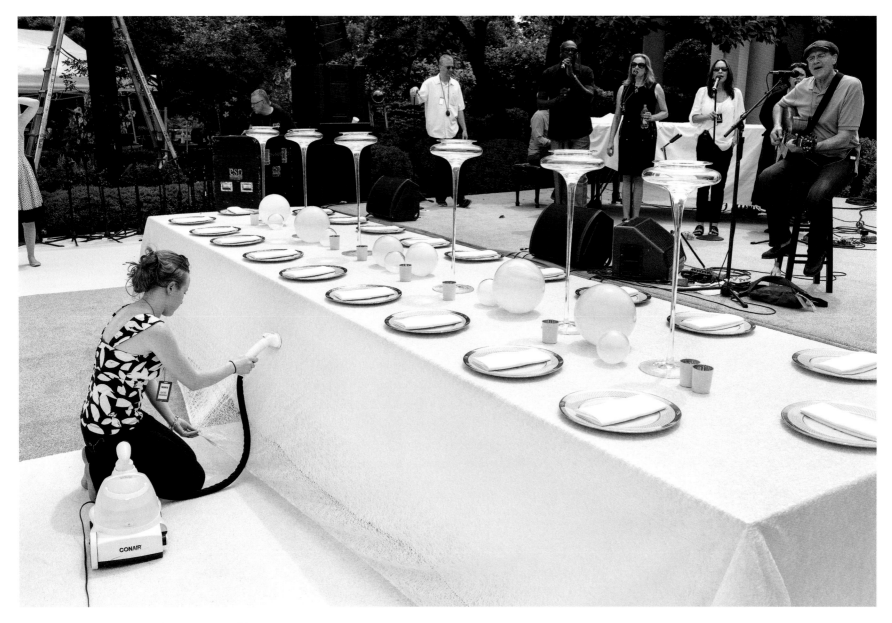

A member of the residence staff steams out wrinkles in the tablecloth as singer-songwriter James Taylor and his band rehearse before a state dinner in 2015.

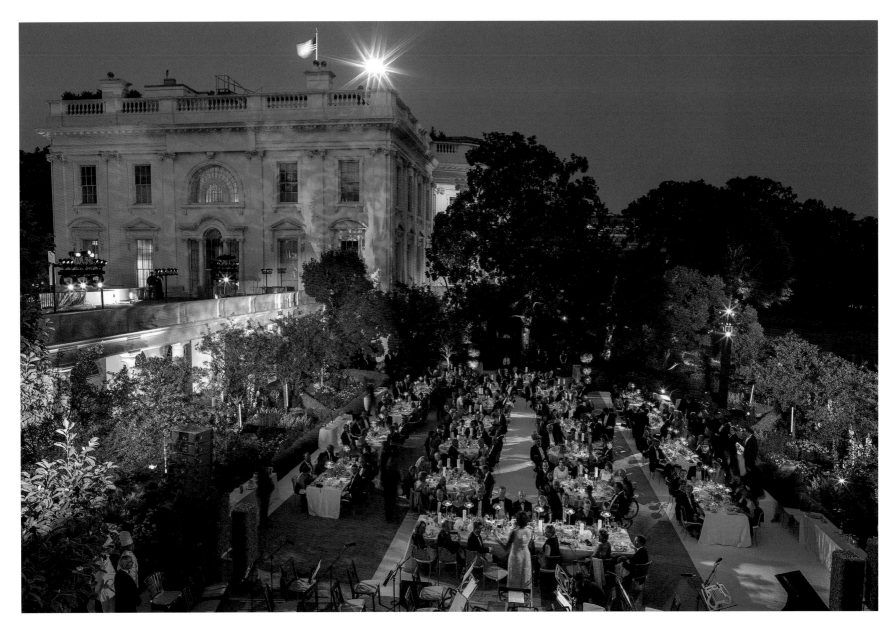

The state dinner later that night, when the President
presented Merkel with the Presidential Medal of Freedom.

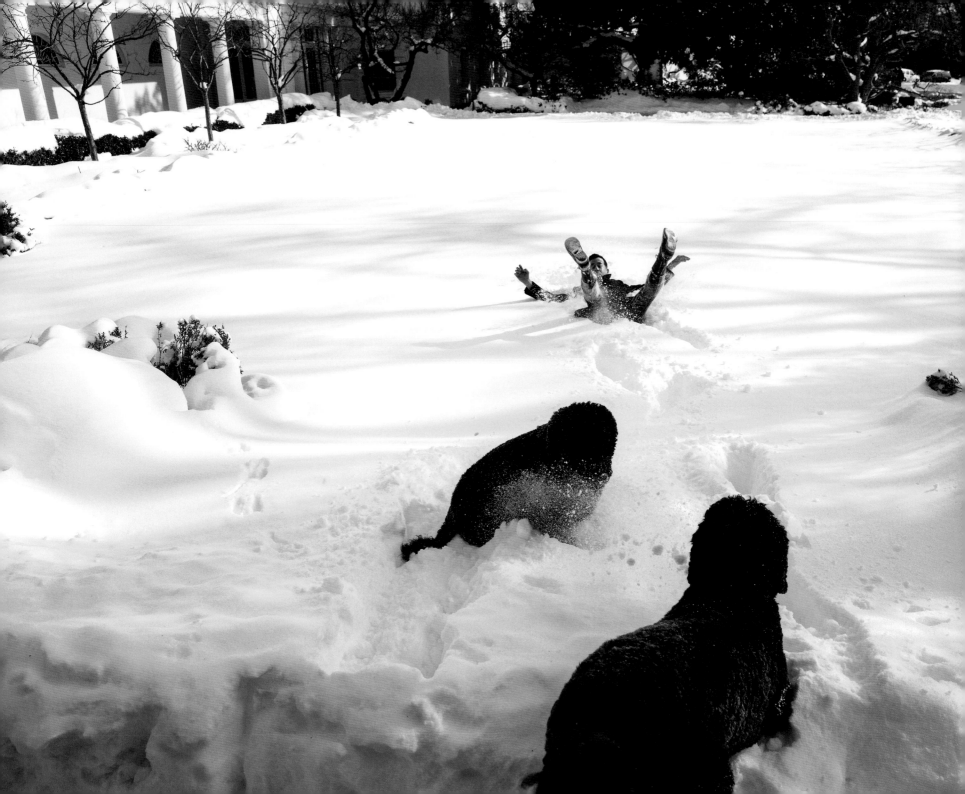

Above: My footprints in the snow.

Left: Brian Mosteller tries to entice Bo and Sunny to play in the snow in 2016.

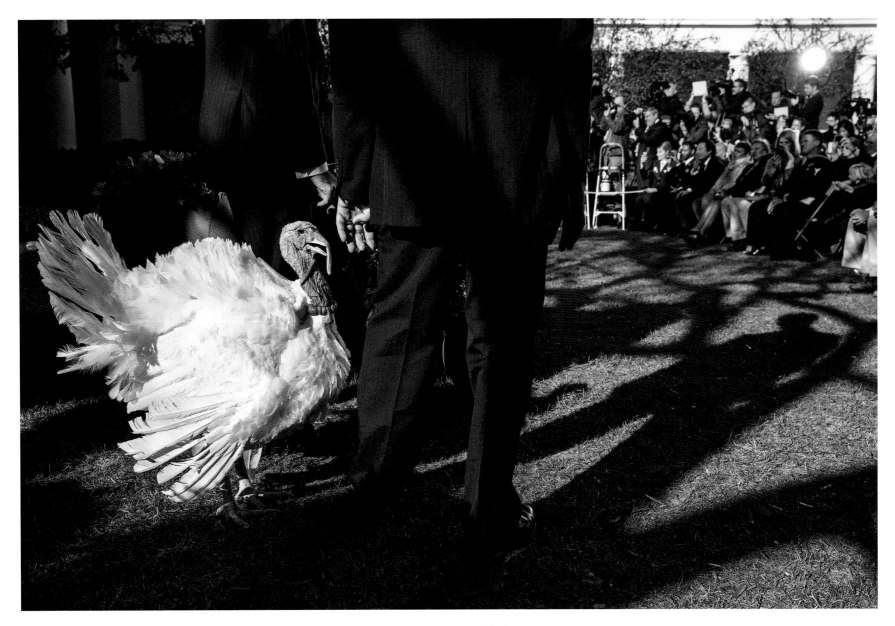

The annual Turkey Pardon in 2010, a tradition that dates back several administrations. President Kennedy had a Rose Garden ceremony upon the presentation of a turkey in 1963 and declared, "Let's keep him going" (though a sign around the turkey's neck said, "Good eating, Mr. President"). During the Reagan and George H. W. Bush administrations, these "pardons" became a yearly occurrence, setting the norm for future presidents.

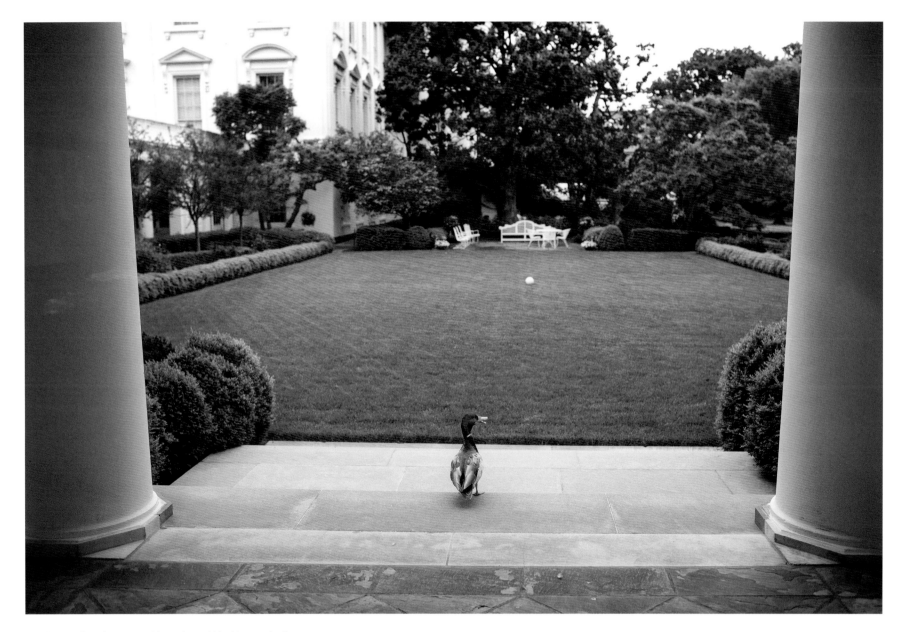

Two hours after the Osama bin Laden raid in 2011, a duck appears on the steps overlooking the Rose Garden, apparently having avoided Secret Service screening.

THE SOUTH LAWN

Stretching to the edge of the Ellipse (the 52-acre park south of the White House), the South Lawn is best known as the site of the *Marine One* helicopter arrivals and departures. There is also a swimming pool, a tennis court (which doubled as a basketball court during the Obama administration), a putting green installed by President George W. Bush, and a kitchen garden constructed at the direction of First Lady Michelle Obama in 2009.

The South Lawn is the site of large gatherings, from official arrivals of heads of state to the annual Fourth of July and Easter Egg Roll celebrations (the latter is pictured at right). In his last year in office, President Obama held what he called "South by South Lawn," modeled after the annual South by Southwest event in Austin, Texas.

Many historic events have taken place on the South Lawn. President Bill Clinton hosted the Jordan-Israel peace treaty in 1994. Shortly after his inauguration, President Reagan welcomed home the 52 American hostages who had been held for 444 days in Iran. In 2015, I photographed Pope Francis as President Obama welcomed him to the White House in one of the largest gatherings on the South Lawn for an official state arrival.

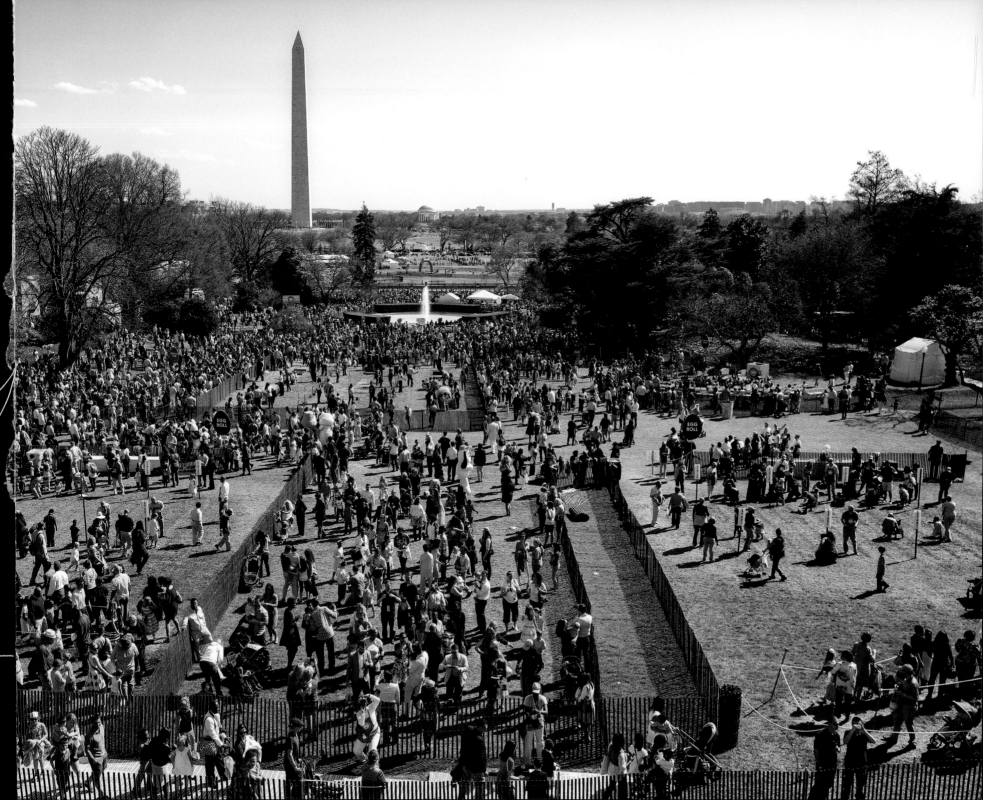

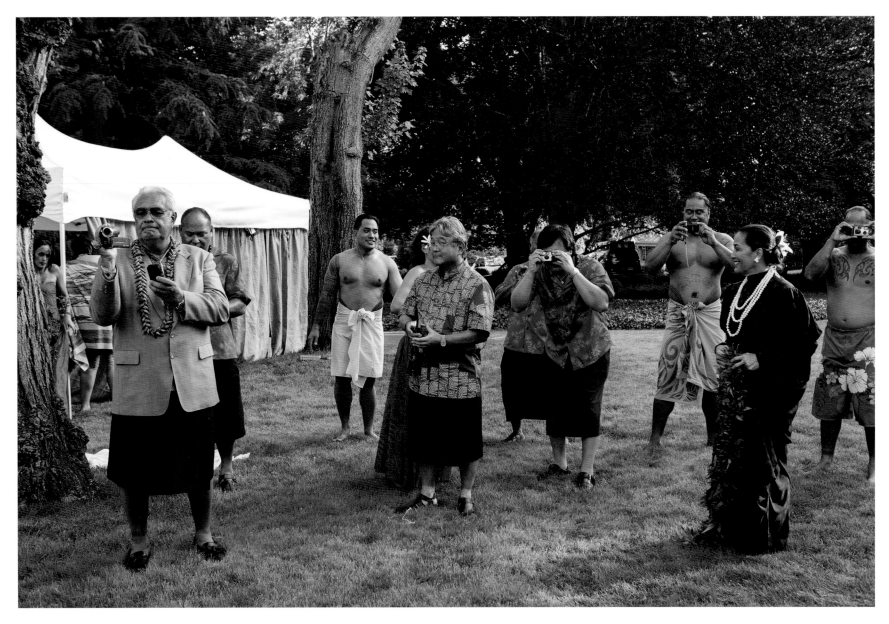

Performers at the 2009 Congressional Picnic, which had a
Hawaiian luau theme, wait to say hello to the President.

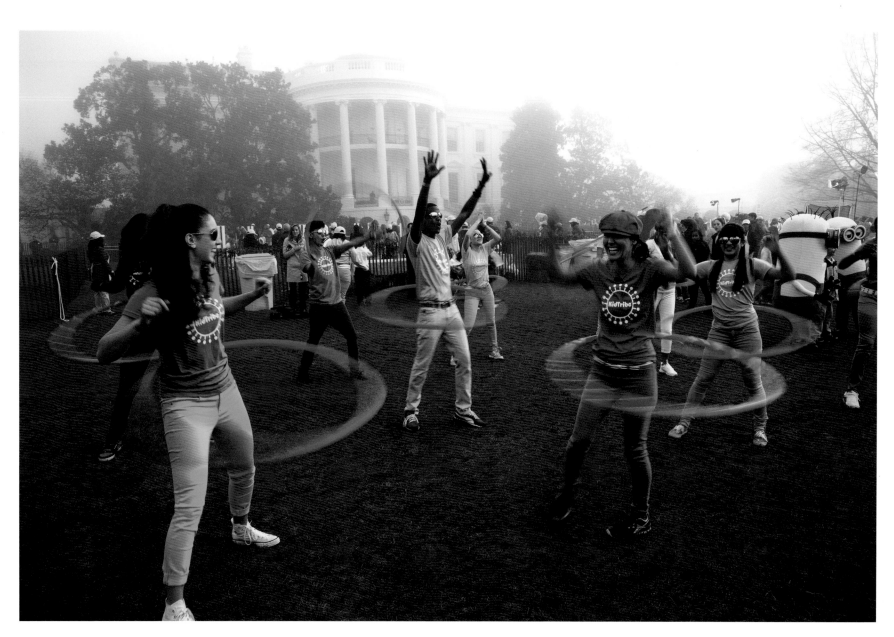

KidTribe hula hoopers perform at the Easter Egg Roll in 2013.
The mission of the Palm Springs, California, nonprofit is to
create positive programming for children that educates,
empowers, and entertains.

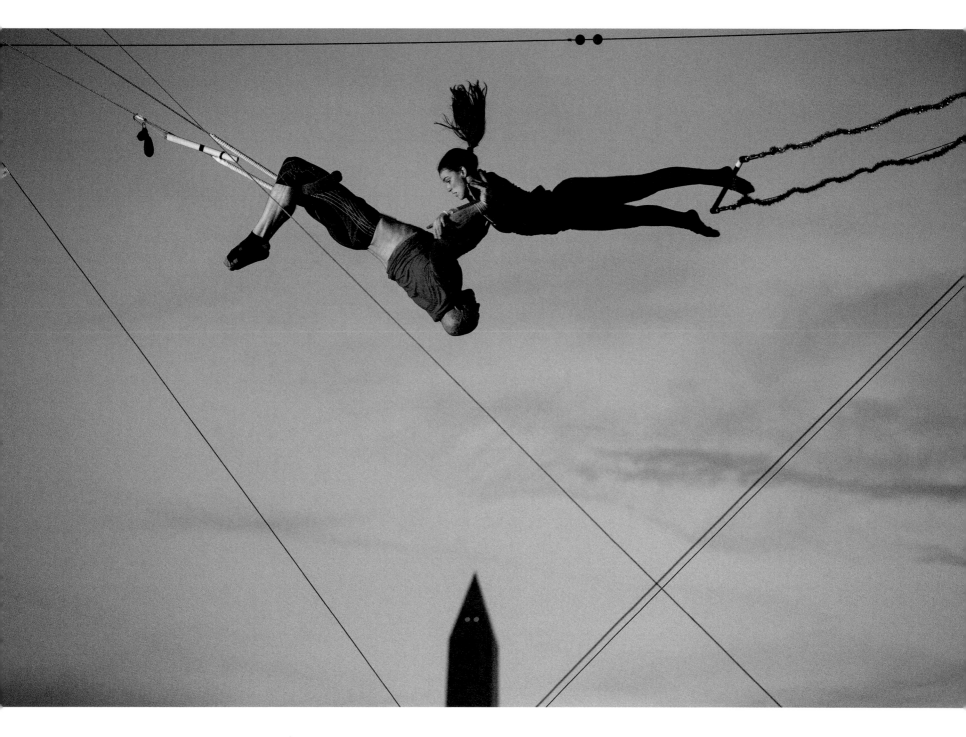

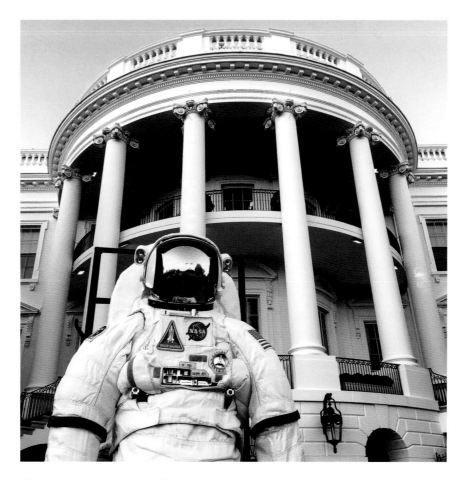

Above: A NASA space suit at White House Astronomy Night in 2015, during which telescopes were set up on the South Lawn to view the quarter-moon. Students and teachers interacted with scientists, engineers, and NASA astronauts. President Obama had also invited Texas high school student Ahmed Mohamed, who had recently been arrested (while wearing a NASA T-shirt) for bringing a homemade clock to school, which teachers mistook for a bomb.

Left: Acrobatic performers rehearse on a trapeze before the annual Halloween trick-or-treat event in 2015.

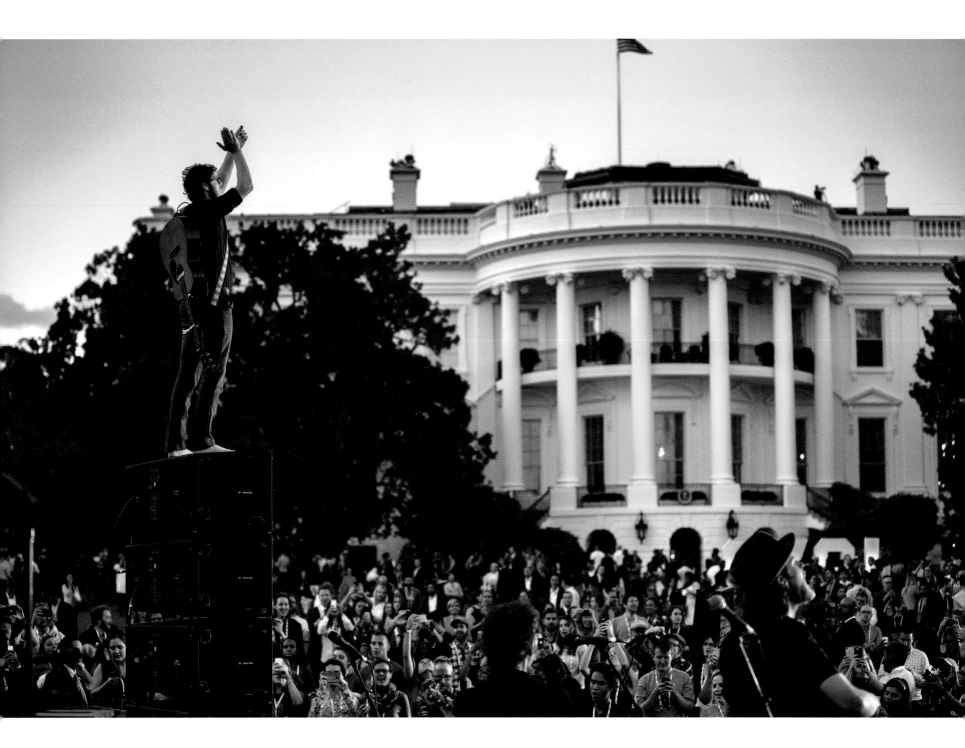

Above: Brandi Carlile, Tim Hanseroth, Phil Hanseroth, and Josh Neumann wait to take the stage during the Fourth of July concert for military families and White House staff in 2010. Lead guitarist Tim Hanseroth recalls this moment: "Hard to believe a few grunge kids from Seattle getting to play the President's house on the Fourth of July!" Brandi and the band performed at my wedding in the Rose Garden in 2013.

Left: The Lumineers perform during the South by South Lawn event in 2016. Guitarist Stelth Ulvang, standing atop a loudspeaker, says he remembers this being "a spur-of-the-moment attempt at engaging the crowd more. The bizarre part was my nerves went away, despite the wobbly stack of speakers and the better view of the White House. It was a shortcut to connecting with so many people instantaneously."

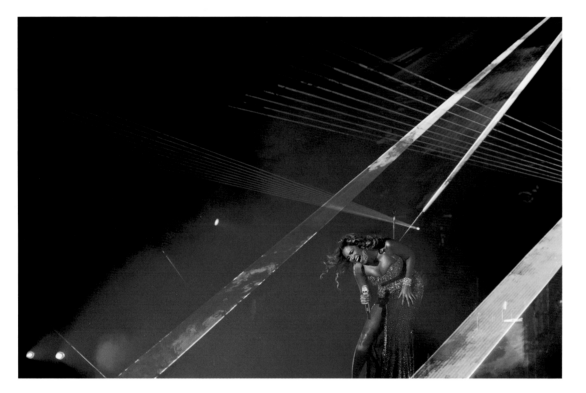

Above: Beyoncé performs inside a large tent erected on the South Lawn during a state dinner in honor of President Felipe Calderón of Mexico in 2010.

Right: The view of the South Portico of the White House as seen through a translucent tent during a state dinner in honor of Prime Minister David Cameron of the United Kingdom in 2012.

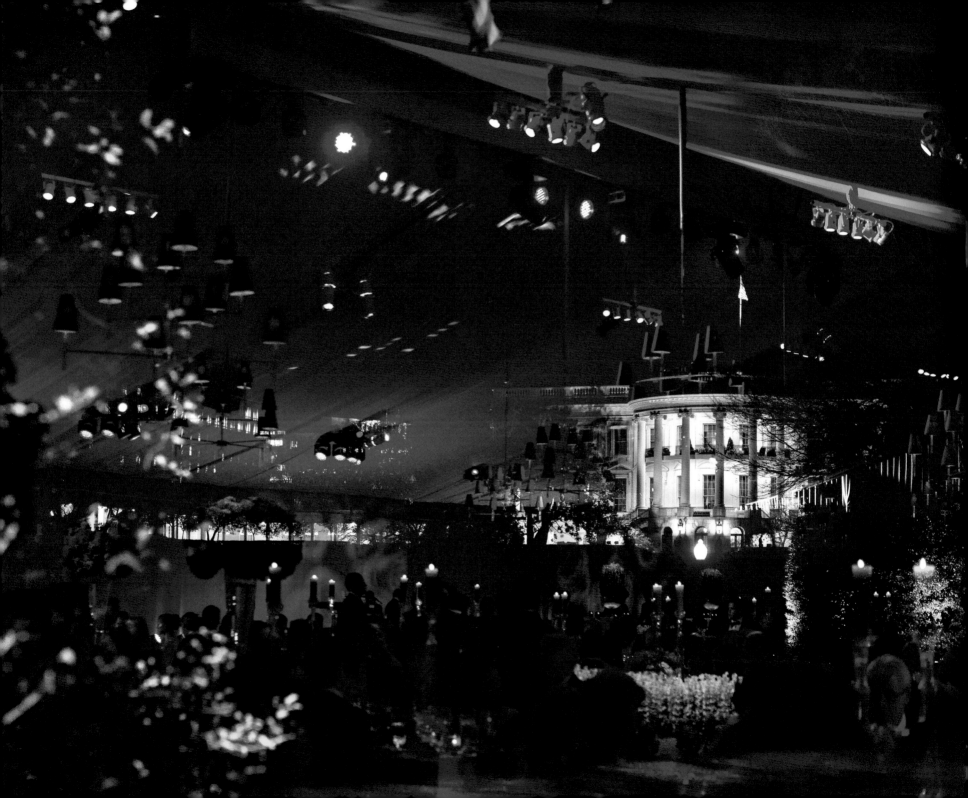

Above: Chamomile in the kitchen garden, which was started by First Lady Michelle Obama with the assistance of local schoolchildren in 2009. It became the first major vegetable garden at the White House since First Lady Eleanor Roosevelt's victory garden during World War II.

Right: Beekeeper Charlie Brandt, who was also one of the White House carpenters, works in the beehive that was put in place near the kitchen garden in 2009. So much honey—175 pounds a year—was harvested that President Obama purchased a home-brewing kit in 2012, and the kitchen staff brewed the first beer in the White House—a honey brown ale. The beer was served at official events.

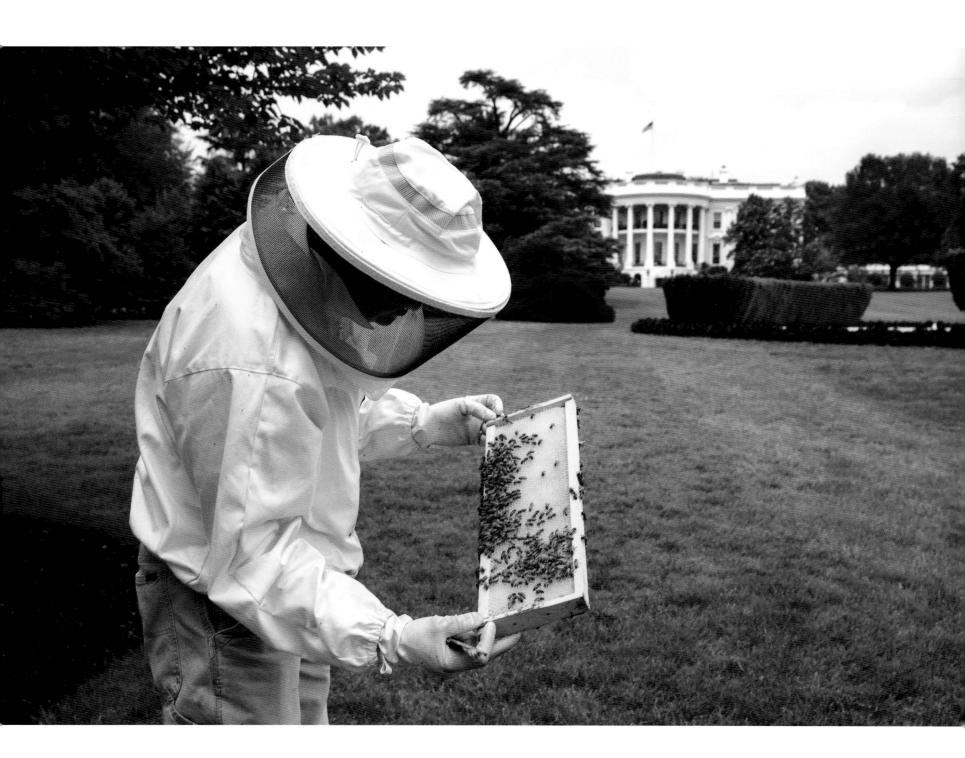

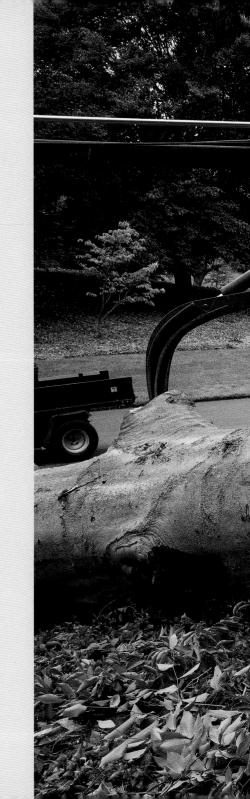

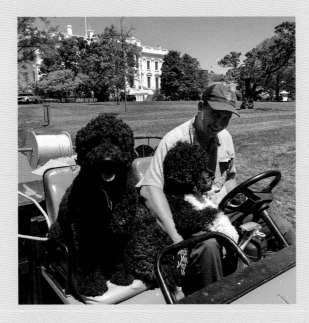

WHITE HOUSE GROUNDSKEEPERS Groundskeepers from the National Park Service have been taking care of the 18 acres of the White House grounds since the 1930s. I remembered several of the groundskeepers from my time during the Reagan administration who were still working during the Obama administration.

My colleague Amanda Lucidon interviewed many of them for a multimedia piece we did in celebration of the 100th anniversary of the National Park Service in 2016. "My job is to help beautify the White House grounds and to preserve its history," groundskeeper Kevin Tennyson told Amanda.

President Obama reminisced about shaking hands with groundskeeper Ed Thomas, a Black man who had worked at the White House for more than 40 years. "His hand, thick with veins and knots like the roots of a tree, engulfed mine,"

the President recounted in his memoir, *A Promised Land*. " 'I like to work,' Ed said. 'Getting a little hard on the joints. But I reckon I might stay long as you're here.' "

One of the groundskeepers from the Reagan days, Dale Haney, became the superintendent of the White House grounds in 2008. Throughout his tenure, Dale (seen in the blue jacket with folded arms in the photo at right) has also been the go-to person for taking care of the presidential dog(s) since the Nixon administration (Trump did not have a dog). If Bo and Sunny were not hitching a ride with one of the other groundskeepers (above), they could usually be found with Dale.

The American beech tree at right, planted before 1900, collapsed during a storm in 2015. The groundskeepers were nice enough to cut a slab of the trunk for me as a souvenir.

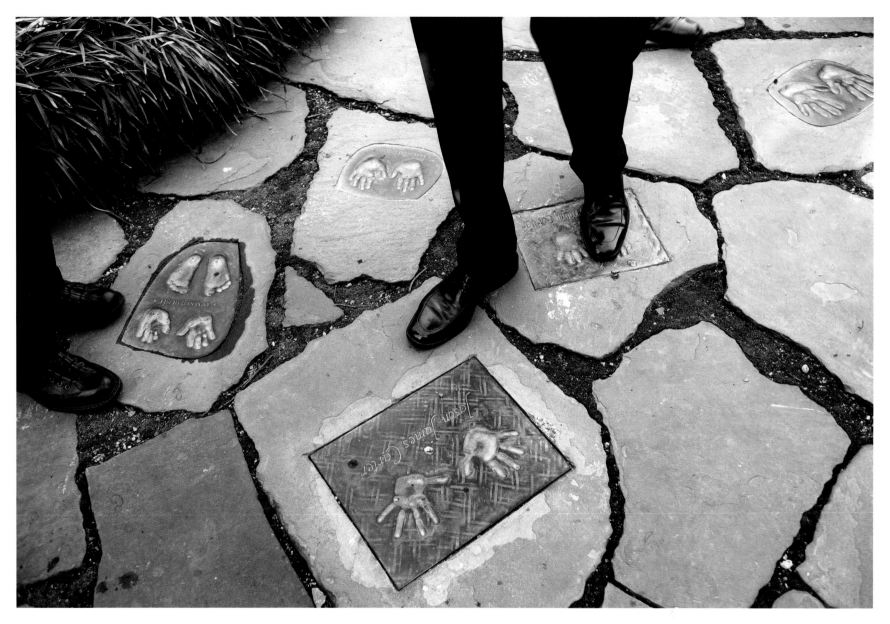

The President walks in the little-known Children's Garden near the tennis court, which was established by First Lady Lady Bird Johnson in 1969. Since then, 19 presidential grandchildren have pressed their handprints and footprints into clay that was then cast in bronze and embedded in the flagstone paths.

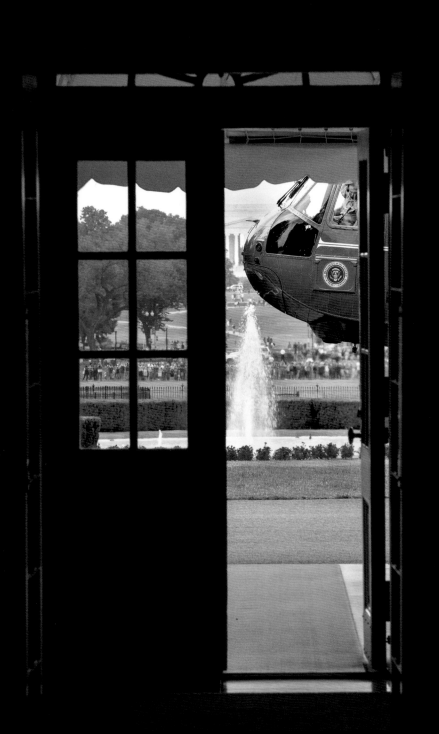

Near right: Framed through the doorway of the Diplomatic Reception Room, *Marine One* lands on the South Lawn before transporting the President to Joint Base Andrews, where he boarded *Air Force One* en route to Joplin, Missouri, following a devastating EF5 tornado that killed more than 150 people in 2011.

Far right: Marine One kicks up snow upon landing on the South Lawn in 2017.

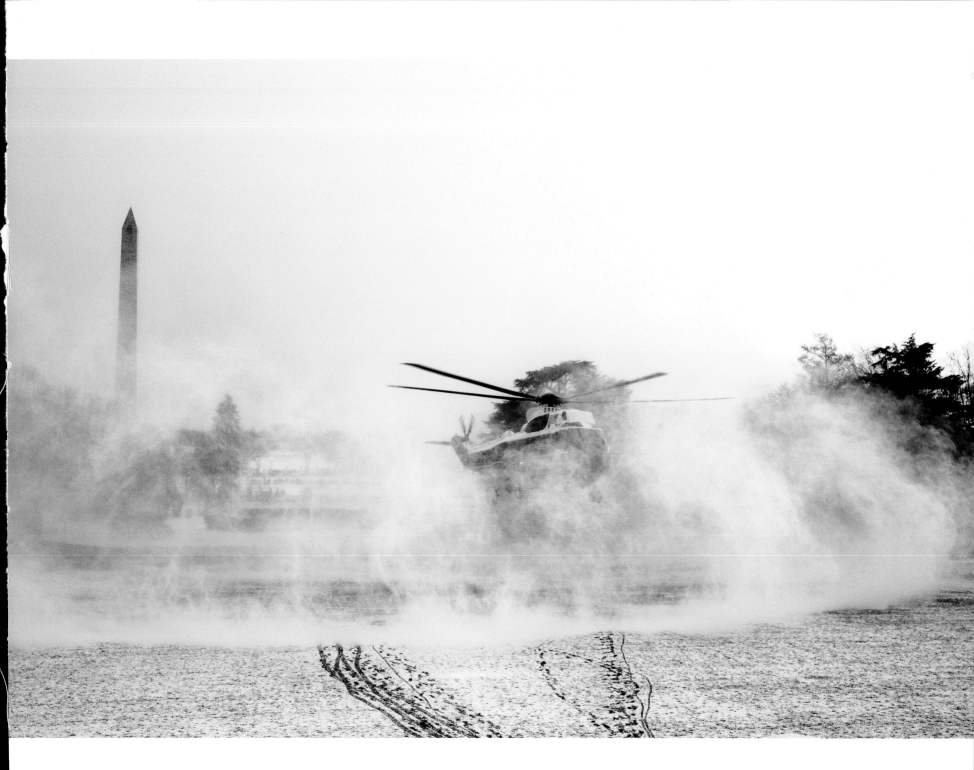

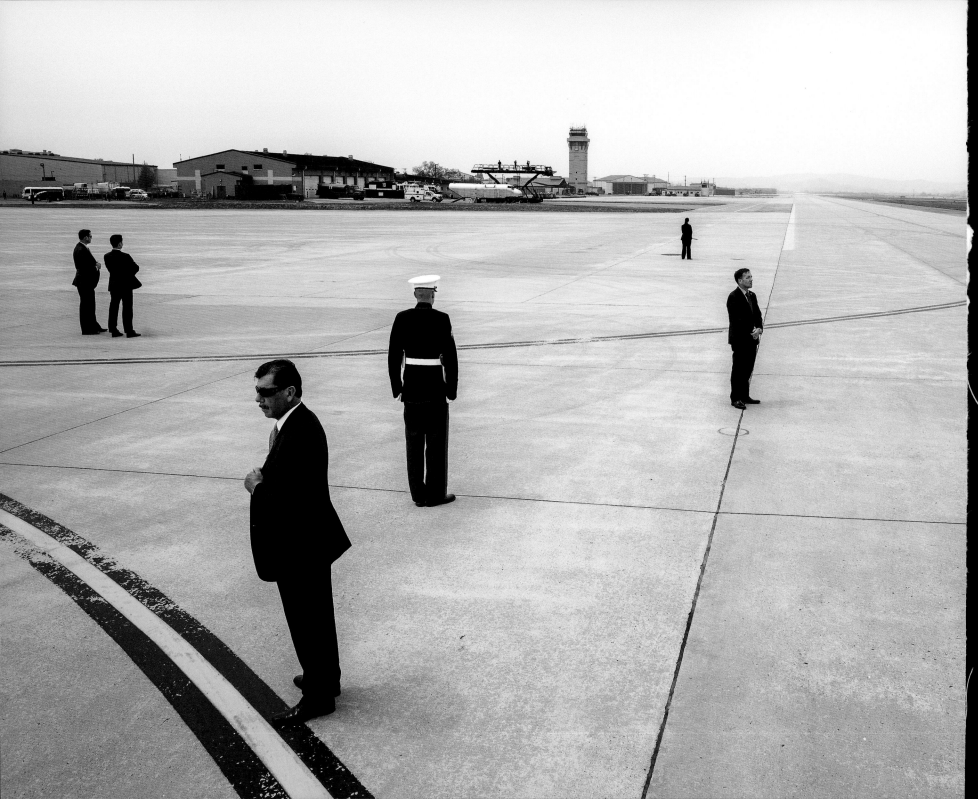

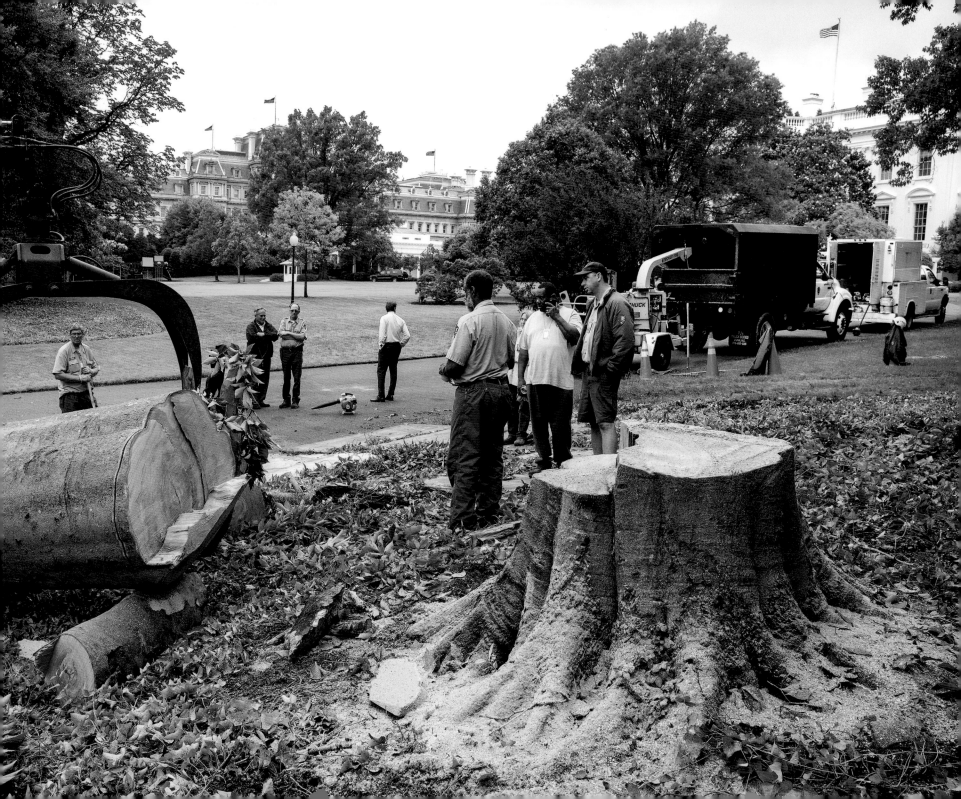

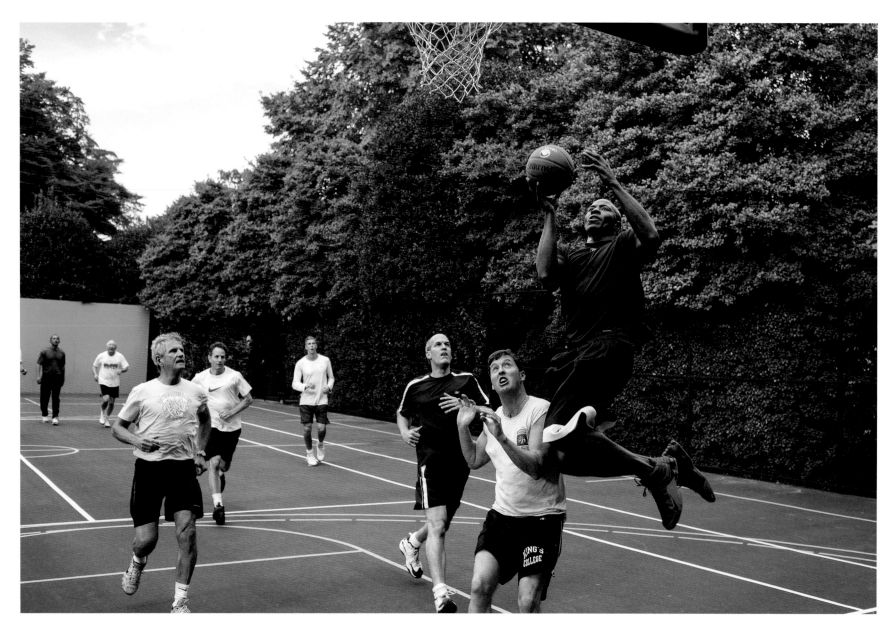

Reggie Love shoots a layup during a basketball game with White House staff, Cabinet secretaries, and members of Congress in 2009. President Obama had the White House tennis court adapted so it could be used for both tennis and basketball.

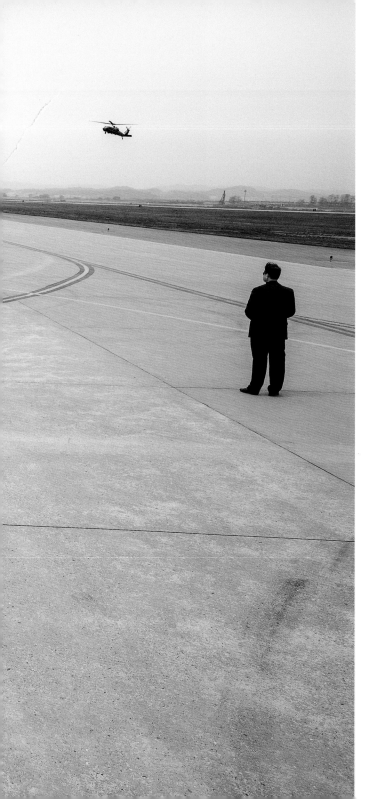

ON THE ROAD

People often ask me if I miss working at the White House. The answer is not really; the 24/7/365 aspect of the job took its toll on me. But I do miss traveling with the presidential entourage: not only visiting places that I never would have seen otherwise, but the ease of getting there. During the Obama administration, we traveled to all 50 states and more than 75 countries. I never once had to go through TSA security at the airport. I'd board the helicopter on the South Lawn of the White House, fly to Joint Base Andrews, then board *Air Force One*.

Wherever we landed, I'd jump in the motorcade and off we'd go. We never encountered any traffic, thanks to local police officials blocking off all intersections along the route. Meanwhile, the luggage I had dropped at the White House in the morning magically appeared in my hotel room that evening.

When we were traveling overseas, I'd joke that I never saw my passport for eight years. Which was true, and not a joke. Someone from the State Department traveled with us, and he or she took care of our visas, and everyone's entries into other countries. At left, *Marine One* lands at Osan Air Base, Republic of Korea, in 2014. Traveling home was just as logistically easy in reverse. Suffice it to say, it's not like this when I travel anymore.

AIR FORCE ONE

My best memory of the presidential plane? *Air Force One* had the sweetest grapes. The red ones. They had green ones, too, but I could never understand why other staff members aboard ate the green ones. The red ones were the best.

Franklin D. Roosevelt was the first president to fly in a plane. The name *Air Force One* came into use in 1953 during the Eisenhower administration. During the Reagan administration, we flew in a Boeing 707. It wasn't until 1989 that a 747-200B became the new *Air Force One* (there are actually two identical planes). The blue, white, and gold color scheme, designed by Raymond Loewy at the suggestion of First Lady Jackie Kennedy, remained in place, as did the familiar "United States of America" printed in Caslon typeface along the body of the plane.

I first rode on the 747 in 2004. President George W. Bush sent the plane out to California after President Reagan's death, to transport his body to Washington, D.C., where he lay in state at the U.S. Capitol. I was on board because I had been hired as the official photographer for the Reagan funeral.

I was amazed to see the "new" plane. It was seemingly twice as big as the 707, with a massive conference room and large staff cabins. Four of the seats had been removed in the much larger guest cabin to strap down Reagan's casket, covered with an American flag.

During the Obama administration, I circled the globe the equivalent of 58 times aboard *Air Force One*. If I wasn't photographing the President working in his cabin or meeting with his staff, I spent most of my time in the conference room. There we often played the card game Spades on long flights: White House Trip Director Marvin Nicholson and I were partners versus the President and Reggie Love (and later, a rotating cast of other partners when Reggie departed the White House).

Usually, we would be served lunch on a cafeteria-style tray emblazoned with the *Air Force One* seal. After lunch one day in 2015, chief flight attendant Rob Nation came to retrieve my tray but instead only picked up my dirty dish. I didn't quite understand what was happening until I looked down at the tray he had left behind. Printed next to the seal were the words: "Mr. Pete Souza, Commemorating You on Your 1,000th Flight Aboard *Air Force One*." It is my favorite memento from my White House tenure and sits on a shelf above my desk at home.

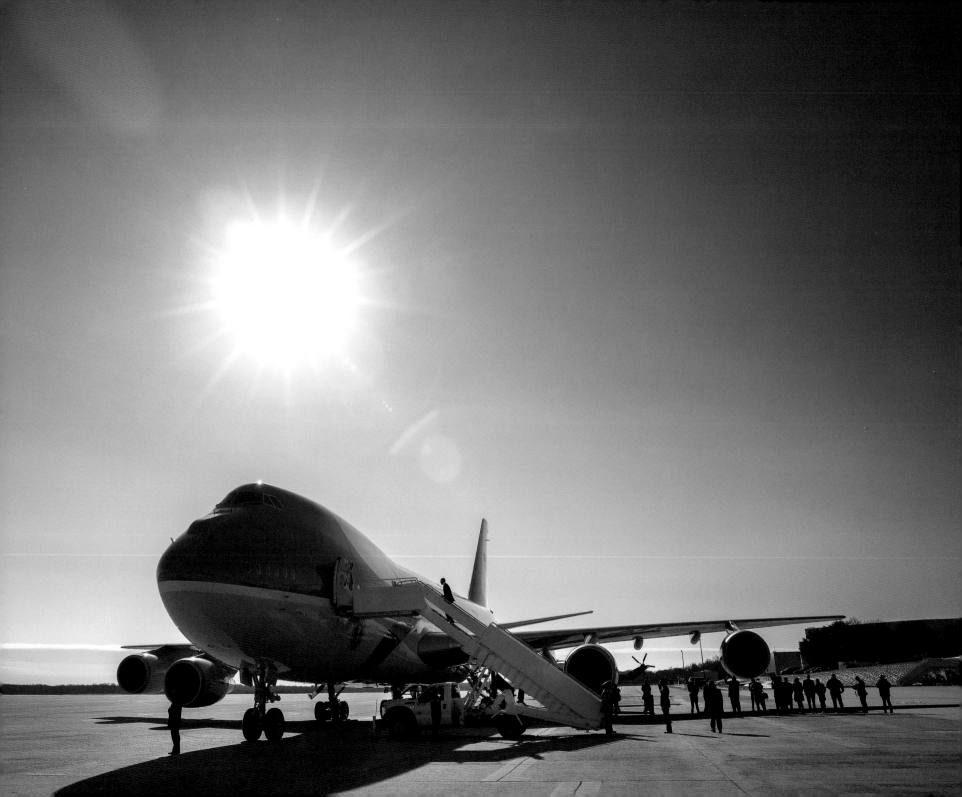

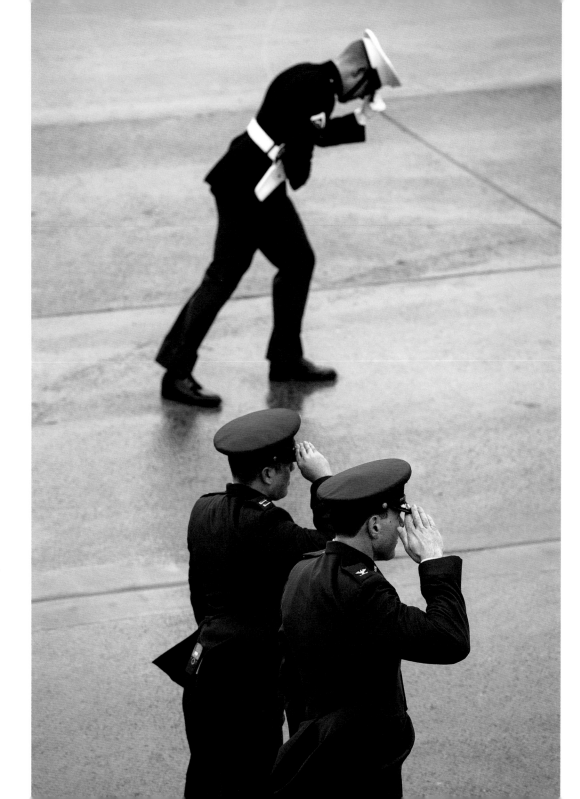

Near right: Air Force personnel salute while a Marine guard holds his cover as *Marine One* lands at Joint Base Andrews in 2009.

Far right: Photographed with a remote GoPro camera, President Obama boards *Air Force One* in 2014.

MILITARY AIDES Each president has five military aides, one from each branch of the service plus the Coast Guard. Serving an average of two years, the military aides are nominated by their respective military branches and then chosen by the White House military office with input from the current aides.

They are probably best known as the carriers of the "football," the presidential emergency satchel that contains authentication codes to authorize a nuclear attack and presidential emergency declarations. The football is ever-present with one of the rotating military aides in the motorcade and aboard *Marine One* and *Air Force One*. Navy military aide Tiffany Hill carries the football and another briefcase off *Marine One* in 2012, above, and a Coast Guard military aide boards *Air Force One* in 2010, at right.

Because President Trump did not attend the inauguration of Joe Biden on January 20, 2021, and was instead already at his Florida club, Mar-a-Lago, news reports indicate two footballs were dispatched that day. Trump's was to be deactivated in Florida at 11:59:59 a.m., one second before Joe Biden was scheduled to be sworn in as President. Because Biden took the oath of office at 11:48 a.m., 12 minutes ahead of schedule, it's unclear when Trump's football was deactivated and Biden's football activated.

The military aides also serve many other functions, both substantive and ceremonial. One aide is dispatched before every presidential trip to coordinate military logistics alongside the advance and Secret Service teams. During formal state arrivals, one of them, in full dress uniform, walks behind the President as he reviews the troops both at home and in foreign countries. At the White House, they are also intricately involved in other events, including Medal of Honor ceremonies.

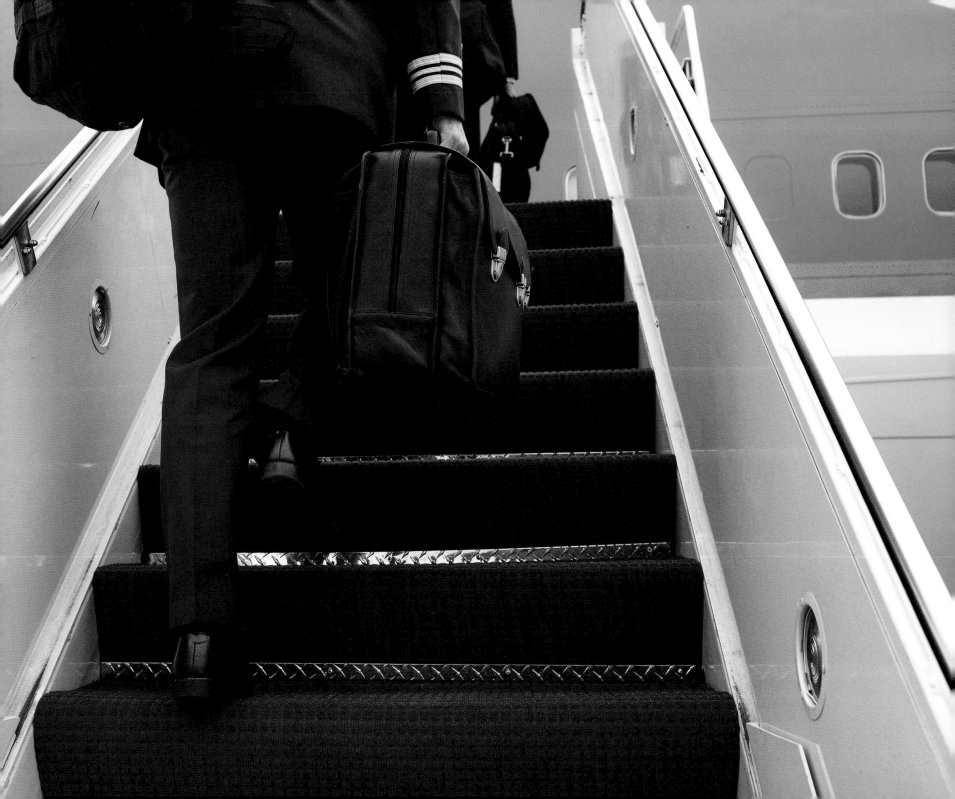

Near right: Ethan Gibbs, son of Press Secretary Robert Gibbs, on his first *Air Force One* flight in 2009.

Far right: Inside the cockpit with the pilots and flight crew in 2014.

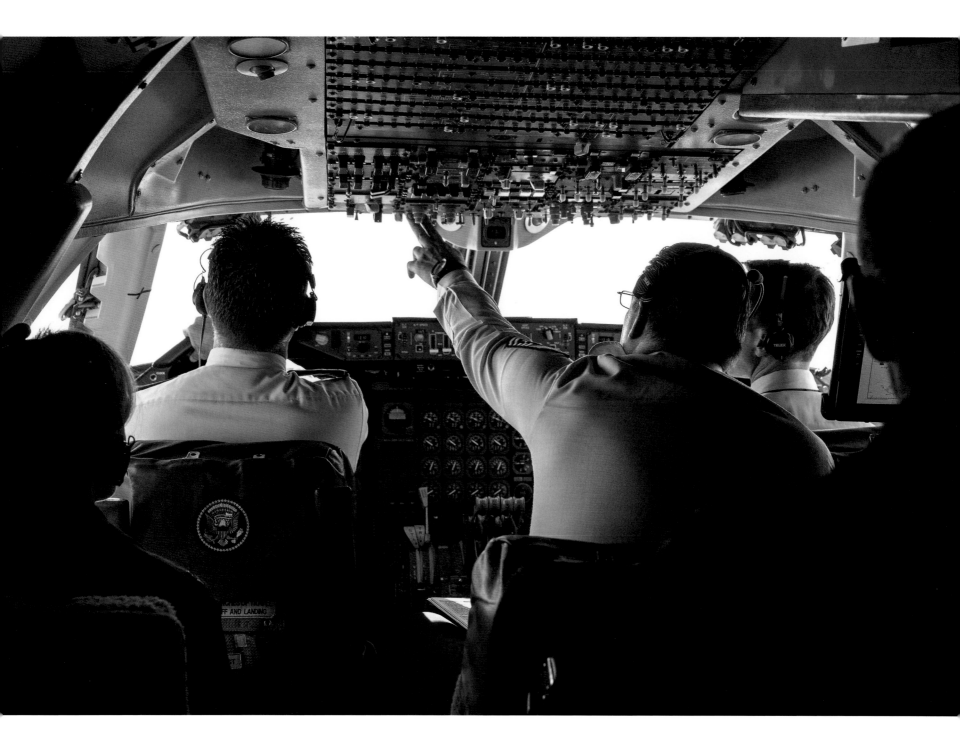

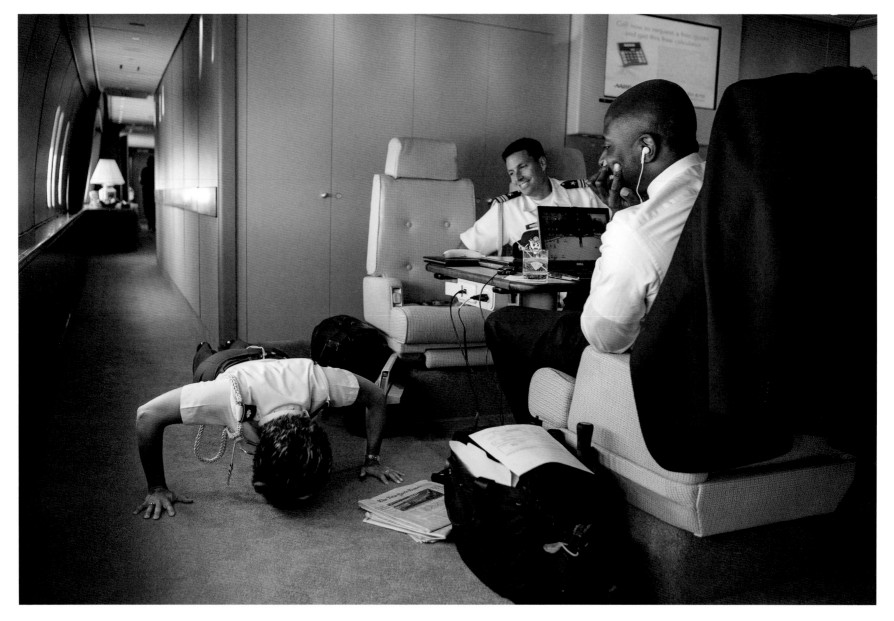

Navy military aide Clay Beers and body man Reggie Love, at right, watch as Air Force military aide Gina Humble does a series of push-ups as a challenge from Reggie in 2009.

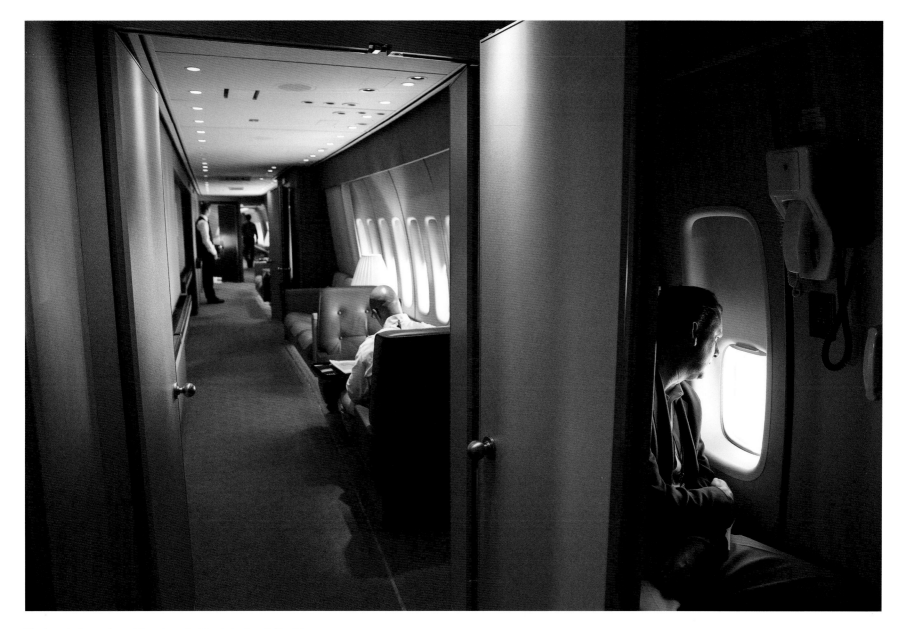

The long hallway aboard the plane that leads to the staff cabins and conference room. The President's cabin is immediately to the left. Marvin Nicholson, at right, is looking out the window of the main exit doorway as we head to Moore, Oklahoma, following an EF5 tornado in 2013.

Members of the White House press pool, who thought *Air Force One* was flying back to Washington following the end of a European trip, listen as White House officials inform them that the plane was instead being diverted for an unannounced trip to Baghdad, Iraq, in 2009.

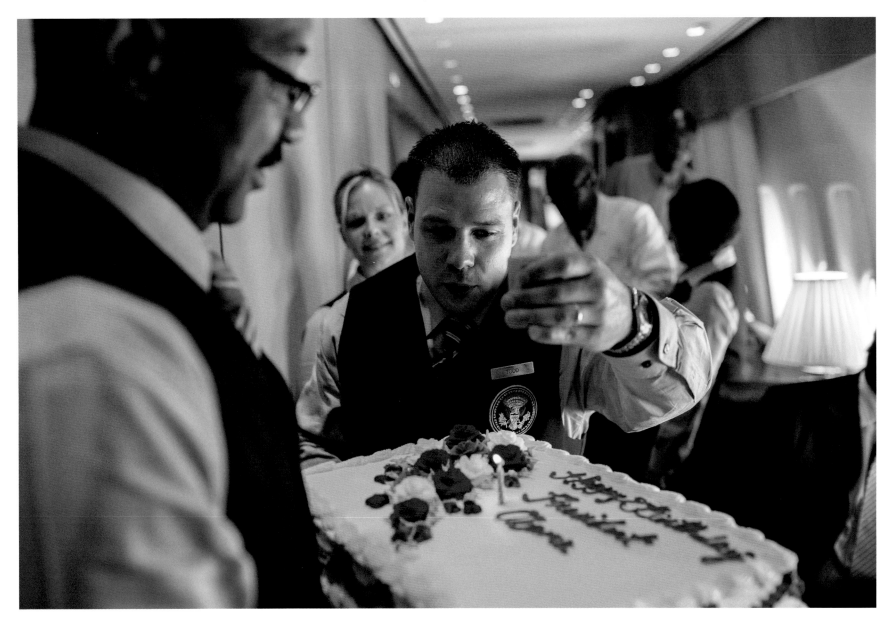

Air Force One flight attendants Reggie Dickson, left, and Todd
Serino light a candle on the President's birthday cake in 2009.

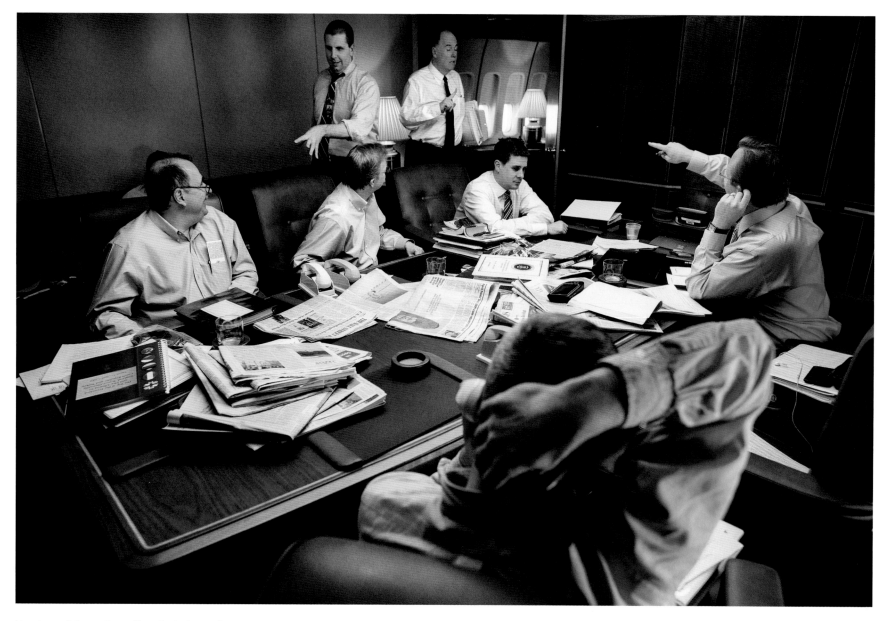

Members of the senior staff confer in the conference room on
President Obama's first official overseas trip in 2009.

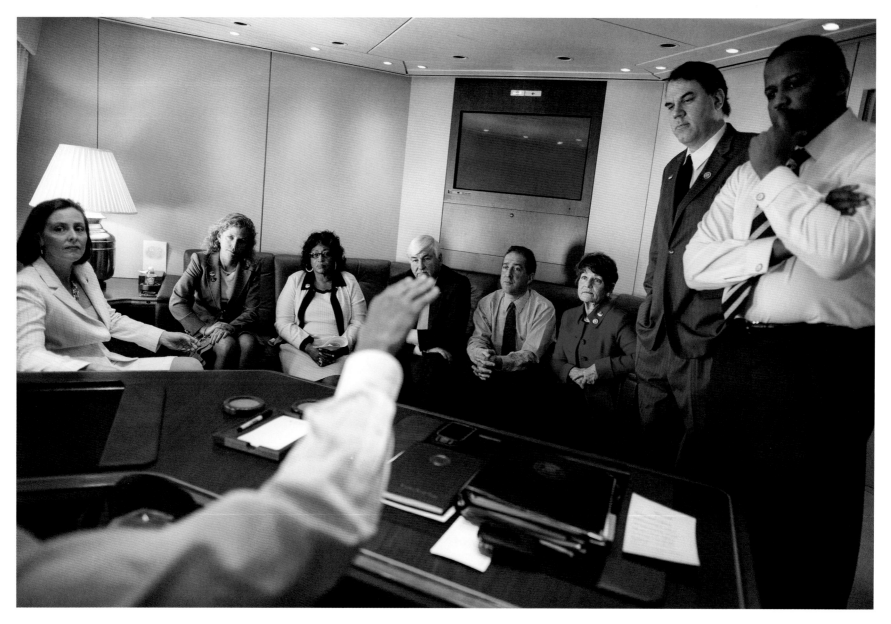

In his office aboard the plane, the President meets with
members of the Florida Congressional delegation as we flew
to Fort Myers in 2009.

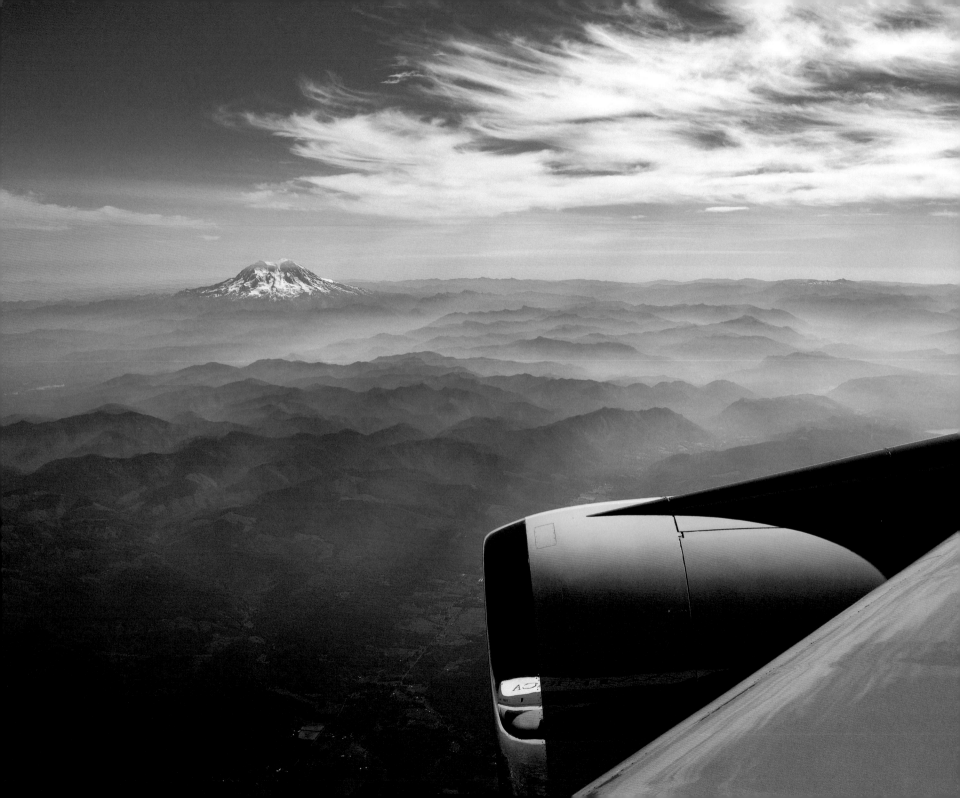

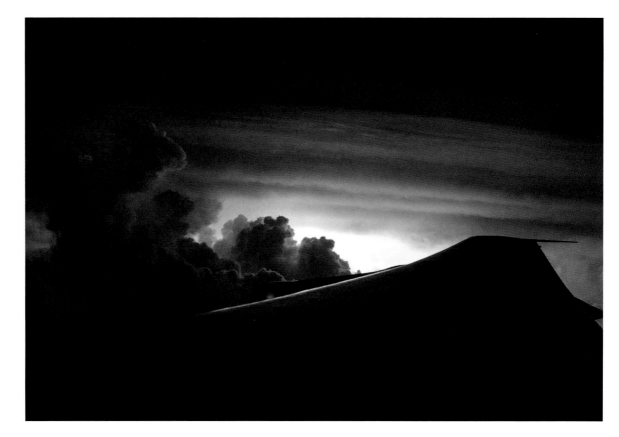

Above: I frequently made photographs out the window of the plane, mostly from the conference room. While almost everyone was asleep flying home from Argentina in 2016, I managed to capture a lightning bolt lighting up the clouds and the edge of the starboard wing during a thunderstorm over Bolivia.

Left: A view of Mount Rainier as we flew from Los Angeles to Seattle in 2010.

Above: Landing in Amsterdam, the Netherlands, in 2014.

Right: A red carpet is ready to be unfurled for the President's arrival in Phnom Penh, Cambodia, in 2012. I would usually deplane from the rear exit along with the Secret Service agents so I could be in position to photograph the President when he deplaned and whatever arrival ceremony was planned.

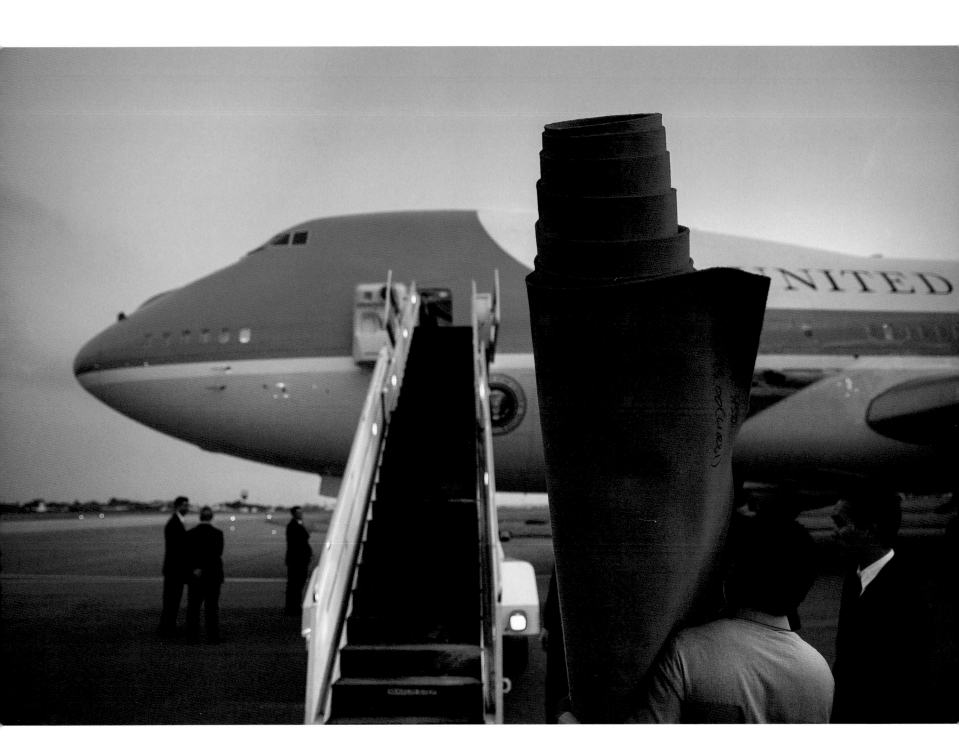

THE TRAVELING WHITE HOUSE STAFF

Imagine forklifting the working White House and dropping it onto a cargo plane along with the presidential "Beast" (the official state car) and backup limousine and helicopters. Add all the other support personnel and equipment to the mix. Then organize all this with the Secret Service and military offices, along with arranging the departure and arrival timing of not only *Air Force One* and *Marine One* but of all the planes and helicopters involved in a presidential trip. It's a giant undertaking . . . on every trip.

Now imagine being the person who has to coordinate all of this. Meet the deputy chief of staff (DCOS) for operations. For four years, that was Alyssa Mastromonaco, pictured at left. I first met Alyssa when she worked for then-Senator Barack Obama, and I was photographing him for the *Chicago Tribune*. I remember asking someone at the time what her job was in the Senator's office. "Alyssa gets shit done," someone responded.

Alyssa was preceded as DCOS for operations by Jim Messina, and succeeded by Anita Decker Breckenridge, who both deserve as much praise as Alyssa for making the ship run efficiently and on time. To be fair, the DCOS for operations did delegate many logistical details to our incredible scheduling and advance teams. But if something went wrong, guess who got called? (Above, advance lead Michael Ruemmler and Reggie Love eavesdrop toward the end of the President's meeting in London with President Hu Jintao of China in 2009.)

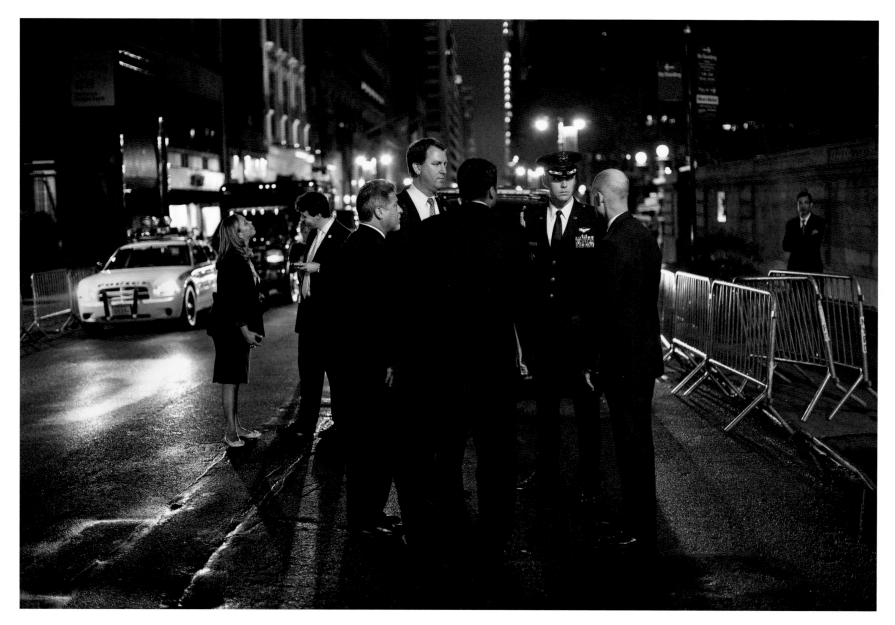

Outside the United Nations General Assembly reception in
New York City in 2011, Secret Service agents confer with the
military aide and White House staff about the logistics of the next
motorcade movement because of a change in the schedule.

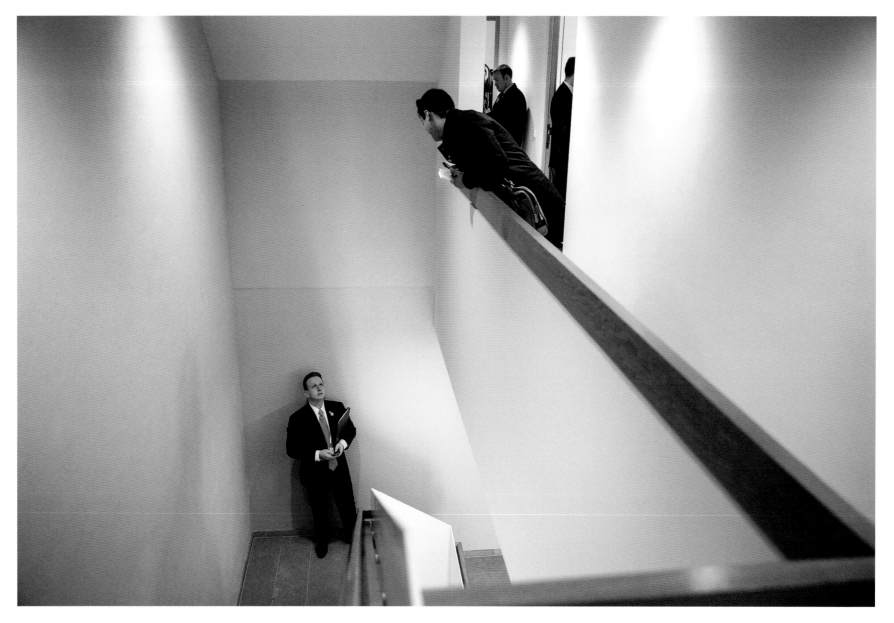

At Schloss Herrenhausen in Hannover, Germany, advance lead Duncan Teater leans over a railing to consult with State Department protocol officer David Solomon while the President met with Chancellor Angela Merkel in 2015. White House advance staffers work closely with the State Department protocol officers to plan logistics on all overseas trips.

ADVANCE LEADS The White House Office of Scheduling and Advance is responsible for the forward planning of all presidential trips. An advance team, headed by an advance lead, is dispatched five to ten days in advance to plan all the on-the-ground logistics of each domestic trip, coordinating with the Secret Service and others. For foreign trips, which were far more complicated than domestic trips, the advance team would be dispatched upward of two weeks ahead. If we were traveling to five different cities abroad, five different advance teams would be dispatched.

Once the President arrived, the advance lead would be right beside him for the remainder of the trip. Some of them were on the White House staff, but others were employed elsewhere and would volunteer to do advance trips.

Nora Cohen Brown, one of our staff advance leads, is shown above braving the splashes of cold water during our boat trip through Kenai Fjords National Park in Alaska in 2015. "Being an advance lead was like having ten different jobs at once," she remembers. "On a given day, I would lead a complex diplomatic negotiation, design a compelling backdrop, coordinate security and attendee logistics, and finalize contingency plans for every possible scenario before meeting the President and traveling team at the airport. It was a high-pressure job, but it was incredibly rewarding to pull off the impossible with our amazing team, and to experience the impact that a presidential visit could have on the public in each host country or town."

Another was Maju Varghese, foreground at right, who is holding on from the force of *Marine One* as it came in to land at the Wall Street landing zone in New York City in 2011. Maju later became assistant to the President for management and administration in the Obama White House, and served as director of the Military Office during the first year of the Biden White House.

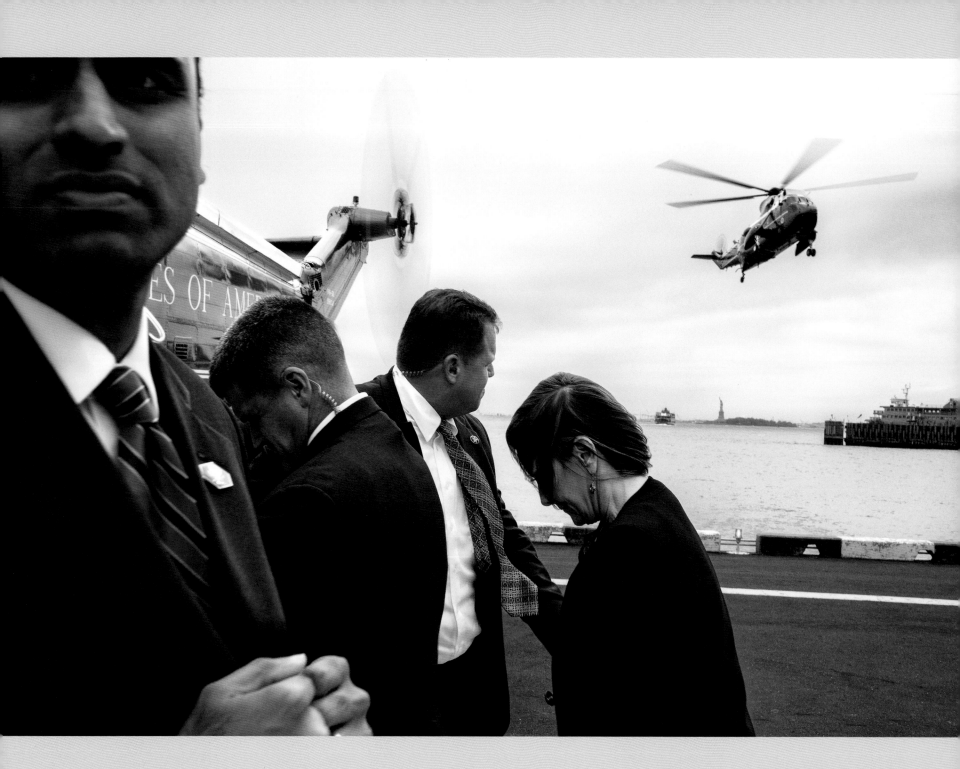

Advance staffer Brandon Lepow acts as a human barrier for the White House press corps as they record the President's visit with a middle-class family in their living room in Seattle in 2010. Brandon later became a regional communications director. In 2013, he was diagnosed with T-cell acute lymphoblastic leukemia in the midst of planning his wedding. The entire staff mourned his death in 2015 after his two-year battle. "Like a lot of young people, Brandon Lepow got into politics because he believed he could change his country for the better," President Obama wrote in a statement at the time. He recalled Brandon as "hardworking, cheerful, one of the most unfailingly kind and gracious people I've had the honor to know. He was someone that any American could be proud to have working on their behalf."

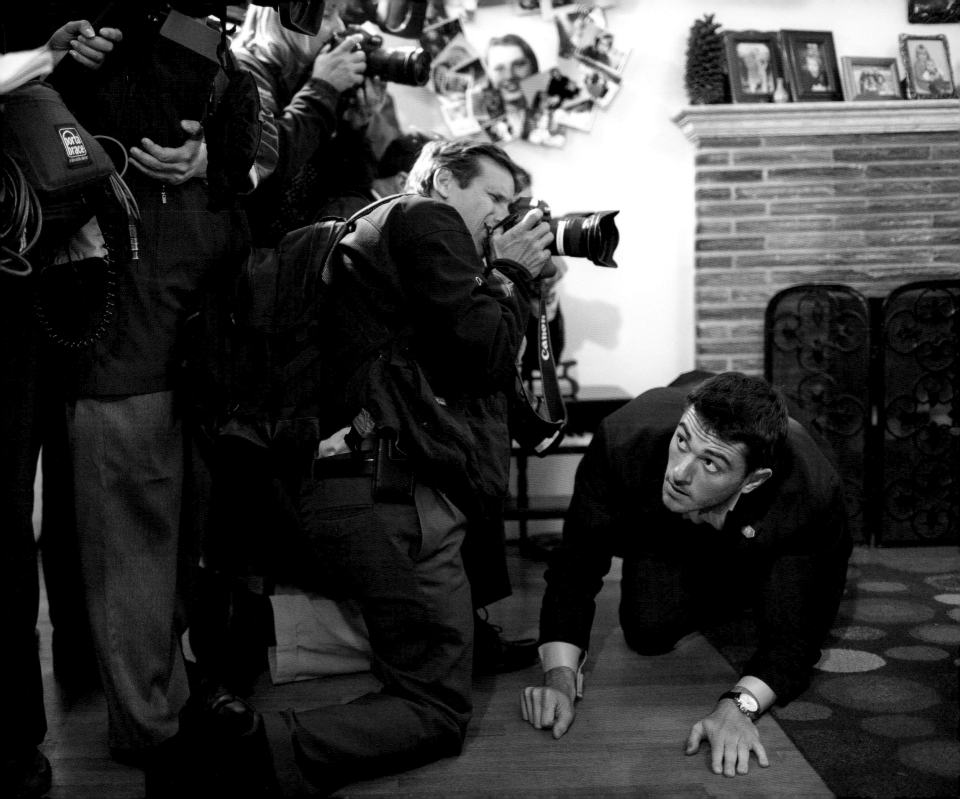

Near left: Members of the audience are mirrored in the teleprompter at Veteran's Memorial Park in Manchester, New Hampshire, in 2012.

Far left: Teleprompter operators from the White House Communications Agency backstage at Georgetown University during the President's speech about energy security in 2011.

Translated, these signs during an event at a Chrysler auto
plant in Detroit in 2010 meant: "Don't step over the red line or
you'll be in the background of the television shot."

The scene inside Elm Street Middle School in Nashua,
New Hampshire, as the President was introduced
at a grassroots event in 2012.

Chief speechwriter Jon Favreau catches up on work in an
early education program classroom as the President
held a roundtable discussion at Guilford Technical Community
College in Jamestown, North Carolina, in 2011.

A common scene during a presidential visit on the road: staff looking at their BlackBerrys or talking on their cell phones in a back hallway at the Cincinnati Music Hall in Cincinnati, Ohio, in 2012.

BODY MAN One of the President's personal aides is referred to as the "body man." On the road he (or she) is the assistant who is always at the ready to provide the President with his speech cards, signing pen, Sharpie, tea, protein bar, coat, and hand sanitizer. During the early years of the Obama administration, the body man was Reggie Love, above and at right with Marvin Nicholson, the trip director. When Reggie departed the White House, Marvin served for a while in the dual role of trip director and body man. He was succeeded as body man by Joe Paulsen for the last few years.

The body man was also the keeper of the President's BlackBerry, and later his iPad. Reggie seemingly always had anything the President could possibly need in his over-the-shoulder bag, which I thought weighed more than the military aides' football that carried the nuclear codes. If the President had ever asked Reggie for the kitchen sink, I was convinced he'd pull one out of his bag.

One of his tasks when we arrived at an airport after finishing a trip was to make sure the President hadn't left any briefing papers or other personal items in the Beast before we boarded the plane. On these return flights, we would often play Spades in the conference room. In the middle of one card game, 35,000 feet in the air, the President said to Reggie, "Hey, do you have my iPad?" Right away, I could tell from Reggie's reaction that the iPad was still in the back seat of the Beast, which was probably being wheeled onto a cargo plane to go wherever the President was headed next.

In my role, staying in touch with the body man was key to getting a heads-up, especially on weekends, about things that weren't necessarily on any schedule.

Above: Reggie Love in a holding room at the United Nations Climate Change Conference in Copenhagen, Denmark, in 2009. We were all constantly jet-lagged on foreign trips, so it wasn't unusual to see someone taking a nap wherever they could.

Right: Waiters watch in amusement as contractors repair an electronic connection during the Heads of Delegations working dinner at the Nuclear Security Summit in Washington, D.C., in 2010. I often hung around backstage while the leaders ate during summit meetings. At the G20 Summit in Pittsburgh in 2009, I was in the kitchen where the food was being prepared when Prime Minister Silvio Berlusconi of Italy walked in. He looked at me and asked, "Whisky?"

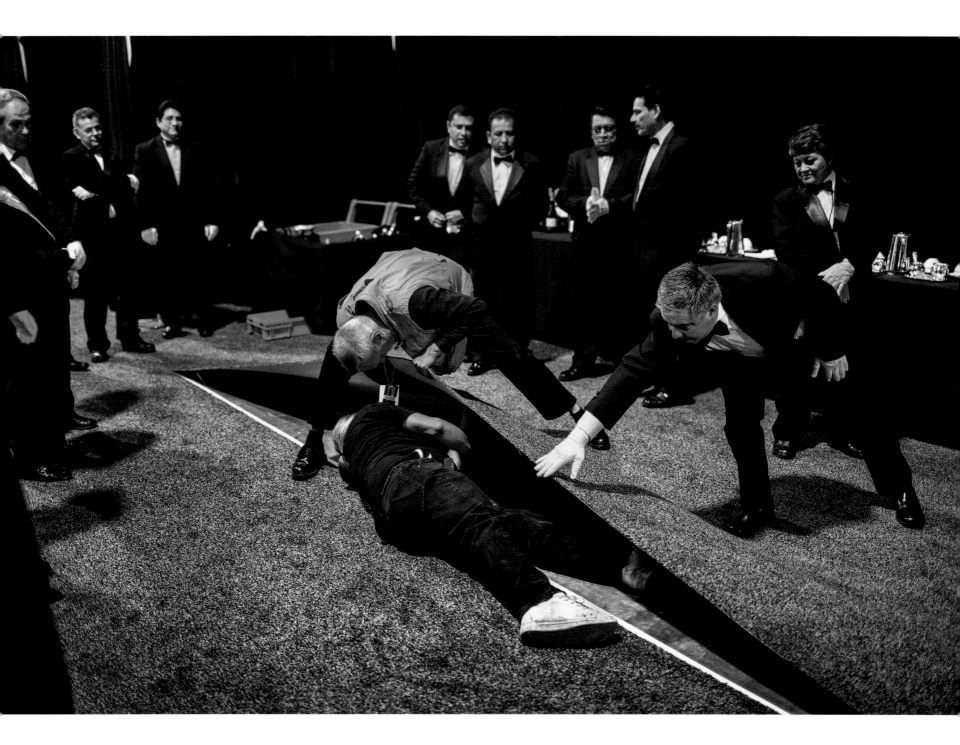

Above: Senior advisor Valerie Jarrett exits a loading dock after a campaign event in Seattle in 2012. Though the presidential limousine was parked inside, the remainder of the motorcade was lined up on a street outside.

Right: Staff members riding in the support vehicle in the motorcade wear football helmets that the President was gifted after visiting the Riddell manufacturing facility in Elyria, Ohio, in 2010.

MARINE ONE AND THE NIGHTHAWKS

Dwight D. Eisenhower was the first president to use a helicopter, in 1957, for transport from Washington, D.C., to his summer home in Rhode Island. After it was deemed safe to land and take off from the South Lawn, Eisenhower departed on a two-passenger H-13J Bell helicopter from the White House grounds on July 12, 1957, for the 57-minute flight to Camp David in Maryland.

Initially the helicopter squadron was a shared function between the U.S. Army and Marine Corps. In 1976, the Marine Corps became the sole military branch providing helicopter support for the President. Since then, whichever helicopter transports the President of the United States has the call sign "Marine One." The squadron is referred to as HMX-1, for Marine Helicopter Squadron One. It also supports the Vice President, heads of state who are visiting the United States, and Department of Defense officials.

During the Obama administration, we flew in a Sikorsky VH-3D Sea King. For longer range flights, we would fly in a Sikorsky VH-60N White Hawk. We often referred to them as the "white tops" because of their dark green livery with white paint on top of the aircraft. Both helicopters were quiet enough that we could converse with other passengers without using headphones, though talking louder than normal was necessary. Adjacent to where the President sat was a tray full of snacks that I don't remember him ever indulging in. Also on the tray was a deck of playing cards with the *Marine One* emblem, which his body man or myself would often snatch for our Spades games on *Air Force One*.

In addition to the Marine pilot, copilot, and crew chief, there were a handful of passengers besides the President, including the military aide (with the football), White House doctor, body man, Secret Service agents, and members of the senior staff. At least 50 percent of the time, I was manifested on *Marine One* when departing the White House for Joint Base Andrews, depending on which senior staff were traveling. If we were using helicopters outside Washington, I would almost always be manifested on *Marine One* so I could take pictures of the President with his special guests like governors, mayors, or the Federal Emergency Management Agency administrator (during natural disasters).

If I wasn't on *Marine One*, I would be manifested on *Nighthawk Two*, which was the same type of helicopter, and flew in tandem with *Marine One*. Other passengers on *Nighthawk Two* included several Secret Service agents, a White House nurse, a representative from the White House Communications Agency, and the lead advance person.

Other support helicopters were usually V-22 Ospreys. They were much louder for the passengers, requiring earplugs if you cared about your hearing.

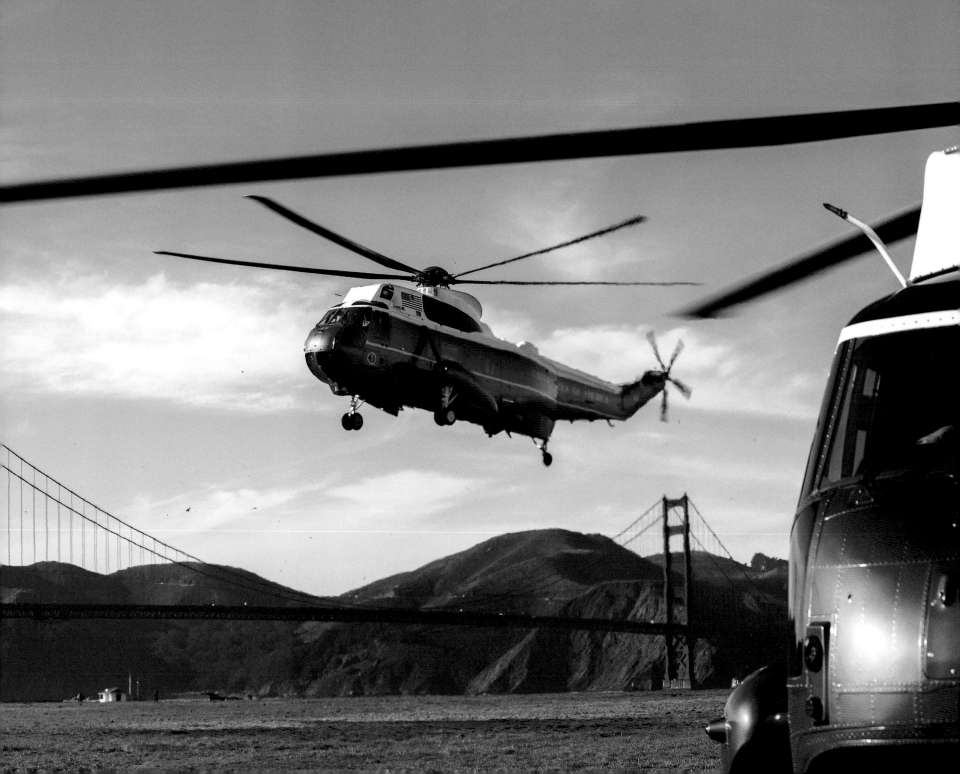

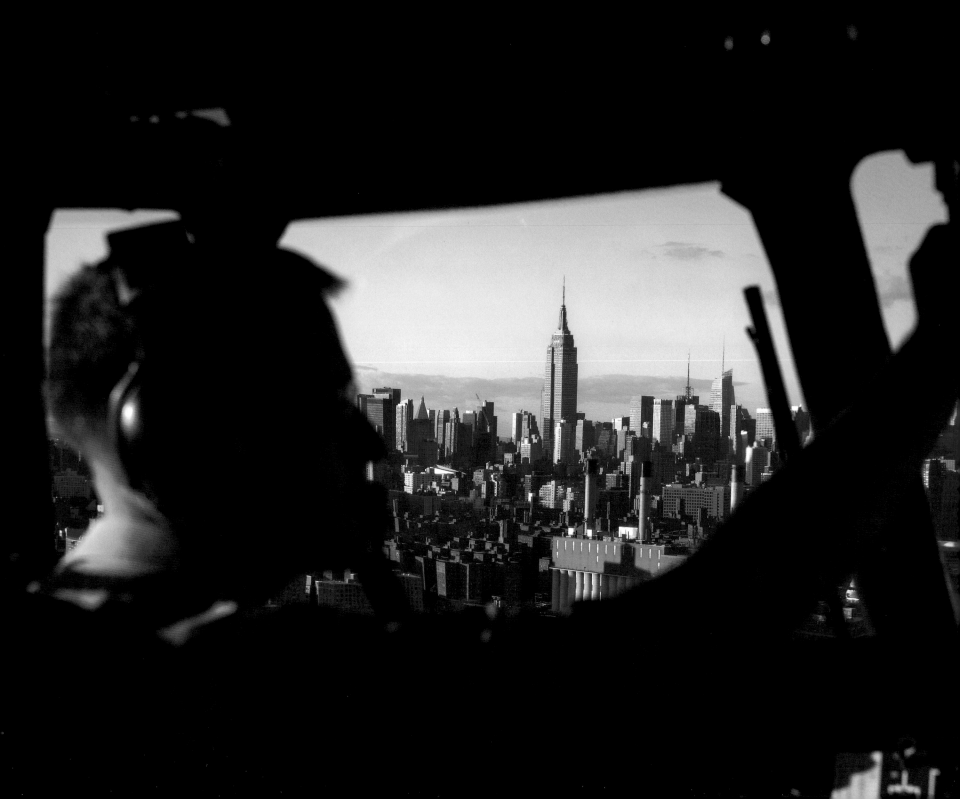

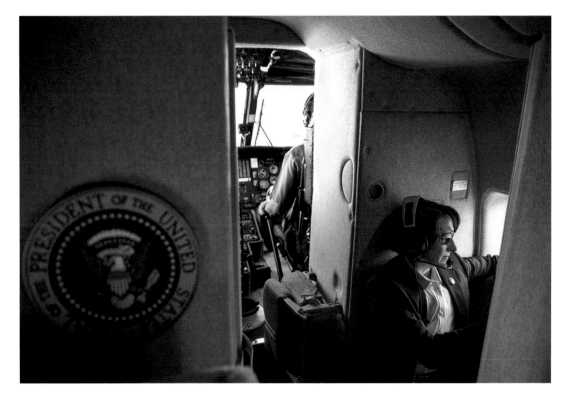

Above: Secret Service agent Leslie Pichon aboard *Marine One* in 2013.

Left: Inside the cockpit of *Marine One* over New York City in 2013.

Personal aide Joe Paulsen catches up on email aboard *Marine One* during a flight in Los Angeles in 2015. We usually flew at such a low altitude that we often had a cell signal. I once watched part of a Red Sox playoff game on my personal iPhone aboard the helicopter.

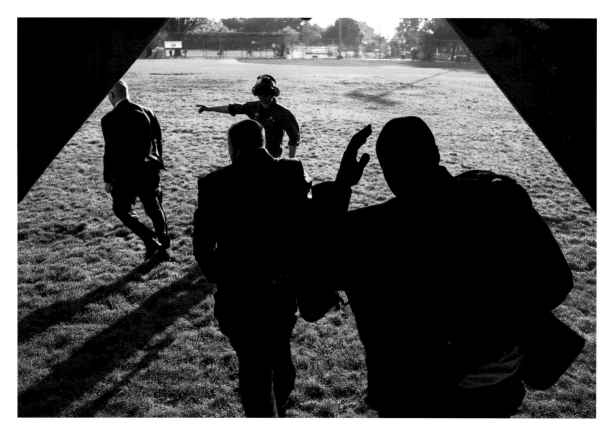

Above: Passengers disembark from *Nighthawk Three* in Los Angeles in 2009.

Right: Secret Service agents position themselves as *Marine One* lands on the lawn at Winfield House, the residence for the U.S. ambassador, in London in 2009.

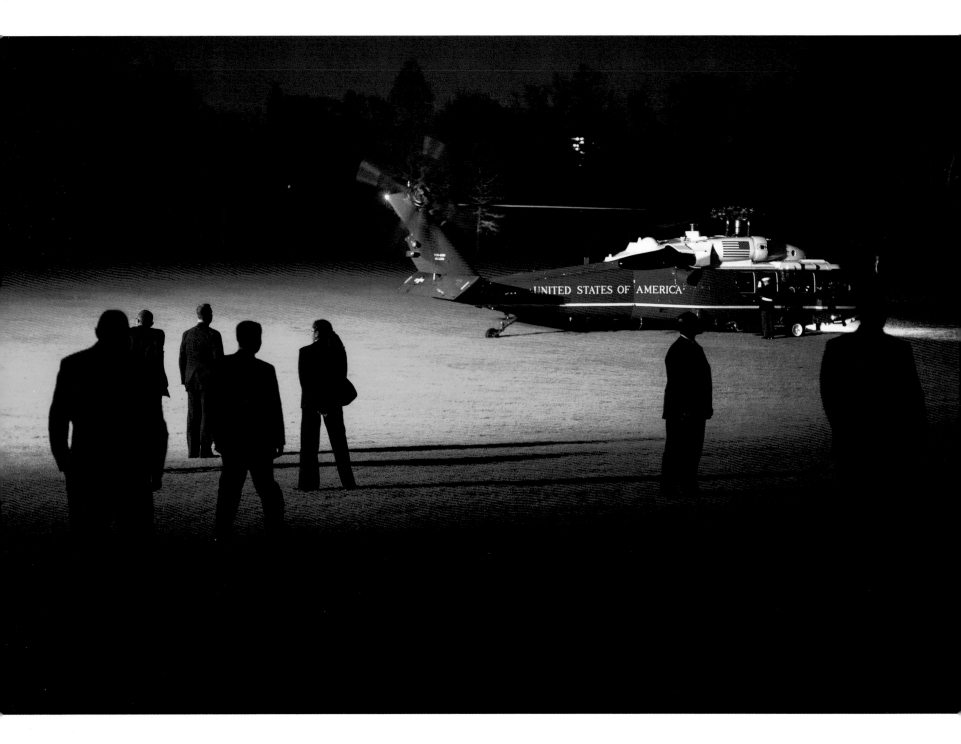

THE PROTECTIVE BUBBLE

For the Secret Service, protecting the President inside the White House is somewhat routine. Not so on the road. Every trip has its own unique security challenges. It certainly must be on every agent's mind that every assassination or direct assassination attempt on a president has happened when the president was away from the White House. (There was also an assassination attempt across the street from the White House when President Harry S. Truman was living at Blair House during the White House reconstruction from 1948 to 1952.)

In addition to the President's detail (the agents specifically assigned to protect him), dozens of additional agents are called in from field offices across the country to support a presidential visit. Like the White House staff advance personnel, the Secret Service sends a team days and sometimes weeks in advance to where the President is traveling to plan the protective bubble as best they can.

At right, special agent in charge Rob Buster has his eye on the President while bystanders (who had all been screened by the Secret Service) attempt to catch a glimpse of him inside The Buff Restaurant in Boulder, Colorado, in 2012.

At one campaign rally, I noticed what I thought was a suspicious man standing in the front row. When others beside him reacted jubilantly to the President's speech, his mind seemed focused elsewhere. Something seemed off. I knew after the speech that the President would greet people along the rope line, including this guy. So I thought it was my duty to mention it to one of Rob Buster's deputies. One of the agents had spotted the guy as well, and they were keeping "eyes" on him. Turns out the guy had a complete personality change, smiling and exuberant, as the President shook his hand along the rope line.

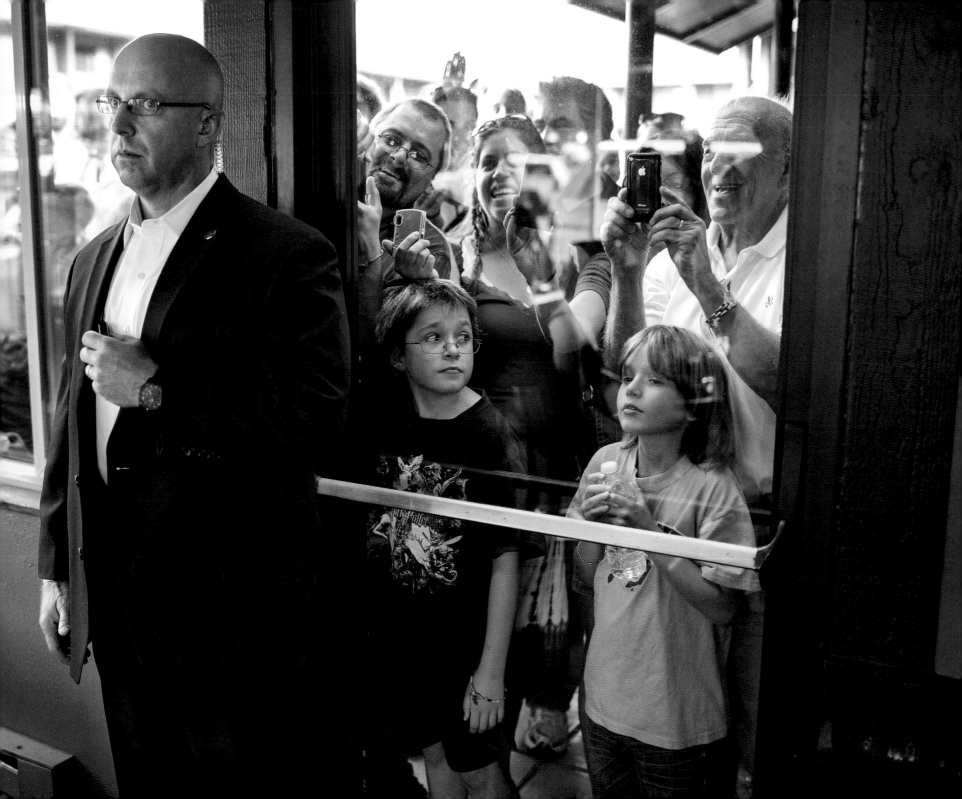

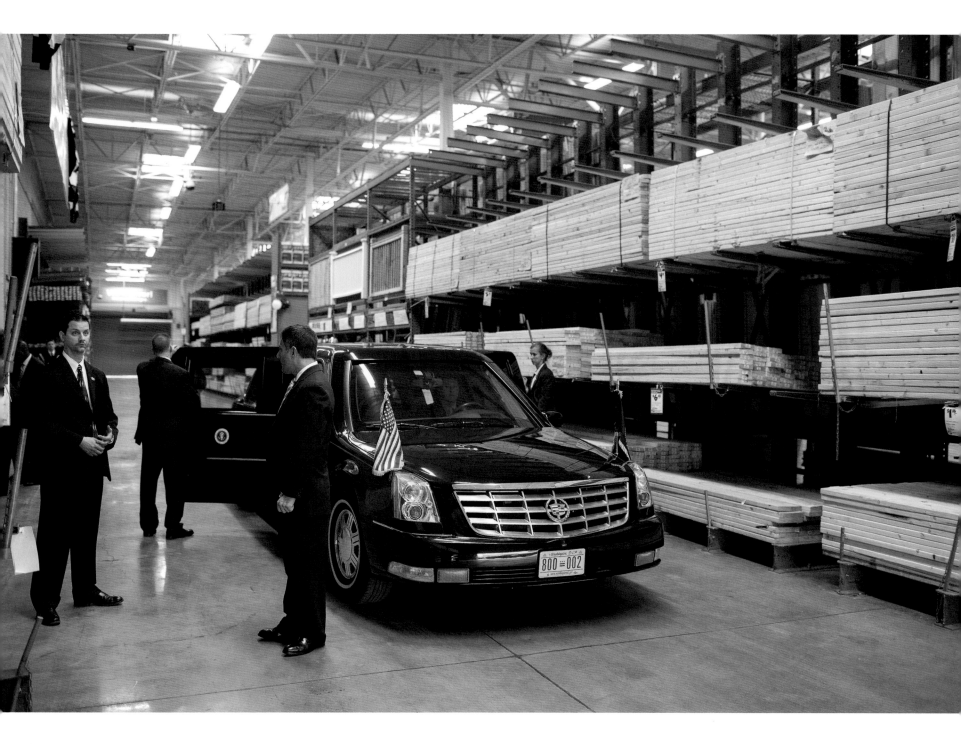

Above: An agent stands post during the President's tour of Chesapeake Machine Company in Baltimore, Maryland, in 2010.

Left: The Beast arrives at a Home Depot in Alexandria, Virginia, where the President held a roundtable on home improvements and energy savings in 2009.

Agents in Los Banos, California, during the President's remarks in 2014 about the California drought.

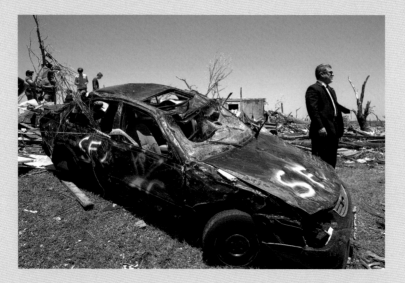

SPECIAL AGENT IN CHARGE OF PPD Like the military, the Secret Service has its own unique acronyms. The SAIC (pronounced "sack") of PPD is the special agent in charge of the Presidential Protective Division of the Secret Service. In recent years, the SAIC usually served in this position for two to three years. The SAIC is the person you will usually see behind the President when he's on the road. As his title indicates, he is the boss of all the agents who protect the President.

I'm proud to say that I've worked alongside six SAICs of PPD during my two tenures at the White House. While each had different personalities, they all had one mission in mind: keep the President safe. Inevitably some agents on the daily shift eventually are elevated to become a SAIC for a subsequent president.

Joe Clancy, at right opening the door of the Beast at Joint Base Andrews, was the first SAIC of PPD during the Obama administration and became a good friend. He was succeeded by Vic Erevia, shown above during the President's stop in Joplin, Missouri, after the devastating EF5 tornado in 2011 that killed more than 150 people. I still keep in touch with Vic today. (The two succeeding SAICS, Rob Buster and Mike White, are featured in other pictures in this section.)

During my tenure in the Reagan administration, which began in 1983, the SAICs were Bobby DeProspero and, later, Ray Shaddick. When Reagan was shot in 1981, Ray—then one of the deputies—had helped Jerry Parr, the SAIC at the time, push Reagan into the limo as the shots were being fired. Ray was then sent to head the Secret Service field office in Honolulu and returned to PPD a few years later as the SAIC.

Secret Service agents and Turkish security surround the
Beast in Ankara, Turkey, in 2009. David Chao, facing forward,
served as the first SAIC for Joe Biden's presidential detail.

Agent Mike White looks back to the doorway as the President boards the Beast in an underground parking garage at the Okura Hotel in Tokyo, Japan, in 2009. Mike became the SAIC for the President's detail in 2016.

Agent Marcus Snipe on a golf course in Scottsdale, Arizona, in 2009.

An agent stands post on a golf course in Kailua, Hawaii, in 2011.

Above: Agents keep close to the President as he greets event attendees along a rope line at Broughton High School in Raleigh, North Carolina, in 2009.

Left: With high-powered binoculars, an agent monitors the outlying boundaries of an event in Capitol Square in Concord, New Hampshire, in 2012.

SAIC Joe Clancy signals a thumbs-up to Secret Service advance agents after the President boarded *Air Force One* at Dane County Regional Airport in Madison, Wisconsin, in 2010. I could always sense it must have been a relief for the agents every time there was a presidential trip without a security incident.

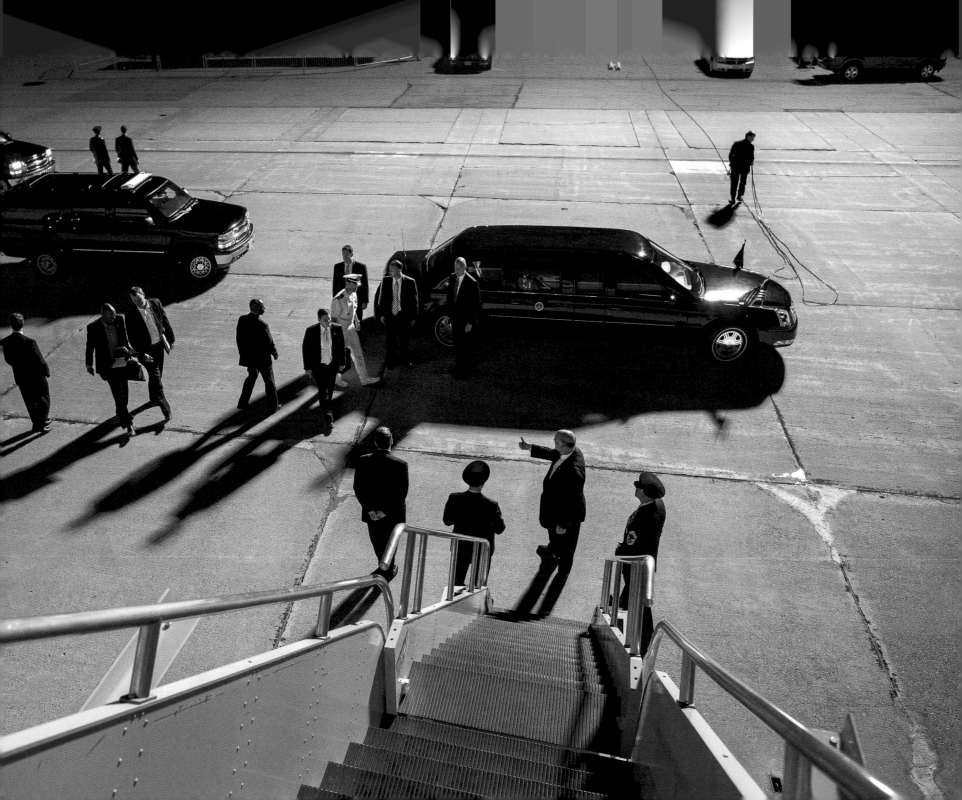

THE SPARE

The presidential limousine is nicknamed the Beast. I rode in an identical vehicle that was positioned in the motorcade just in front of, or sometimes behind, the Beast. It was called the Spare, because it also served as the backup vehicle for the President if there was a mechanical problem with his Cadillac limousine, which had bulletproof windows and five-inch-thick military-grade armor. Above, PPD Secret Service agent Colin Johnson (who tragically died from cancer in 2018) holds open the door of the Spare.

For the last five years of the Obama administration, my seat in the Spare was where Reggie Love is sitting in the picture at right. Next to Reggie (and then later me) was the White House doctor, who in this picture is Dr. Jeffrey Kuhlman. Across from me was a member of the President's Secret Service detail, armed with a weapon during the entire motorcade ride.

On out-of-town trips, the fourth seat in the back of our limousine was occupied by the head Secret Service agent from the local field office. Up front was a Secret Service driver and the number-two agent on the President's detail.

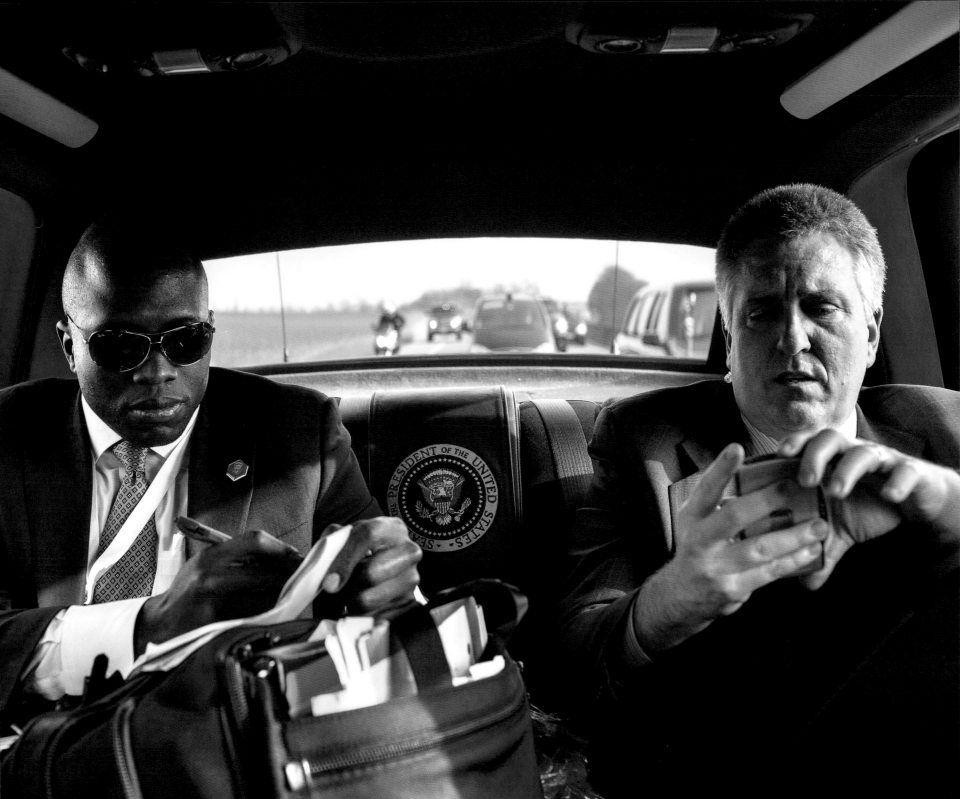

Camden, New Jersey, 2015. From my vantage point in the Spare, it was amusing to photograph people along the motorcade route looking into the window with hopes of seeing the President. We could be traveling 30 or 40 mph, but I could still catch a glimpse of their focus and anticipation—and then sometimes even their disappointment that it wasn't *him*. A few seconds later, I could hear their excitement as they caught sight of the President through the window in the vehicle behind us.

Above: Tools of the trade.

Right: Normally, there were three or four of us in the back of the Spare. Many of the agents would ride in another vehicle, nicknamed the Follow-up. After an event in Saint Petersburg, Russia, in 2013, the Follow-up was forced to move from its assigned position, so agents piled into the back of the Spare. I was sitting on someone's lap when I made this picture. I wish I had had a fish-eye lens so I could have fit all 11 passengers into my frame.

Following page: My view out the back bulletproof window looking at the Beast as crowds line the street in Havana, Cuba, in 2016.

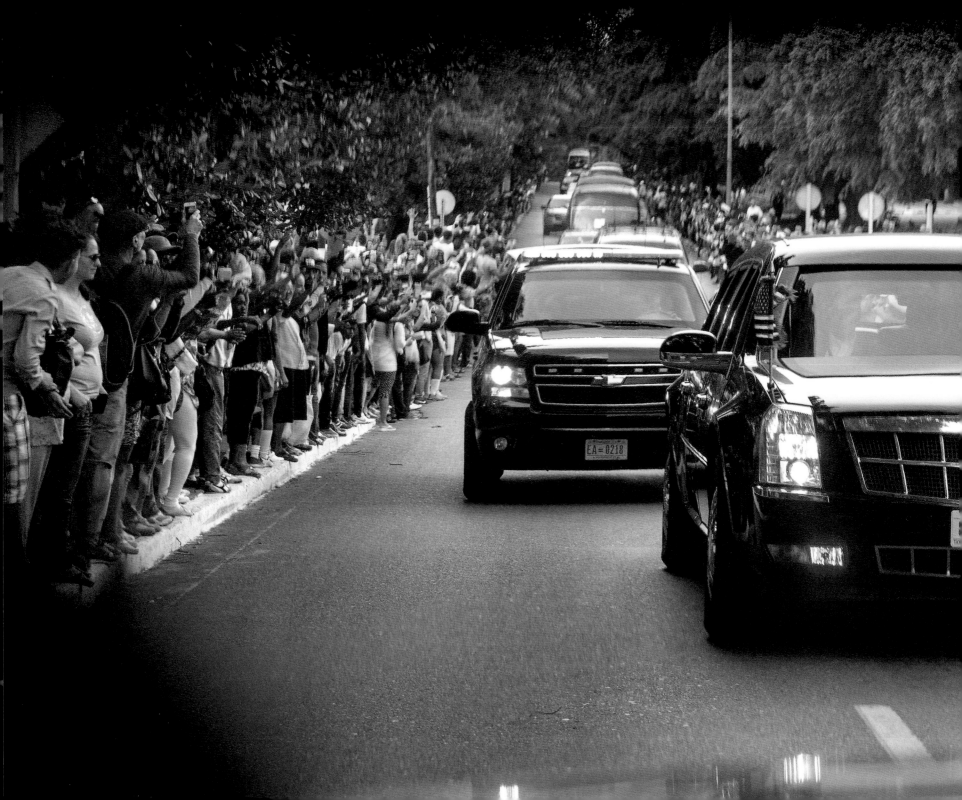

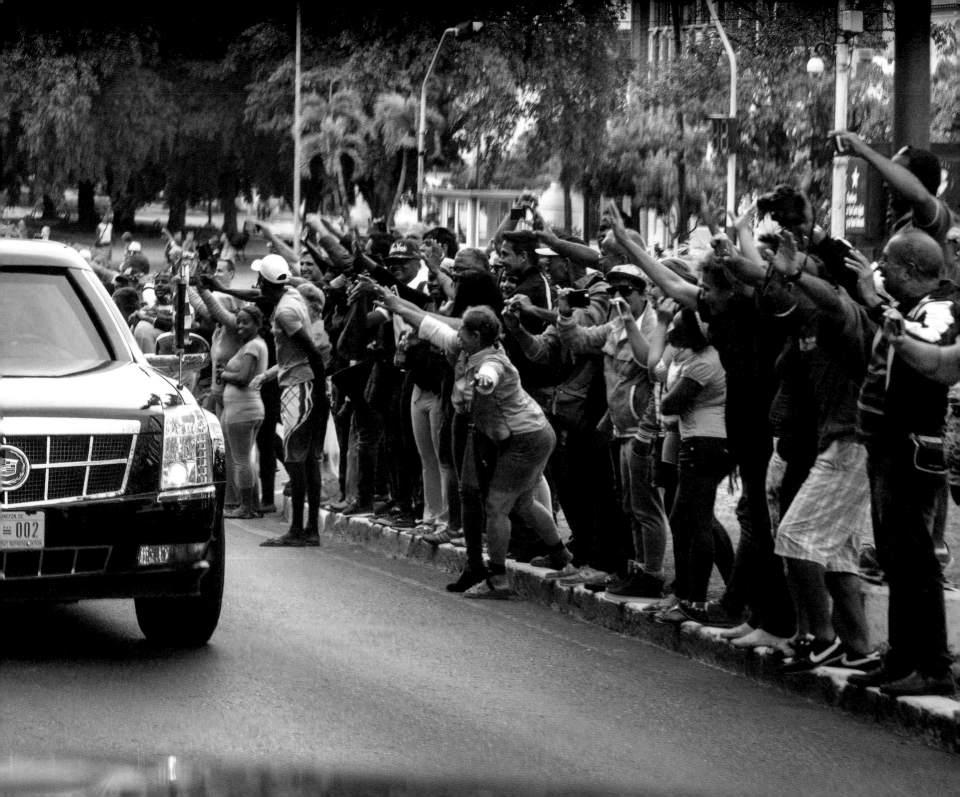

Top: Havana,
Cuba, 2016.

Near right:
Kotzebue,
Alaska, 2015.

Far right: San José,
Costa Rica, 2013.

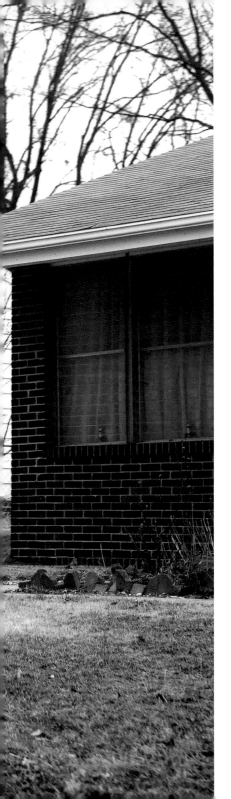

Above: A view of the Beast through the bulletproof window in Strasbourg, France, in 2009.

Left: Hannah H. Thomas waves in Adelphi, Maryland, in 2014; the photograph appeared on our Flickr photostream shortly thereafter. Post-presidency, I reposted the photo on my Instagram and received an email from Hannah. I sent her a JPEG of the photo, along with a message that I could send her a print if she'd like.

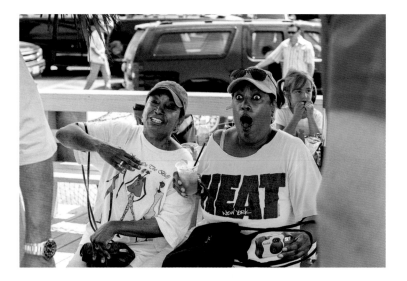

THE PRESIDENT COMES TO TOWN

"Guess who I saw today!" Imagine having breakfast at a restaurant when the President of the United States unexpectedly walks in the door. I was always on the alert for how people reacted in these situations, many of which were "OTRs," an acronym for "off-the-record movements." Above, startled customers react upon seeing the President at Nancy's Restaurant in Martha's Vineyard in 2009. At right, supporters who were security-screened in advance react to seeing the President at JFK International Airport in New York in 2011.

These stops would be surreptitiously checked out in advance by a member of the White House staff and a Secret Service agent. Once a decision had been made to proceed, a small group of agents and advance staff would descend on the location about an hour ahead to alert the owner. Secret Service would then lock down the site, and examine with a metal detector wand any customers and workers who were already inside. Anyone else would undergo a further security check before being allowed to enter.

There were often audible screams when the President showed up. People would scramble for their phones in hopes of capturing the moment. Some people expressed befuddlement or annoyance, usually those who were not supporters of the President. (I'm sure in today's political climate, it is more challenging for a president of either party to do an OTR.)

With the press pool beside them, a couple
watches the commotion as the President eats lunch
during an OTR at Hamilton Family Restaurant in
Allentown, Pennsylvania, in 2009.

Trying to catch a glimpse of the President in Asheville,
North Carolina, in 2010.

Capturing a selfie with the President, who is off camera in the far background during an OTR at the Magnolia Cafe in Austin, Texas, in 2014.

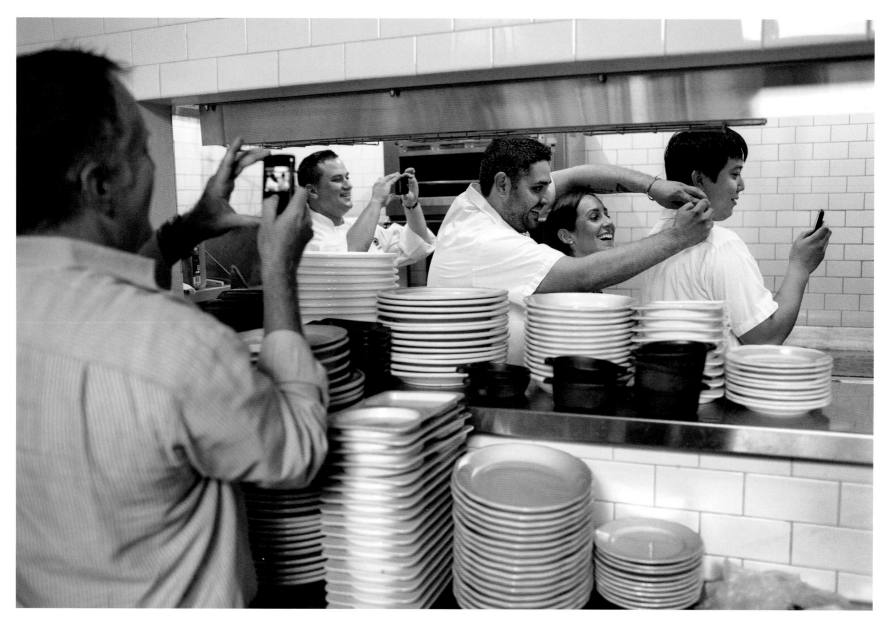

Kitchen staff snap photos of the President greeting other workers during an OTR at Ted's Bulletin in Washington, D.C., in 2011.

A woman stands on her tiptoes to make herself appear taller
as she poses for a photo with the President at the West Tampa
Sandwich Shop in Tampa, Florida, in 2012.

Above: A bartender at the Fontainebleau hotel in Miami Beach, Florida, snaps a photo during a fundraiser in 2009.

Right: Patrons peer out the window hoping to see the President after he had dinner with his two daughters at Carbone restaurant in New York City in 2015.

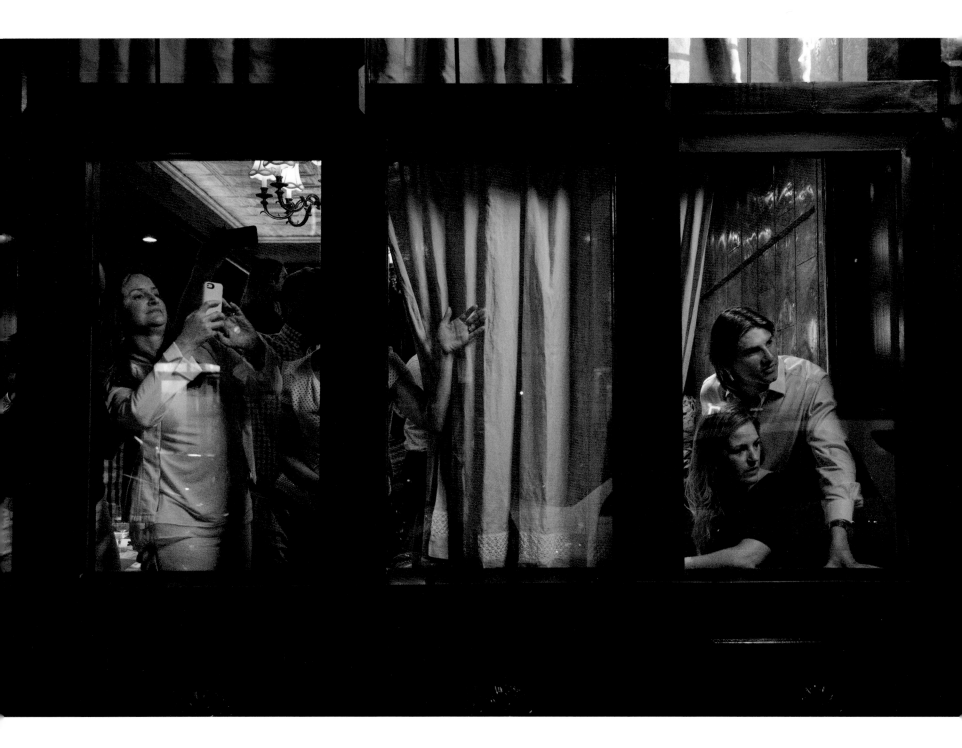

THE WORLD STAGE

Traveling overseas was full of surprises and oddities. At summit meetings with multiple countries, my eye often strayed from my main subject. Instead of focusing on the President, I'd zoom in on the toe-marks for each head of state (at right), or on the traditionally attired servers at some centuries-old palace.

Entertainment in foreign countries often led to quirky situations that I wouldn't see in the United States. To produce the biggest bang or brightest lighting display at summit meetings, countries like Russia and China spent exorbitant amounts of money seemingly just to outdo anything the United States would do (see pages 242 and 243).

The biggest challenge for me overseas was that my access was dependent on the country we were visiting. Our advance staff would help enormously by obtaining a "delegation" credential for me that would theoretically gain me more access than one that said "official photographer." Sometimes that worked, but sometimes I had to fend for myself. Trying to subvert the host security became almost a game for me. Still, I often found myself in scuffles. I once boldly stuck my finger in the chest of an Egyptian security official, yelling at him not to push me again. It turned out he was President Hosni Mubarak's chief bodyguard. He ended up respecting me for standing up for myself, though I profusely apologized to him for using the F word.

The President found my confrontations with foreign security very amusing. When French security manhandled me at the Paris Agreement climate event in 2015, he had to ask National Security Advisor Susan Rice to intervene. A few times, as he was heading into a summit meeting, I'd walk right beside him so when a security official tried to stop me, President Obama would say, "He's with me." That gave me better access than any credential could.

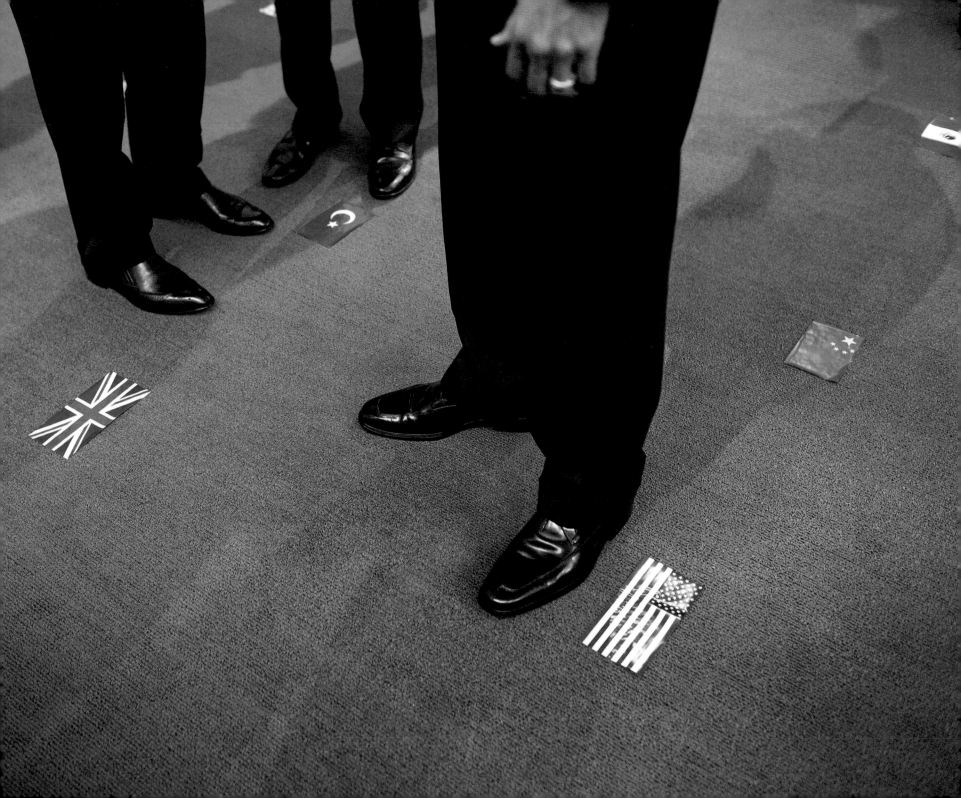

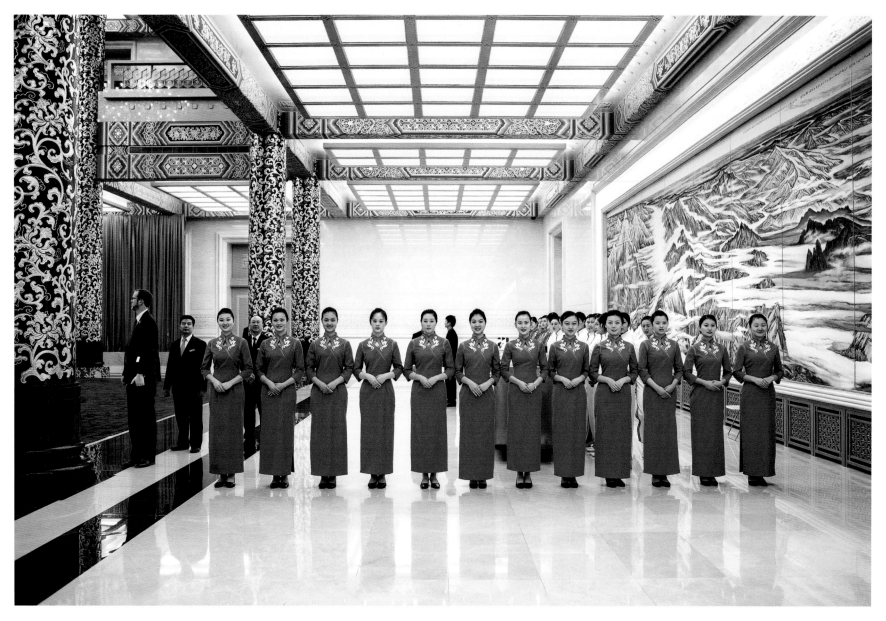

Servers wait for the arrival of President Obama and
President Hu Jintao of China during an official state dinner
at the Great Hall of the People in Beijing, China, in 2009.

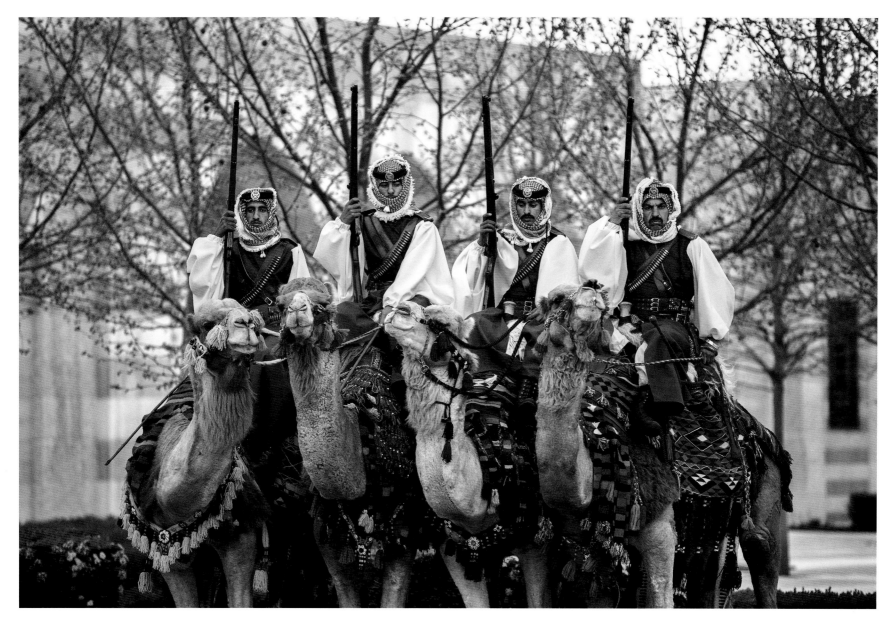

Jordanian soldiers during the official arrival ceremony
of the President and King Abdullah II bin Al-Hussein at
Al Hummar Palace in Amman, Jordan, in 2013.

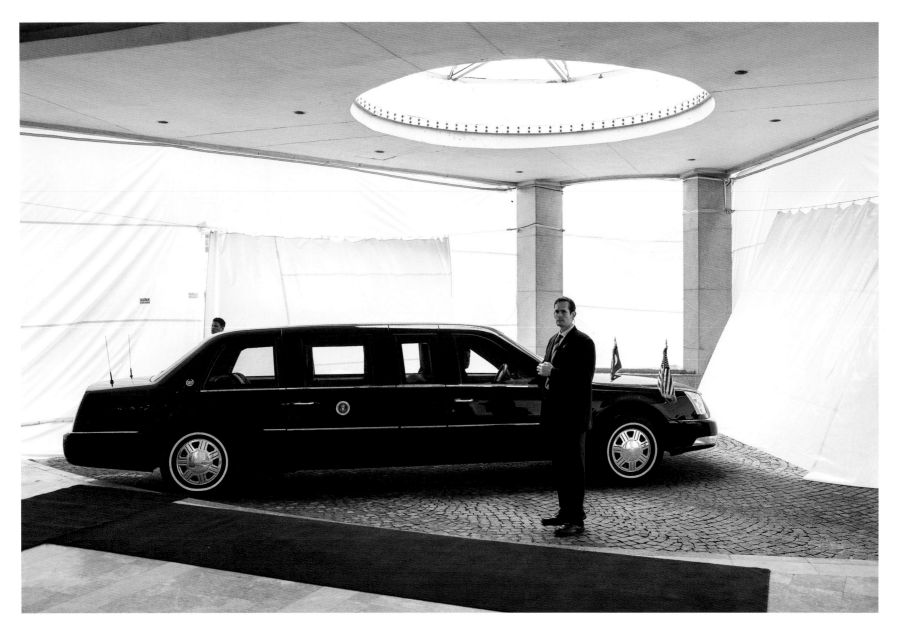

The Beast and Secret Service agents await the President's
departure from a hotel in Istanbul, Turkey, in 2009.

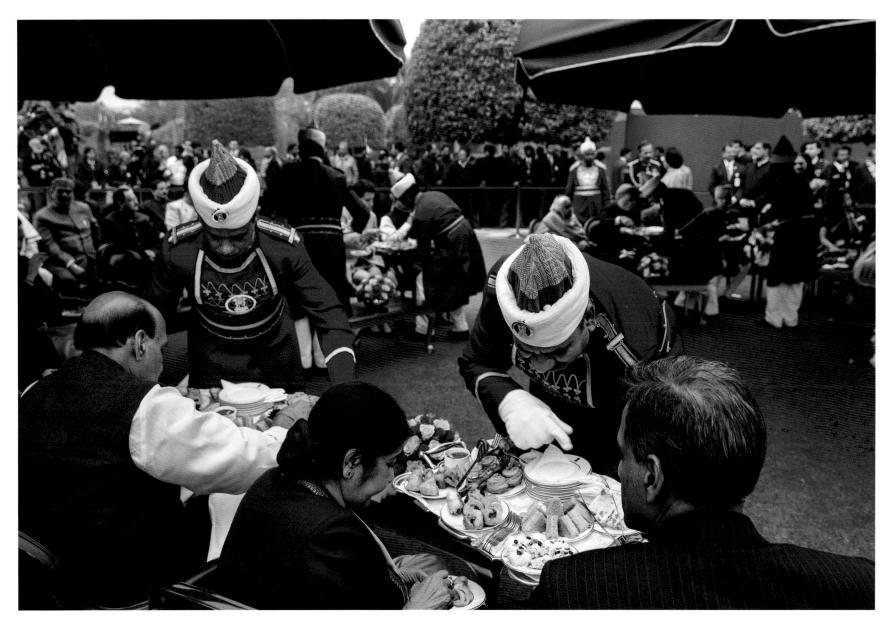

Servers during a reception on the Central Lawn of the Mughal
Gardens at Bhawan in New Delhi, India, in 2015.

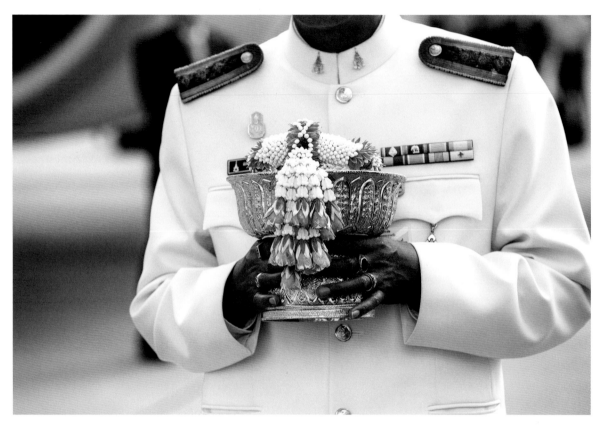

Above: A Thai official holds a gold bowl with flowers for the President just after our arrival at Don Mueang International Airport in Bangkok, Thailand, in 2012.

Right: A police officer is framed in a doorway at the Wat Pho Royal Monastery in Bangkok in 2012.

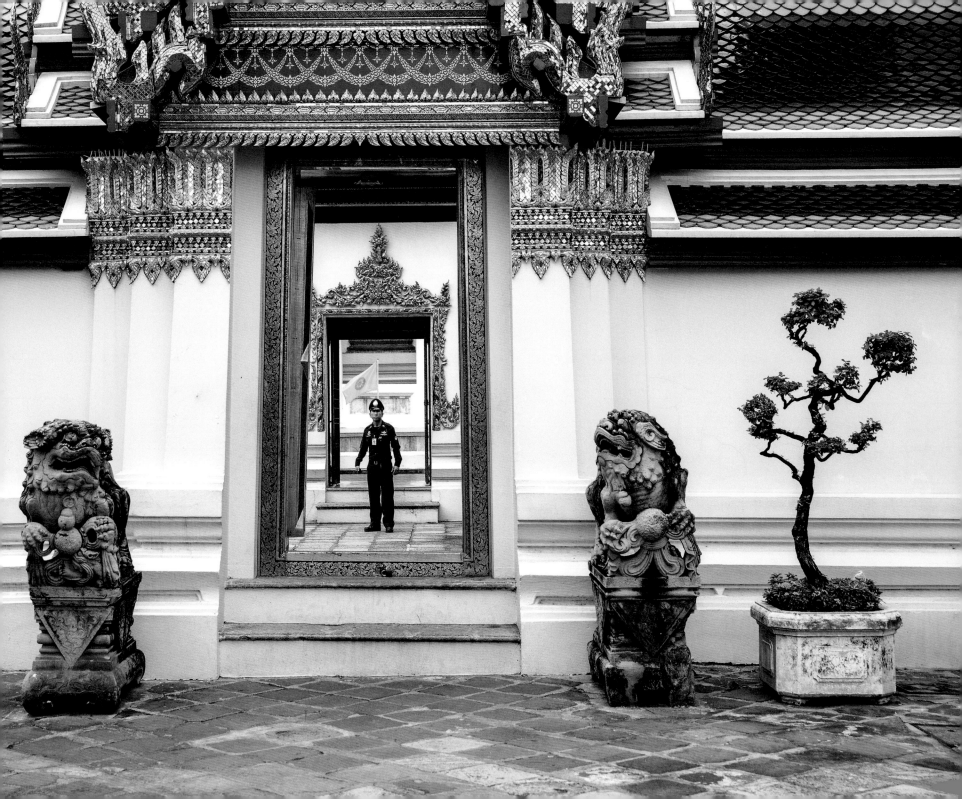

CHIEF OF PROTOCOL Although a State Department position, the Chief of Protocol works closely with the White House on all overseas presidential trips and visits by heads of state to the Oval Office. Capricia Marshall served in that role for four years during the Obama administration. She had previously been the social secretary during President Bill Clinton's second term. Pete Selfridge succeeded her as Chief of Protocol.

Carrying the title of Ambassador, the Chief of Protocol and her or his team creates the environment that will ultimately lead to successful diplomacy with other countries. At right, Capricia checks on the progress of a bilateral meeting during our visit to Cambodia in 2012. Reminiscing during an interview with her hometown Cleveland television station, Capricia recalled that she thought of protocol as a "superpower." She said that it "always gave me a little shiver" when she greeted foreign dignitaries on behalf of the President of the United States.

I befriended Capricia on our many trips together around the world. It's true that I was always teasing her, or playing practical jokes on her, but it was always in a loving way. She also became my personal advisor in purchasing gifts for my wife when we were overseas. One time she convinced me to buy a beautiful necklace for about US$200 at a bazaar set up in our hotel in Indonesia. But the shop took only cash, either American dollars or local currency, and I had only $20 with me. Capricia figured out the exchange rate and said I needed to withdraw 2,500,000 rupiah from the ATM in the hotel. As I entered the last three zeroes on the keypad, I was sweating because I didn't know if her math skills were as good as her diplomatic skills. Luckily, they were.

Preparing for the departure of the President after he met
with King Abdullah bin Abdulaziz at the king's "farm" in Riyadh,
Saudi Arabia, in 2009.

An Afghan aide holds the *chapan* cape of President Hamid Karzai prior to a formal dinner during our visit to the presidential palace in Kabul, Afghanistan, in 2010.

The bathroom assigned to the White House staff during
our visit to King Abdullah's desert palace in Rawdat Khuraim,
Saudi Arabia, in 2013.

An Italian presidential honor guard in the Sala del Bronzino
at the Quirinale Palace during the President's lunch with
President Giorgio Napolitano in Rome, Italy, in 2014. Next to
him is a bust of an "ideal" male head from a Greek prototype of
the fourth century.

Above and right: Scenes from the Republic Day Parade in New Delhi, India, in 2015.

The gala performance of Zhang Yimou's *Impression West Lake* during the cultural program at the G20 Summit hosted by Chinese President Xi Jinping at West Lake in Hangzhou, China, in 2016. China reportedly spent billions to transform the city before the summit.

Klieg lights frame the Grand Peterhof Palace during the cultural program following the G20 leaders dinner hosted by President Vladimir Putin in Saint Petersburg, Russia, in 2013. The palace had been commissioned by Peter the Great in the 1700s.

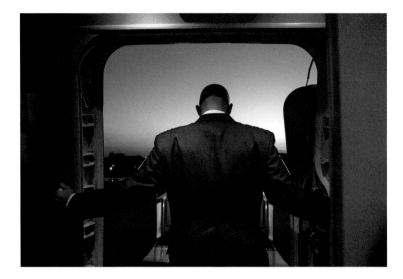

GOING HOME

As much as I enjoyed traveling overseas, going home was a welcome relief. There was something reassuring about seeing Joint Base Andrews after a week abroad with 18-hour days and minimal sleep. A couple of times we landed at the base at 2:00 a.m. in the middle of a snowstorm (at right in 2009), which meant a motorcade ride to the White House instead of taking the helicopter.

More often than not, we'd board *Marine One* and take the familiar 10-minute flight at low altitude over Washington, D.C. The best part would be the final turn north over the National Mall toward the White House, with the Lincoln Memorial to the west and the U.S. Capitol to the east. At that point, we'd be only 250 feet above the ground. If we were arriving before the sun went down, we could even see the shadow of the helicopter halfway up the Washington Monument, albeit for one brief second.

After arriving on the South Lawn, the President would take the elevator to the private residence. I'd stop by my office in the West Wing, drop off my cameras, and head out to my car to drive home. After a few hours' sleep (in my own bed!), the alarm clock would rattle, and I'd get ready to head back to the White House to document another day of history.

Above: Military aide Wes Spurlock catches a glimpse of the shadow of *Marine One* on final approach to the White House in 2016.

Left: Approaching the Jefferson Memorial and the National Mall in 2011.

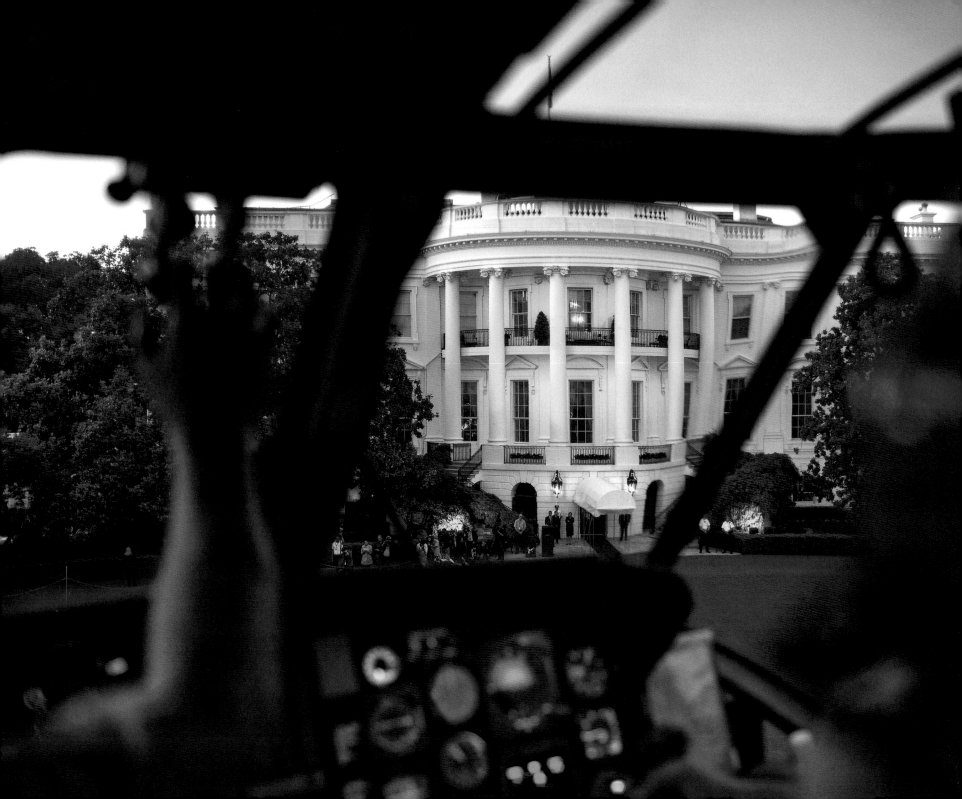

The view from the cockpit of *Marine One* just before touching
down on the South Lawn of the White House in 2012.

A gingerbread rendition of the White House made by executive pastry
chef Susie Morrison for the Christmas holiday in 2016.

MAP OF THE WEST WING
AND EXECUTIVE RESIDENCE

Only key rooms are named below; the East Wing is not pictured.

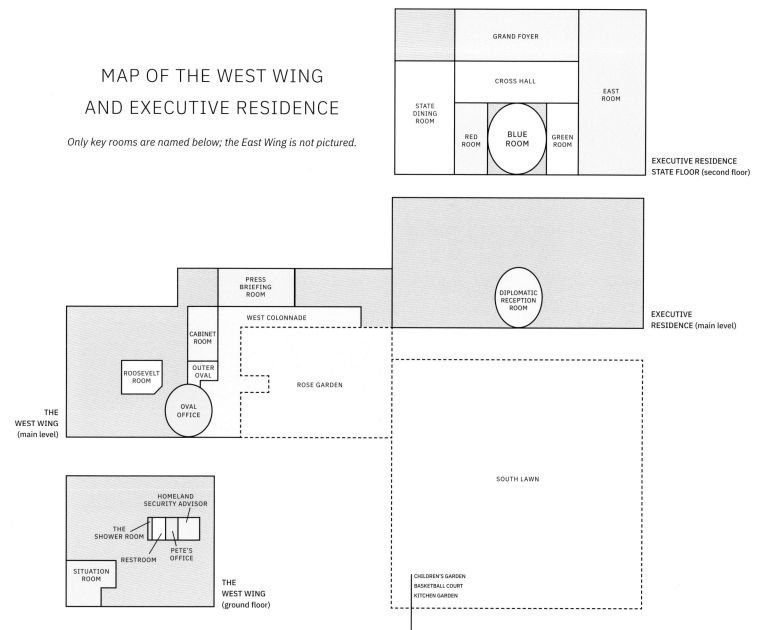

GRAND FOYER

CROSS HALL

EAST ROOM

STATE DINING ROOM

RED ROOM

BLUE ROOM

GREEN ROOM

EXECUTIVE RESIDENCE
STATE FLOOR (second floor)

PRESS BRIEFING ROOM

WEST COLONNADE

DIPLOMATIC RECEPTION ROOM

EXECUTIVE RESIDENCE (main level)

CABINET ROOM

OUTER OVAL

ROOSEVELT ROOM

OVAL OFFICE

ROSE GARDEN

THE WEST WING (main level)

SOUTH LAWN

HOMELAND SECURITY ADVISOR

THE SHOWER ROOM

RESTROOM

PETE'S OFFICE

SITUATION ROOM

THE WEST WING (ground floor)

CHILDREN'S GARDEN
BASKETBALL COURT
KITCHEN GARDEN

The Outer Oval gang poses for a final photograph with
President Obama the evening of January 19, 2017.
All of us had served in some capacity for all eight years of the
administration. Pictured with the President and me, from left,
Brian Mosteller, Joe Paulsen, Marvin Nicholson, and
Ferial Govashiri (photo by chief of staff Denis McDonough).

ACKNOWLEDGMENTS

There is a forever bond among those of us who worked together in the Obama White House. I'm sure that previous administrations feel the same way. This book is for them: the appointees, the permanent White House staff, the Secret Service, and the members of the military who support the President. They all made being inside the presidential bubble a truly unique and magical experience. They are the unsung heroes of every presidency.

A special thanks to those in the Outer Oval with whom I spent so much time during the Obama years: Brian Mosteller, Marvin Nicholson, Reggie Love, Ferial Govashiri, Anita Decker Breckenridge, Joe Paulsen, and Katie Johnson.

Thanks to everyone who worked in my office—the Photo Office—to support and add to the visual archive that we created of the Obama administration. The White House photo editors first selected many of the images that ended up in this book for our Flickr photostream or to hang as jumbos on the walls of the West Wing.

For this book, I once again had the pleasure of working with Mike Szczerban and his team at Little, Brown/Voracious. Thanks to my book agent, David Black, for having faith that this was a worthy book to publish.

The entire process of creating a photography book is both terrifying and satisfying. It's also a collaboration. Working together with Mike Szczerban and book designer Yolanda Cuomo was integral to the process. Yo loves to create photography books and makes the sometimes tedious process just plain fun. Yo's deputy, Bobbie Richardson, once again provided invaluable design and picture selection advice as well as handling the meticulous prepublication details. This team—Mike, Yo, and Bobbie—has been together with me for my last three books. Because of the pandemic, much of our work was done virtually on Zoom. Jenn Poggi, who was one of the Obama White House photo editors, gave valuable picture selection insight during many of our sessions. When I did travel to Yo's studio in New Jersey, she let me stay in a guest bedroom (which she called the Havana Room) and shared wonderful Italian dinners and late-night music courtesy of her husband, Joe.

Thanks to Shelby Marshall for preparing and toning the digital photo files for the book. Thanks to Thomas Hayes at the National Archives, Steve Branch at the Reagan Presidential Library, the LBJ Presidential Library, Mary Burtzloff at the Eisenhower Presidential Library, and Katie Dunn Tempas at the Miller Center. Thanks to those who provided quotes for the book, read portions of my text to ensure I "had it right," or helped with names of people pictured, including: Jodi Archambault, Nora Cohen Brown, David Ceasar, Nate Emory, Vic Erevia, Ferial Govashiri, Tim Hanseroth, Eric Holder, Jim Kuhn, Reggie Love, Alyssa Mastromonaco, Brian Mosteller, Josh Pruett, Manuel Quiroz, Domitilla Sartogo, Bobby Schmuck, Dan Shapiro, Wes Spurlock, Meryl Streep, Stelth Ulvang, Joni Walsh, Mike White, Kori Wilson-Griffin, and Melissa Winter.

I also consulted many published sources to ensure accuracy, including *The White House: An Historic Guide* published by the White House Historical Association, *The President's Photographer* by John Bredar, *The White House Staff: Inside the West Wing and Beyond* by Bradley H. Patterson Jr., *The West Wing* (a guidebook) published by The White House, *The White House* and *The Living White House* by Betty C. Monkman, *Designing History* by Michael S. Smith, *The President's House* by William Seale, various reports by *The New York Times* and *The Washington Post*, and *A Promised Land* by Barack Obama.

Lastly, thanks to Barack Obama for hiring me and to my wife, Patti, for her support during those eight years (and beyond).

Bob Dylan's hat rests on a chair in the Blue Room during the
Presidential Medal of Freedom ceremony in 2012.

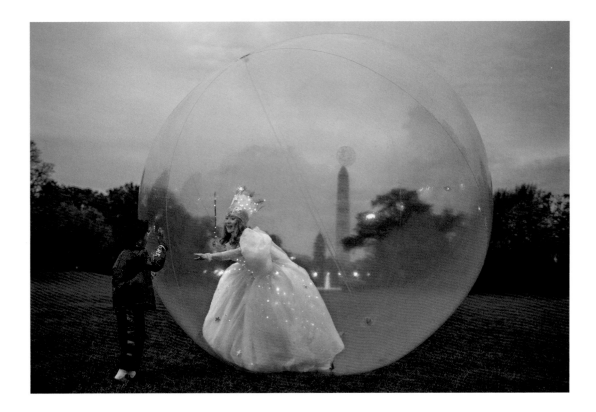

Voracious / Little, Brown and Company
Hachette Book Group
1290 Avenue of the Americas, New York, NY 10104
voraciousbooks.com

First edition: September 2022

Voracious is an imprint of Little, Brown and Company, a division of Hachette Book Group, Inc.
The Voracious name and logo are trademarks of Hachette Book Group, Inc.
The publisher is not responsible for websites (or their content) that are not owned by the publisher.

The Hachette Speakers Bureau provides a wide range of authors for speaking events.
To find out more, go to hachettespeakersbureau.com or call (866) 376-6591.

ISBN 9780316383370 (hardcover) / 9780316500357 (signed) / 9780316500456 (Barnes & Noble signed)
LCCN 2022901661

10 9 8 7 6 5 4 3 2 1

Printed in Italy by Verona Libri

BOOK DESIGN BY YOLANDA CUOMO DESIGN
Associate Designer: Bobbie Richardson